Winged Fantasy

Draw and Paint Magical and Mythical Creatures

Brenda Lyons

IMPACT
CINCINNATI, OHIO
www.impact-books.com

Table of Contents

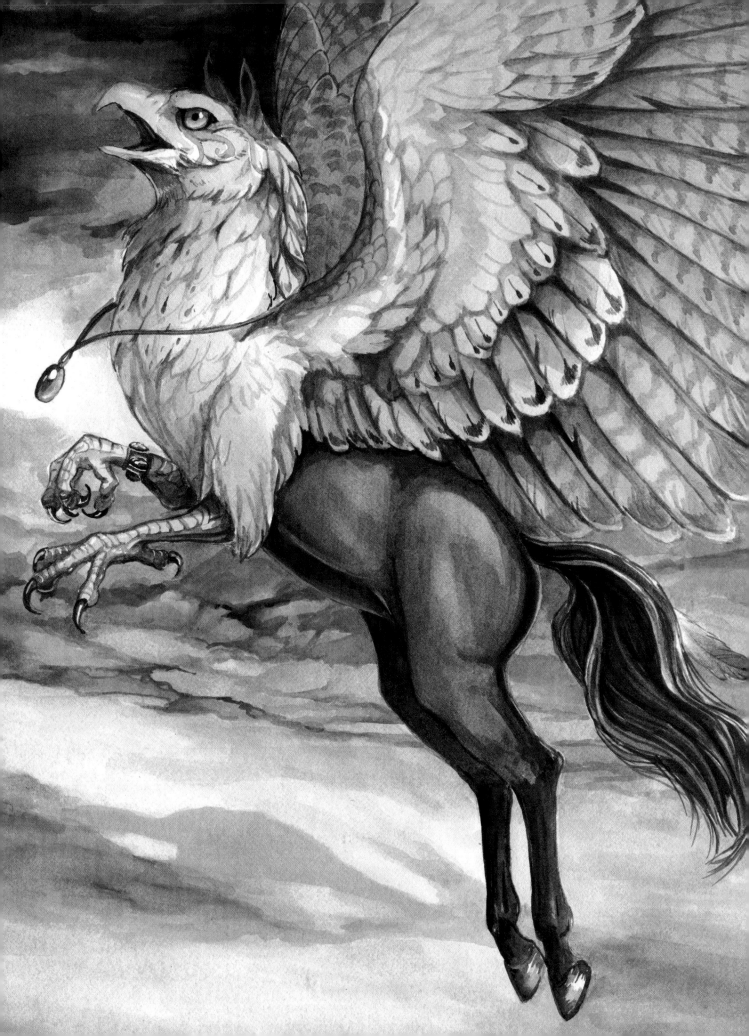

Introduction

Why do we love winged creatures? Why do we put wings on horses and create great, flying beasts that exist only in our dreams and imaginations? Perhaps it begins with our own yearnings for flight. Throughout history, humankind has tried to fly, and through the technology of machinery, we have succeeded. But there is something much more special—more magical—about being able to fly aided only by your own power. We gaze with awe at birds flying effortlessly overhead, pushed only by their own two wings, and our imaginations take flight with them.

Fantastical winged creatures are nothing new. The Pegasus has origins in Greek mythology, gryphons are found in sculpture as far back as the eleventh century and dragons appear throughout Europe and Asia in everything from heraldry to paintings to architecture. In the present day, dragons breathe fire on our movie screens and hippogryphs appear in literature to fly to the rescue. In this book, you will learn to draw and paint these winged creatures. I will introduce you to the materials you need to paint worlds of watercolor and teach you the techniques to bring them to life. Most importantly, you will discover how to create your own creatures and compositions from your imagination and how to tell your own story—one that perhaps future generations will look upon as a legend of the past.

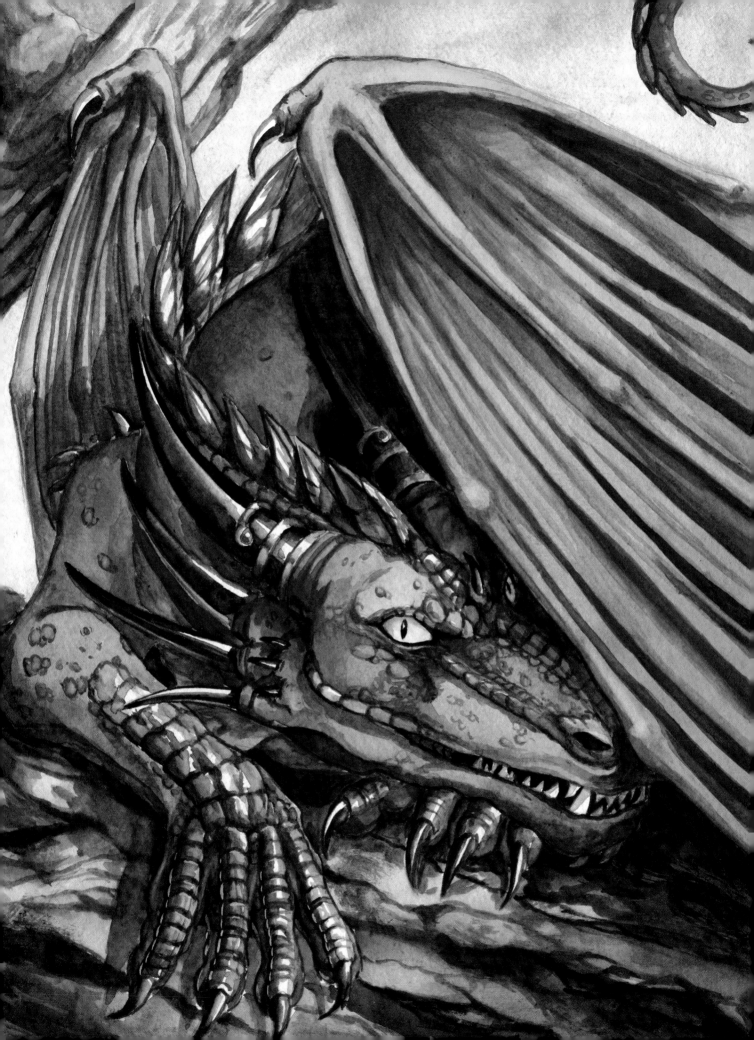

1

Materials and Techniques

Contrary to what many artists who are just starting out believe, the quality of an artist's work is not defined simply by his or her materials. It is true that using quality materials will make it easier to create beautiful artwork, but it is not necessary to buy the most expensive paint or brushes, and many good materials are not only affordable, but often they are very easy to find. In this chapter, I will cover the materials necessary to work in watercolor and explain how to use them.

Techniques go hand in hand with materials. Anyone can dip a brush into watercolor and make a mark on the paper, but how do you create a beautiful gradient? What about the crumbly texture in that rock or the blotchy surface of a dragon's hide? These techniques may look challenging, but you may be surprised to find they are quite simple, and, once explained, you will be eager to try them out for yourself.

Pencils

Pencils are one of the most useful drawing tools, because you can draw as dark or light as you wish and erase any unwanted lines. When drawing from life or sketching ideas in a sketchbook, a simple pencil and eraser are two basic and easy-to-use tools that you can take anywhere. When working in watercolor, graphite allows you to draw light lines as a guide for your watercolor paintings. You can also use shading within your drawing with different hardnesses of graphite.

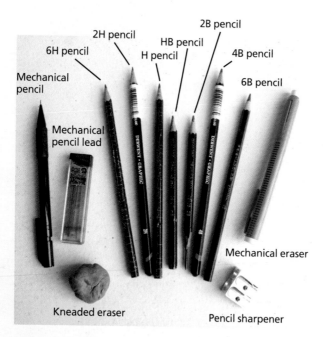

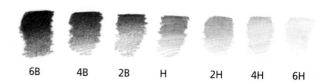

| 6B | 4B | 2B | H | 2H | 4H | 6H |

Graphite Hardness

Pencils come in different graphite hardnesses. Most commonly sold for standard use is HB and 2B. However, for drawing you will find harder and softer leads are useful for creating a variety of value. H pencils have harder lead and create a lighter line. B pencils have softer lead, and create a darker line. In the diagram above, you can see how the hardest lead at the right, 6H, is much lighter than the softest lead at the left, 6B. No matter how hard you press with a 6H pencil, it will never be as dark as a 6B pencil.

There are different types of pencils. I prefer a .05mm mechanical pencil with HB lead for my go-to pencil because it keeps a constant point. If you prefer a traditional pencil, make sure you keep a pencil sharpener handy. Experiment and see what kind of pencil you like the best. Kneaded erasers are good for larger areas, whereas mechanical erasers give you a small, concentrated eraser for details.

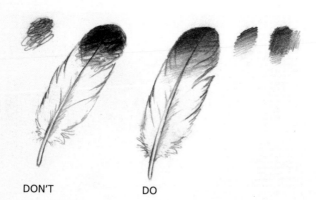

DON'T DO

When you shade, try not to scribble in random directions. This can result in random light and dark areas and lines. Try to shade in one direction; this will make your shading look smoother and more controlled. Sometimes it's fine to leave lines showing when shading. This is called hatching and is a wonderful way to shade.

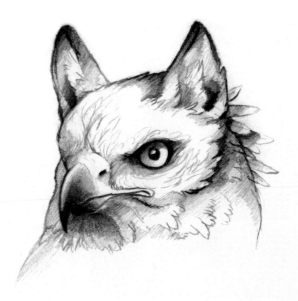

How to Use Different Pencils

I used a variety of pencils on this gryphon head. The very dark area around the eyes is a 6B, and the very, very light shading is a 4H pencil. I used an HB pencil for the general feather details. For the subtle gradation of the beak, I used a 6B at the very tip, then a 2B, H and 4H at the base. When shading with a hard pencil such as a 4H, try not to push down too hard; otherwise the lead will press lines into your paper. If you want to go darker, use a softer lead, such as an HB. You will find that by using different hardnesses of graphite, your pencil drawings will have deeper and smoother values.

Paints

For most of us, our first experience with watercolors was a small set of watercolor cakes with a small, bristly brush. Watercolors come not only in cakes, but tubes as well. What's best is you only need a pan with a few colors, some water and brushes, and you can take your paints anywhere! Unlike other paints, such as oils, you don't need odorous chemicals to use them, and unlike acrylics, they don't become dead once dry; add a little bit of water, and your watercolors will spring to life once more.

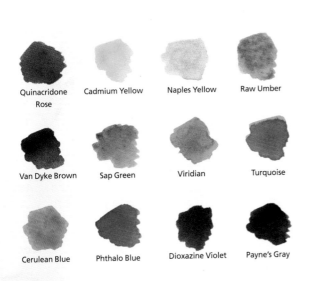

Quinacridone Rose Cadmium Yellow Naples Yellow Raw Umber

Van Dyke Brown Sap Green Viridian Turquoise

Cerulean Blue Phthalo Blue Dioxazine Violet Payne's Gray

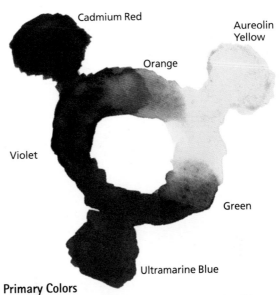

Cadmium Red

Aureolin Yellow

Orange

Violet

Green

Ultramarine Blue

Additional Useful Colors

You may want to use other colors that you cannot create by mixing alone or colors you use often enough that you'd prefer not to mix them. Some of these include roses and pinks, dark browns and grays, and more cyan-based blues.

Primary Colors

Red, yellow and blue are the primary colors for painting. When combining two of these three colors, you can create other colors, including the secondary colors: orange, green and purple. Combining all three primary colors will result in a dull, dark mud color, so keep this in mind when mixing colors.

Cakes vs. Tubes

Watercolors come in both cake and tube form. Cakes are dry pigment neatly preformed in a plastic pan. They are a wonderful way to start with watercolors because they contain the most common colors you need in one, neat package. Many brands of cake watercolors sell pan refills for individual colors, so you don't have to buy a brand-new set when you use up one color. The main drawback is it can be difficult to remove contaminated color if you happen to dip another color in. Some pigments are also difficult to achieve a rich color with after they are completely dry, which is where tube watercolors are an advantage.

Tube watercolors are excellent if you want a certain color that you don't have in your pan of cake watercolors. They also give you a wet pigment that can provide a richer color. Tubes allow you to put as little or as much paint as you want in your palette, which is useful if you know you will be using a lot of one color or need a lot of concentrated color. You can also use them to refill your cake watercolors when you use up a certain color. Tube watercolors come in sizes as small as 5mL, but don't let the tiny size fool you — you can get a lot of use out of a tiny 5mL tube! One of these tubes often lasts me six months to a year, depending on how frequently I use that color.

Visit www.impact-books.com/wingedfantasy for free bonus content.

Paper and Boards

The type of paper you use can affect your painting in surprising ways. Typically you want to use at least a 90-lb (190gsm) paper. Paper thickness is measured in pounds. This, of course, is not the weight of one sheet, but rather the weight of a ream (typically 500 sheets). Heavier-weight paper is thicker and thus resists warping and buckling better than thinner paper. In addition, watercolor papers come in different textures, depending on the type of press used to create the paper. Two papers of the same exact weight but of a different type of press and sizing can handle watercolor in completely different ways. The best way to find the paper that works well for you is to experiment with different types. Some companies sell sample packs online, or you can buy a single full sheet of each.

Types of Paper and Boards:

WATERCOLOR PAPER: Watercolor papers are the most commonly used surfaces. They come in three main textures or presses—hot press (smooth), cold press (slightly textured) and rough (very textured). The heavier the paper, generally the rougher the texture. More-textured papers tend to hold paint better.

ILLLUSTRATION BOARD: Illustration boards are thick boards usually made of cotton fiber. They are acid-free and because of their thickness, resist warping and buckling. Illustration boards come in textured and smooth surfaces.

BRISTOL BOARD: Bristol board is a stiff type of paper that is excellent for pencil and ink. It can also be used for watercolor. Often the paint soaks in and dries quicker, resulting in hard edges. Some artists love this effect, so don't be afraid to experiment and see if you like it too!

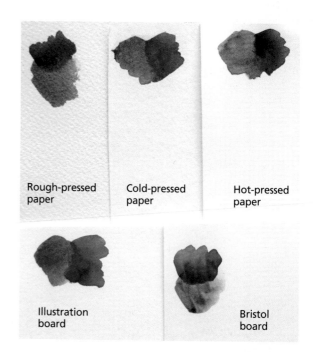

Rough-pressed paper Cold-pressed paper Hot-pressed paper

Illustration board Bristol board

Stretching Paper

Even heavy watercolor paper can warp, so stretching or taping down your paper will ensure it stays put. Stretching involves soaking the paper long enough for it to expand, then taping it down so when it dries, it shrinks again and becomes taut. Most art stores sell a gummed tape called butcher's tape, which is a brown paper tape with an adhesive side that gets gummy when wet.

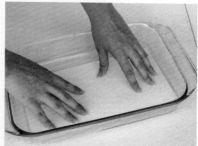

1 Soak the Paper
Wet the entire paper by soaking it for a few minutes in water. When you remove it, use a clean sponge to gently remove the excess water. Then lay the paper flat on a piece of Masonite.

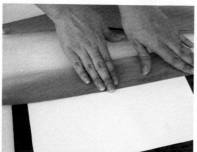

2 Start Applying Tape
Using another sponge (to avoid getting adhesive on other surfaces), wet the adhesive side of your butcher's tape. Then press down along the edge of your paper, making sure the tape is covering both paper and board.

3 Finish Taping the Paper
Repeat on all four sides. Wait until your paper is completely dry before painting. As long as most of the paper is stuck down with the tape, it will resist warping. Leave your paper stretched while painting so it doesn't buckle. When done, cut the taped sections off with scissors.

Brushes

When you walk into an art store and look at their brush section, you will notice many different sizes and types of brushes. It may be overwhelming. What brushes should you pick? Flat and round brushes are the most commonly used for watercolor, though other brushes, such as the mop and bristle, can be useful.

Types of Brushes:

ROUNDS: Round brushes have a body that holds water and tapers to a fine tip. They are the brushes you will use the most while painting with watercolor. Many artists believe they need to have a very fine and very small brush to paint details, but with watercolor, a fine tip with a big base is best because it holds more pigment than a tiny brush. The tip of a No. 2 is excellent for details. Larger rounds, such as the No. 6, are good for filling in larger areas where you also need to paint in small, narrow sections.

FLATS: Flat brushes are excellent for filling in large sections with color. Expanses of sky, for instance, are easier to paint with a flat. They hold a good amount of pigment and lay down a single stroke of color.

MOP BRUSHES: These brushes are the best for laying down a wash of water for wet-on-wet painting. Mop brushes hold a lot of water and are useful for charging color into sections where you want an irregular wash rather than a smooth, solid color.

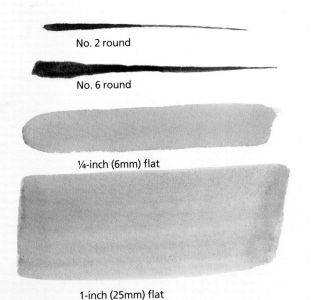

No. 2 round

No. 6 round

¼-inch (6mm) flat

1-inch (25mm) flat

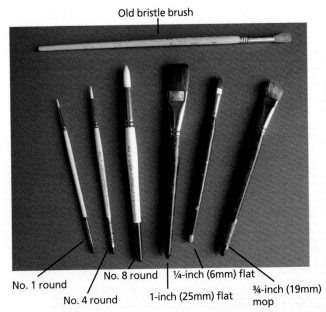

Old bristle brush

No. 1 round
No. 4 round
No. 8 round
1-inch (25mm) flat
¼-inch (6mm) flat
¾-inch (19mm) mop

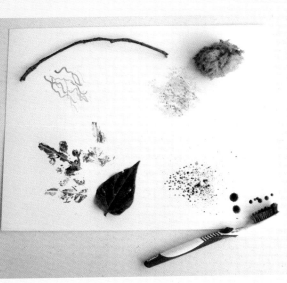

Other Painting Tools

Sticks and leaves can leave interesting textures and imprints. An old toothbrush, loaded with wet paint and flicked or dragged with your thumb, is an excellent way to create splatters. A damp sponge dabbed on wet paint or loaded with paint and pressed on your paper can create effects that brushes alone cannot.

Visit www.impact-books.com/wingedfantasy for free bonus content.

11

Other Materials

Paints, paper and brushes are the basics you need to get started, but other materials will make painting easier. Not all of the materials covered here are required for successful painting, but you may find them to be useful.

ARTIST'S MASKING TAPE: This tape is easy to find in most art stores and many craft stores. It is a low-tack, acid-free tape that will not leave a residue on your paper. It is excellent for taping down paper and for masking areas with a straight edge, such as the edge of your paper to leave a white border around your painting.

PAINTING BOARDS: Masonite or other solid boards are useful for taping your painting down. Cardboard can be used in a pinch, but may warp when your paper is wet.

MASKING FLUID: Masking fluid is used for blocking areas of your painting that you want to keep white, such as stars or sparkles. Using an old brush, paint the masking fluid anywhere you want the white of the paper to show, then paint over it. When you are done painting, rub the masking fluid away gently with either your thumb or an old piece of kneaded eraser. Masking fluid dries very quickly, so always use an old brush, because that brush will likely end up with dried masking fluid in it. Wetting the brush a little can help, but be sure to constantly rinse your brush in a container of water to prevent it from building up.

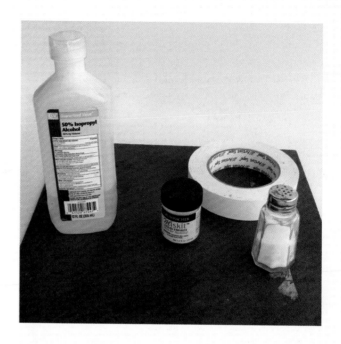

Art Supplies on a Budget

Art stores often offer items you can find at other shops for a fraction of the price if you know where to look! Painting boards, for example, are sold as specialty items at art stores. However, most painting boards are simply hardboard. A trip to your local hardware store that sells lumber will show that you can buy a large sheet of Masonite for under $10. Many stores cut the board for free, so ask them to cut it to whichever sizes you prefer.

Any nonporous, flat surface will work fine for a palette. In a pinch you can use the plastic lid from a carry-out container to hold color. Remember, watercolor does not require any special chemicals or solvents to clean your brushes! In fact, solvents such as turpentine will damage your delicate watercolor brushes over time. Clean water will wash away any leftover paint in your brushes.

Taping your paper to a Masonite board with artist's masking tape will keep the edges crisp and white, and also keep it from warping too much while you're painting. You can wet the paper first or tape it dry.

Transferring Your Drawing

While you can draw directly on your watercolor paper, you may find you want to create a painting out of a drawing you've done in a sketchbook or on a piece of paper that's unsuitable for watercolor. In this case, you can transfer the drawing onto a piece of watercolor paper or illustration board.

If you have a scanner, you can scan your drawing into an image editing program and then print it out. This will preserve your original drawing and allow you to resize it if you wish to paint larger or smaller. Otherwise, you can transfer from the original drawing itself.

MATERIALS LIST

Paper: watercolor paper or illustration board, graphite-based transfer paper

Other materials: Masonite board, artist's masking tape, ballpoint pen

1 Tape the Paper
Tape a sheet of watercolor paper to a piece of Masonite. Tape the top edge of your artwork to the Masonite board, making sure your drawing will be centered on your painting surface after it's transferred. Place your transfer paper between the artwork and the watercolor paper so the graphite side is facing the watercolor paper.

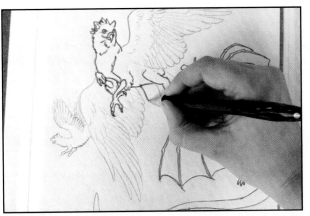

2 Trace Your Drawing
Use a ballpoint pen to trace the lines of your drawing. Be sure to press firmly, but not too hard — it doesn't take too much pressure to transfer your lines. If you are unsure that your lines are transferring, you can lift the artwork and look beneath the transfer paper. Because your artwork is firmly taped along the top, you can lift it up and it will not shift.

3 Check Your Lines
After you have traced your entire drawing, lift your artwork to make sure you haven't missed any lines. If you see any lines missing, simply go back and trace them. After you've transferred your entire drawing, remove the taped artwork from the Masonite board and you're ready to start painting!

Transferring Tips

- Pressing too hard with the ballpoint pen can result in gouged lines in your watercolor surface. This can create unwanted texture with smooth washes. If you want darker lines, you can always go back over them with a pencil.
- Any rubbed-off graphite can be easily removed with a kneaded eraser.
- If you don't have transfer paper or can't find any in your local art stores you can create your own by covering a piece of paper with a 2B pencil. It may eat up your pencil, but it's good in a pinch!

Painting Over Your Graphite Design

Pencils are an excellent and versatile medium. Even a single hardness allows a variety of values, and pencils are easy to find and affordable. Many watercolor artists like to create a detailed, shaded drawing and paint over it with watercolor. Unlike opaque paints, such as oils and acrylics, watercolor is translucent, and therefore will allow your beautiful pencil drawing to show through!

MATERIALS LIST

Paper: hot-pressed watercolor paper

Pencils: 6B, 2B, HB and 4H pencils

Brushes: Nos. 2 and 4 round brushes

Paint: Cadmium Yellow, Dioxazine Violet, Naples Yellow, Quinacridone Rose, Raw Umber, Sap Green, Turquoise, Ultramarine Blue, Van Dyke Brown

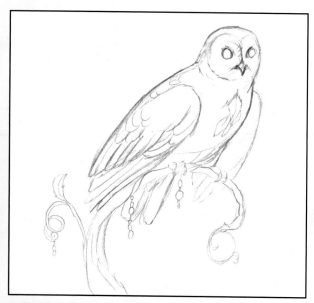

1 Sketch the Owl
Lightly sketch your drawing on your watercolor paper using an HB pencil. Here we have an owl with some jewels, so some subdued browns will contrast nicely with the bright colors of the hanging baubles.

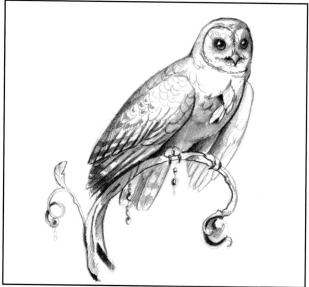

2 Shade Your Drawing with Graphite
Use an HB and 2B pencil for general shadows, such as for the belly and far side of the face. Use a 6B pencil for deep shadows and darker details, such as the owl's talons, eyes and the hollow of the tree branch. For the very light areas of shadow under the tail and on the far wing, use a 4H pencil.

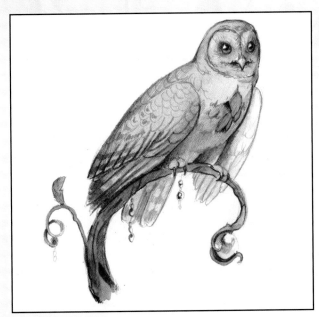

3 Add the Base Color

Use a No. 4 round to paint a wash of Raw Umber mixed with a little Dioxazine Violet onto the body and tail. For the face and inner wing, use a light mixture of Raw Umber and Naples Yellow. After everything is dry, go back with a No. 2 round and paint Sap Green in the leaves and the twisting vine. Wet the branch with clean water and paint random sections with Van Dyke Brown, Ultramarine Blue and Raw Umber.

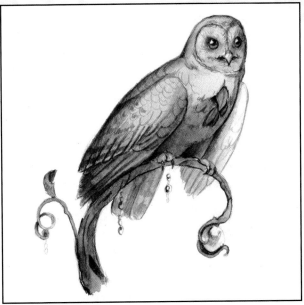

4 Enhance the Shadows

Continue to use your No. 4 round and add a wash of Van Dyke Brown mixed with Dioxazine Violet to the areas where you used your 2B pencil for the shadows. Add a wash of Ultramarine Blue to the tail and the inner wing, and paint a light wash of Dioxazine Violet to the flight feathers of the owl. Create a concentrated mixture of Sap Green and Dioxazine Violet to add shadows for the leaves.

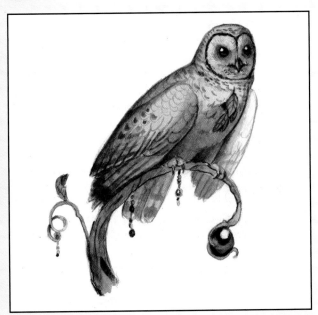

5 Final Details

Add color to the eyes with Quinacridone Rose and Dioxazine Violet with the tip of your No. 2 round. Use a mixture of Dioxazine Violet and Van Dyke Brown for the frilly feathers around the face and to add a few extra feathers on the head. For the large jewel, use Quinacridone Rose and Dioxazine Violet. Color the smaller baubles with Turquoise, Sap Green and Cadmium Yellow. Add a mixture of Ultramarine Blue and Van Dyke Brown to the beak, wing bars, tail bars and the shadows of the face.

With this technique, your pencil drawing and painting work with one another. The painting is accentuating your pencil drawing and vice versa. By creating most of your shading with graphite, you only glaze color over with your paint.

Drawing with Ink

Many artists are hesitant to work with ink because it is not as forgiving as graphite, and certainly less erasable! Ink, however, can be a rewarding medium, particularly after you learn a few techniques. Ink is not limited to pens, however: quills, brushes and specialty nibs can all be used to create beautiful compositions with ink.

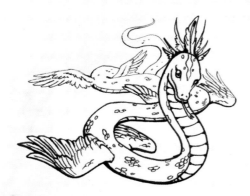

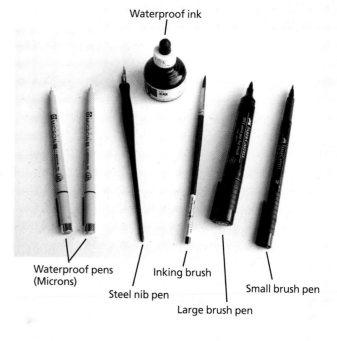

Waterproof ink

Waterproof pens
(Microns)

Steel nib pen

Inking brush

Large brush pen

Small brush pen

Line Weight

Depth is created by making certain lines heavier than others. Lines closest to the viewer are generally heavier, whereas lines get thinner when they're farther away. Heavier lines can also imply shadow.

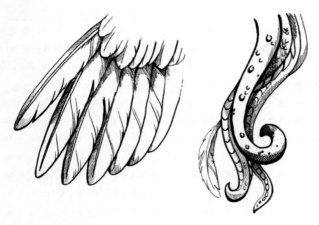

Hatching and Crosshatching

Hatching and crosshatching work especially well in ink to suggest shadow. When hatching, draw lines rapidly one right after the other in the same direction. Crosshatching is simply hatching back over your previous lines, but in a different direction to create deeper shadow or texture.

Stippling

Stippling is using small dots to imply texture or value. This works best with an ink pen such as a Sakura Pigma Micron or Copic Multiliner. Create a smooth texture by creating evenly spaced dots, and deepen the value in areas such as shadows by placing the dots closer together. Stippling works best when the dots are very small.

Brush Lines and Washes

Ink will age and weaken a brush faster than watercolor, so I recommend buying a special brush just for inking.

Unlike watercolor, after an ink wash is dry, it cannot be lifted and is more difficult to manipulate while wet. One advantage, however, is that you can paint over waterproof ink without any fear of the ink coming up.

Painting Over an Ink Drawing

Like graphite, ink will show through your watercolors and won't lift up, regardless of how wet you get the paper. Many artists like crisp outlines for their watercolor paintings, and often they use ink to accomplish this. Simple shading and color can let your ink work show through without making the painting too busy. Here you will learn how to use a little bit of watercolor to enhance a simple ink drawing.

MATERIALS LIST

Paper: hot-pressed watercolor paper

Pencils and pens: HB pencil, 08, 05 and 02 Micron pens or a G-nib with waterproof ink

Brushes: No. 2, 4 and 6 rounds

Paint: Aureolin Yellow, Cadmium Orange, Cadmium Red, Payne's Gray, Raw Umber, Thio Violet, Van Dyke Brown, Viridian

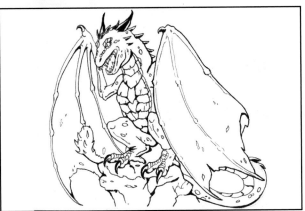

1 Sketch the Wyvern and Add Ink Lines
Lightly sketch the wyvern with an HB pencil. Use an 05 Micron to add the heaviest lines such as the tail and belly scales. Go back with an 08 Micron to shade the horns and claws. For the finer lines of the fingers of the wings and smaller scales, use an 02 Micron.

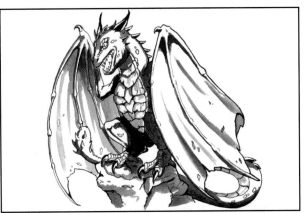

2 Paint the Shadows
With a No. 4 round, mix a wash of Thio Violet and Van Dyke Brown to paint in the shadows on the body. For the underwings and belly scales, use Van Dyke Brown. Mix a bit of Payne's Gray with Van Dyke Brown for the shadow on the rock.

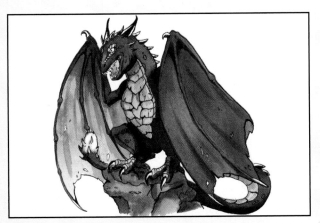

3 Add the Base Colors
For the wyvern's red hide, combine Cadmium Red with a little Aureolin Yellow and paint the body, tail and outer wings with a No. 6 round. Use a No. 2 round for the inner wing fingers. Let it dry, then paint the inner wings with Cadmium Orange. While the paint is still wet, switch to Aureolin Yellow and paint to the bottom. Do the same for the mouth to suggest growing fire.

Wet the rock with clear water and a No. 4 round, then paint irregular sections of Van Dyke Brown, Raw Umber, and Payne's Gray, letting the colors bleed and blend.

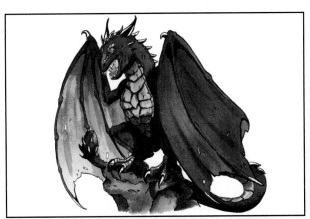

4 Final Details
Add color to the end of the wyvern's tail with a mixture of Viridian and Van Dyke Brown with a No. 2 round. For the eye and round body scales, paint in Aureolin Yellow and add just a spot of Viridian to the eye. Deepen the shadows with Van Dyke Brown and finish the rock with Payne's Gray.

Basic Painting Techniques
Wet-on-Wet Painting

Wet-on-wet painting is, as its name suggests, adding wet paint to wet paper. Many watercolor artists first discover this technique by accident when they try to paint another part of their painting before the section next to it is dry. When you use this technique purposefully, you can achieve beautiful, soft blended colors and seamless gradients.

MATERIALS LIST

Paper: cold-pressed watercolor paper
Brushes: No. 6 round, ¾-inch (19mm) mop
Paint: Phthalo Blue, Quinacridone Rose

1 Wet the Paper
Wet the paper with a ¾-inch (19mm) mop brush and clean water. The paper should be wet enough so it doesn't dry too quickly, but not so wet that you end up with puddles.

2 Start Adding Color
While the paper is still wet, load your No. 6 round with Phthalo Blue and touch it to the still-wet paper. The paint will bleed, following the water.

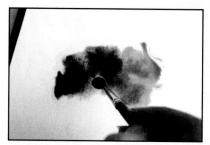

3 Layer More Color
Clean your brush and load it with Quinacridone Rose, then touch it to the wet paper next to the bloom of Phthalo Blue. The two colors will continue to blend together while the paper is still wet.

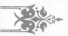

Glazing

Glazing is adding a wash of color over a previously painted section to add color, but retaining the texture and value of the color beneath. To glaze, the layer beneath must be dry, otherwise your colors will blend and you will lose the detail of the first layer. Glazing is useful if you want to brighten a color or add reflected light, such as adding a bit of yellow to a figure that is lit by a candle.

MATERIALS LIST

Paper: cold-pressed watercolor paper
Brushes: No. 6 round, ¼-inch (6mm) flat
Paint: Aureolin Yellow, Cadmium Red, Dioxazine Violet, Turquoise

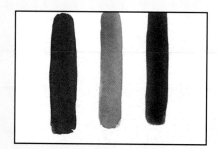

1 Paint Stripes of Color
Using a ¼-inch (6mm) flat brush, paint a stripe of Cadmium Red, Turquoise and Dioxazine Violet. Let them dry completely.

2 Layer Other Stripes of Color
Wet your No. 6 round with a wash of Aureolin Yellow. Gently paint over your previous stripes of color. Using a single color as a glaze can unify your composition. Experiment with other colors and see what you get from different glazes.
For more on glazing, go to www.impact-books.com/wingedfantasy.

Drybrushing and Splatters

With watercolor, sometimes artists (myself included!) get so caught up in making everything smooth and blended that we forget to add a little texture. If you look at the real world, not everything is as smooth as glass. Adding speckles or roughness to your paintings will give them a little bit more life. Drybrushing and splattering are two techniques that will add a little grain to your brushstrokes, and lifting will let you go lighter while keeping your original colors.

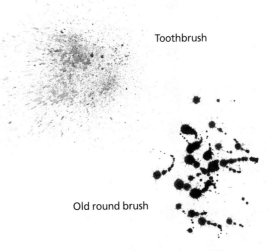

Toothbrush

Old round brush

Drybrushing

The term drybrushing may not sound like it makes much sense. After all, how would a dry brush be useful with watercolor? Drybrushing uses mostly dry pigment, with just enough moisture to stick to the brush. Do this by wetting a brush and then drying it off so it's barely wet. Then brush it into whichever color you want to use. The result is a brushstroke where the texture of the bristles is visible. This works best with stiff brushes.

Splatters

For rock and cliff textures, the bark of a tree or the pocked hide of an ancient dragon, splattering watercolor can give you an excellent irregular texture. Splattering paint is best done with an old toothbrush or an old bristly brush. For a toothbrush, load it with your color and drag your thumb along the bristles a few inches from your paper. You can direct where the splatters go by moving the brush in different directions.

When using an old bristly brush, you can either use the thumb-drag technique, or you can flick the brush quickly with your wrist close to the paper. This technique tends to result in larger spots of color with tails behind them.

Tips and Tricks

- When splattering paint, use your hand or a piece of paper to shield the other parts of your painting.
- If you plan on lifting a paint, test it on a scrap piece before using it. You want to make sure it lifts well!

Lifting

After watercolor dries on your paper, it is not frozen in place like acrylic or ink. One of the dangers of watercolor is it is not waterproof; if your painting gets wet again, it can smear. However, you can use this drawback to your advantage through lifting. Lifting is purposefully rewetting a section of your painting and then dabbing at it with a paper towel. By doing this, you lift up your previously dried paint, resulting in lighter sections.

Using Salt and Rubbing Alcohol

Salt and rubbing alcohol are two substances that affect the way water dries. By interfering with the speed at which sections dry, you will end up with unusual effects as your pigment pools and concentrates. Any salt will work, though salt that has been kept dry and sealed will work better than the salt in your salt shaker, which has been exposed to moisture in the air.

Coarse Salt

Here I sprinkled some coarse salt onto the wet paint. Because coarse salt has larger grains than table salt, it resulted in bigger blocks of absorbed paint. Coarse salt won't give you the lace-like starburst patterns that regular table salt does, but it does create its own patterns.

Regular Table Salt

I painted a wash of Cadmium Orange, and while the paint was still wet, I sprinkled on table salt. After the paint was dry, I brushed the salt away with my hand. Be careful not to brush it away too soon; it takes much longer for paint to dry when there's salt on it.

Because the grains are small, they create little starburst patterns. Single grains will create tiny stars, whereas larger piles result in larger clusters. The starlight patterns look a lot like dapples on a dappled gray horse or could be used for a snowflake texture.

Tip

Certain pigments react better with salt than others. You may notice some paints create beautiful patterns with salt, whereas others barely create a pattern. Experiment with different colors and different concentrations of pigment to see what works best.

Rubbing Alcohol

Because alcohol dries faster than water, dripping rubbing alcohol on your wet paint results in spots of faster-drying paint. It pushes the pigment out of the drop of alcohol as soon as it touches, so this method is one of the most fun to watch. This method is especially useful for creating bubbles underwater.

White Gouache and Gel Pens

The best way to make anything white is to keep the white of the paper showing. You can do this by painting around objects or creating a mask using liquid frisket. White gouache and white gel pens can also be useful tools.

Gouache is similar to watercolor but is opaque. It appears to be milky when mixed with watercolor. Remember that white gouache will always be darker than your paper, even straight out of the tube. Try not to use it as a way to return a spot to white.

White gel pens are excellent for drawing thin lines over watercolor or to create small points of white, such as stars or sparkles. Like white gouache, it can be reactivated with water after it is dry. Take care if painting over what you've done with the gel pen—it may smear or dull with water!

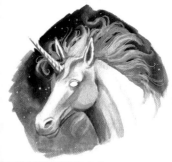

Ghostly White

White gouache over the dark blue background created a milky, wispy mane. Re-wetting the blue background and then painting white gouache caused it to bleed into the blue and look ghostly. I used a white gel pen for the stars and the thin tendrils of the mane to finish it.

Icewings

Living in a cold land, this frigid bird with feathers of snow and ice can stop you in your tracks with its icy stare. The blue and purple tones fit perfectly with its surroundings. For the highlights, a white gel pen will make its iciness pop.

MATERIALS LIST

Paper: cold-pressed watercolor paper

Pencils: 2B pencil

Brushes: Nos. 2, 4 and 6 rounds, ¼-inch (6mm) flat

Paint: Cerulean Blue, Cobalt Blue, Dioxazine Violet, Naples Yellow, Phthalo Blue, Turquoise, Ultramarine Blue

Other materials: white gel pen, white gouache

1 Sketch the Bird

With a 2B pencil, sketch the bird onto your watercolor paper. Details aren't too important because the white gouache will cover some of your pencil lines.

2 Paint the Base Color

With a ¼-inch (6mm) flat, mix equal parts white gouache and Cerulean Blue to paint the head. Then mix white gouache with Phthalo Blue for the wings and back of the bird. For the base of the tail use a No. 6 round and mix white gouache with Ultramarine Blue. Blend down to the tips of the feathers with a mix of white gouache and Dioxazine Violet.

3 Paint the Shadows

Combine Phthalo Blue with just a little white gouache and paint the shadows on the bird's wings with a No. 4 round. Use a No. 2 round for the feather details. Switch back to a No. 4 round and mix Cobalt Blue with white gouache for the shadow on the head and neck. Use Ultramarine Blue to paint in the details of the tail.

For the head feathers, face and jewels on the tail and neckband, use a No. 2 round and paint in washes of Turquoise.

4 Final Details

Use a No. 2 round and Naples Yellow to paint the eye, beak and metal of the neckband. With a white gel pen, draw in the edges of each feather and the pearls on the neckband. You can go back with a slightly wet No. 2 round to blend the edges.

Use a No. 2 round and Phthalo Blue for the ring around the eye, pupil and nostril. Then deepen the shadows.

Using Reference Photos

Most fantasy creatures are based on the anatomy of real animals. By studying the bodies of animals, your Pegasi, gryphons and dragons will look even more realistic. Reference photos are an excellent way to study the figures.

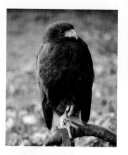

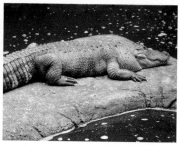

A trip to the zoo, aquarium, aviary or farm is a great way to collect reference photos. When photographing animals, don't be discouraged if you can't find the perfect angle. Often the photos you take from odd angles will be beneficial later on. When taking photos, natural light is best. A camera with a good zoom will allow you to take detailed shots without needing to get extremely close.

When taking your own reference photos, don't focus only on animals. Environments are just as important for your paintings, and it's useful to have a collection of landscapes, trees, clouds and textures to reference.

A Note on Copyright

The Internet is full of wonderful photos to reference. However, unless you took the photo, the copyright belongs to someone else. If you see a photo you like, always contact the owner first and ask permission.

You can also use stock photography or photography under a Creative Commons license. Files under a Creative Commons license specify what the photo can be used for and usually allow use as reference for artwork. Flickr and deviantART are great for stock photos.

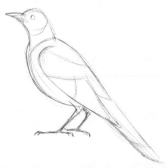

Drawing from life can be a challenge, particularly because animals move! Start with quick gesture drawings, focusing on the movement and overall figure. Don't worry about perfect shading or details; those can be added later. Focus on the shape and proportions.

Using Colored Pencils

Colored pencils are an excellent blending medium and are a bit more forgiving than watercolor. Like graphite, they are erasable, though they will often leave a little color behind. Unlike graphite, colored pencils all have the same hardness. If you want a darker color, you can either use a darker pencil or mix a lighter color with a darker color. Because most colored pencils are wax-based, it's often better to use them over your painting rather than beneath.

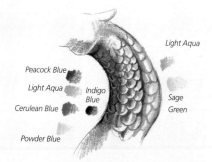

Peacock Blue

Light Aqua

Light Aqua Indigo Blue

Cerulean Blue

Sage Green

Powder Blue

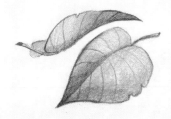

Burnishing

Burnishing involves putting all your colors down and using a lighter color on top to smooth it all out. After you do this, it is very difficult to add more color because the paper is now slick with pigment. Be sure to burnish only when you are completely finished.

Layered Blending

You can blend colored pencils by gradually building up color. The two leaves here contain three colors. By coloring in one direction with gentle pressure, I created subtle changes in color and tone.

Cloud Scout

Soaring through the sky and protecting its territory, the cloud scout always keeps a watchful eye. When using colored pencils over watercolor, they're most useful for creating textures, such as fur, where an opaque medium is needed. This winged wolf has a coat of browns, grays and creams, and adding a bit of colored pencil will make its fur look soft and textured.

MATERIALS LIST

Paper: cold-pressed watercolor paper

Pencils: HB and 6B

Colored pencils: Black, White, Deco Yellow, Yellow Ochre, Burnt Ochre, Light Umber, Dark Brown, Beige, Cool Gray 20%, Cool Gray 70%

Brushes: Nos. 2, 4 and 8 rounds

Paint: Payne's Gray, Raw Umber, Ultramarine Blue, Van Dyke Brown

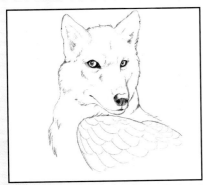

1 Sketch the Wolf
Using an HB pencil, sketch your wolf. Go back over the details with a 6B pencil, darkening the mouth, pupils and shadows of the ears.

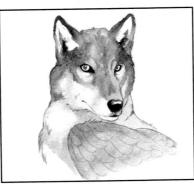

2 Paint the First Layer of Color
Take a No. 8 round and paint loose washes of Raw Umber on the nose, forehead, ears and wing. While still wet, paint a mixture of Ultramarine Blue and Van Dyke Brown on the sides of the face. Let it dry. Using Payne's Gray, paint the mouth, eyes and nose. Use a very light wash of Ultramarine Blue with Raw Umber for the white of the chest and face.

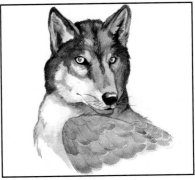

3 Deepen the Colors
Once dry, go back with a No. 4 round and deepen the colors. Let the colors blend to make the fur look natural. Deepen the gray shadows and add whiskers with a No. 2 round.

Mix Van Dyke Brown with Raw Umber and add color to the tips of the feathers. Rinse the brush and use clear water to drag the color up so it's darker at the tip than at the base.

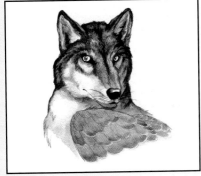

4 Paint the Fur
Use a Light Umber pencil to draw the fur on the nose, paying attention to the direction the fur would lie on a real wolf's nose. Switch to Cool Gray 70% for the gray fur and White to draw the lighter fur. Use Dark Brown for the top of the head and Cool Gray 20% for the white fur detail.

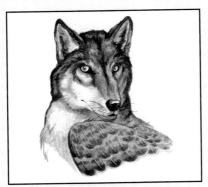

5 Paint the Feathers
Draw a line for the shaft of each feather down the center with White. Then gently blend from the bottom up with Light Umber. Then go back over the bottom with Dark Brown. Add highlights with White.

6 Add Final Shadows
With a Beige pencil, burnish over the feathers to smooth out the bars. Use Deco Yellow to color in the eyes, then add depth with Yellow Ochre and Burnt Ochre. Continue to add dimension to the fur with Black, Dark Brown and Cool Gray 70%.

Visit www.impact-books.com/wingedfantasy for free bonus content.

23

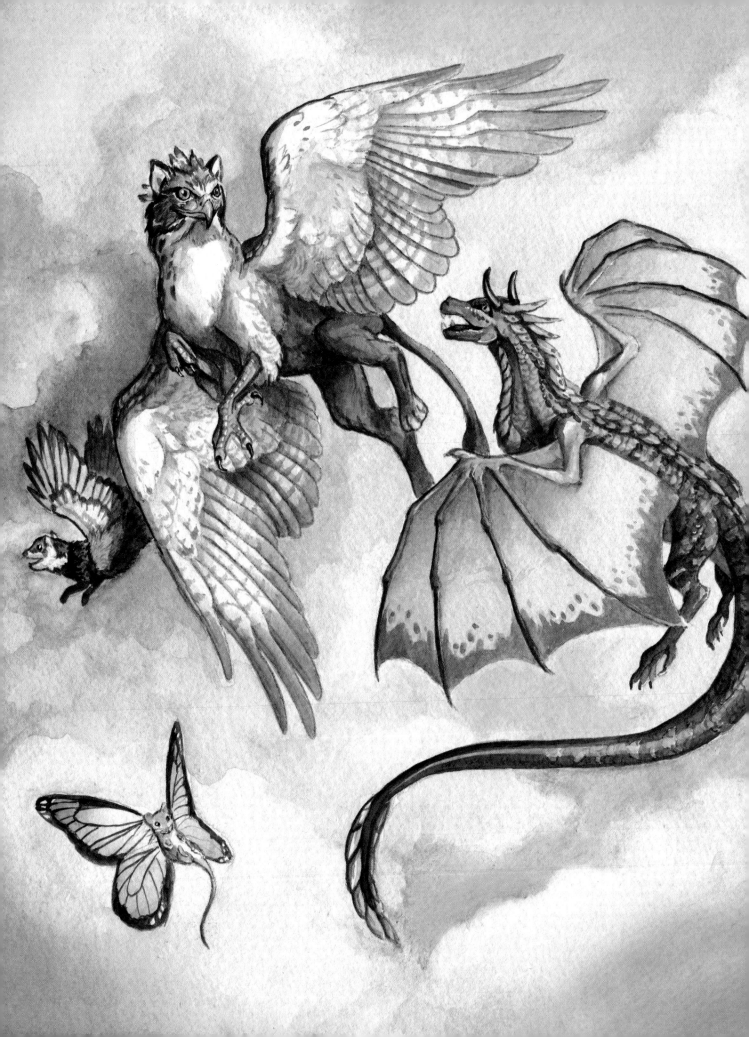

2

Drawing Wings

Wings, imagination and a bit of magic are what
give flight to the fantastical creatures of stories and
myths. Many artists are intimidated by the complex
appearance of wings, so they either overly simplify
them or avoid drawing them altogether. After you
understand their basic structure, however, wings
become a little less overwhelming and much more
intriguing. Wings don't have to be difficult. Like any
piece of anatomy, they have a solid structure, and there
are rules about how they move. After you learn the
basics of wing anatomy, drawing them will be a joy
instead of a burden!

In this chapter, I will cover two main types of
wings—bat wings and bird wings—and explain their
structure and movement. You will also learn a bit about
insect wings and how to attach wings to the bodies of
your beasts to create a believable fantasy creature ready
to take flight.

Types of Wings

Although no one has yet been able to produce life studies of a real dragon or gryphon, the anatomy of fantasy creatures is based on real animals. Dragons typically have bat-type wings, and the gryphon, being traditionally half-eagle, has a bird's wings. The wings of real birds, bats and insects are always the best inspiration to springboard from, and after you understand the basic parts of a wing, you can let your imagination run wild and come up with all sorts of dreamlike flying creatures.

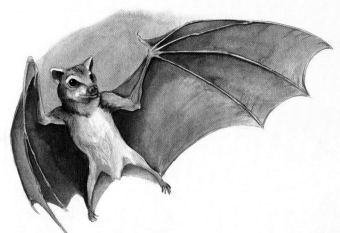

Bird Wings

When it comes to flight, birds are the masters of the air. Different species have developed their own specialized wings, depending on their habitat and behavior. Vultures have large, broad wings for effortless soaring, whereas swifts have long, tapered wings for speed and hairpin turns. All in all, the bone and muscle structure of bird wings are the same, but differences in the size, length and structure of each species' feathers can change the function of the wing.

When closed, the wing folds in perfectly against the side of the bird. Each feather folds beneath the other to keep the bird warm and protect the wings. All flighted birds are lightweight for their size and have hollow bones. Heavy fantasy creatures such as gryphons and Pegasi don't seem to follow this rule though!

Bat Wings

Bats are the only mammals capable of true flight. Their wings consist of elongated fingers with webs of skin connecting them. With their light weight, slender wing size and use of echolocation, bats can move extremely fast in the air to catch insects. Like humans, bats have four fingers and a thumb, and three joints in each finger. Unlike most mammal bones, the bones in each finger are fairly flexible, so they can fold their wings in ways that will not cause damage. Your dragons will appreciate this feature, because rigid, inflexible finger joints may cause problems when in battle or making a hard landing.

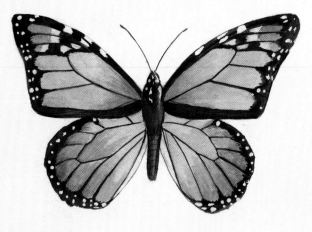

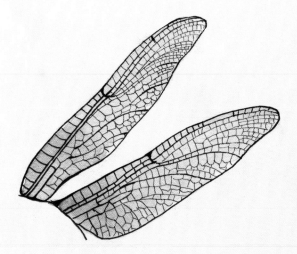

Insect Wings

The last group of winged creatures is insects. Insect wings come in a wide variety of shapes, sizes and functions. Most insect wings are gossamer, such as bees and dragonflies, with a few having opaque wings, such as butterflies and moths. Unlike bat and bird wings, insect wings don't contain joints or muscles throughout the wing itself; they move from the base of the insect's body. What they lack in movement, insect wings make up in marvelous colors. Many insects have iridescent or brilliantly colored wings, and these types of wings can give colorful flight to a tiny dragon or a mouse.

Bat Wings

The long, fingered wings of bats have been the favorite for dragon artists for centuries. Perhaps it is the smooth, hairless and featherless surface that complements the dragon's reptilian scales and hide so nicely. Throughout history, dragons and wyverns appear in art, sculpture and heraldry with bat-like wings, usually modified in ways to fit the dragon better, but the overall structure remains the same—webs of skin stretched between long fingers.

In nature, bats are the only mammals that can fly, and they do so with expert precision and dizzying speed. Unlike birds, whose wing joints, comparatively, have limited mobility, bats can move every joint in their tiny wings, and this ability allows them to make minute adjustments in mid-flight to catch insect prey in mid-air.

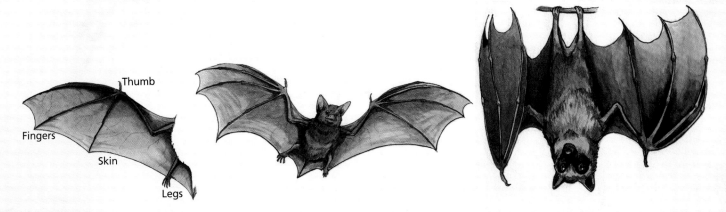

Parts of the Bat Wing

Bat wings, though elongated, contain all the same finger joints and bones (phalanges) as a human hand. The skin that stretches between each finger is very thin and sensitive, and can tear easily. Fortunately this membrane heals quickly, because it is rich with small veins. The membrane stretches between the thumb and all four fingers, and attaches to the bat's body, leg and tail.

Insectivorous Bats

Different kinds of bats have slightly different wings. Insectivorous bats are smaller and thus have slimmer, nimbler wings for high-speed chases and to make sudden turns in the air. The membranes are very thin, so they often appear translucent and veiny.

Fruit Bats

Fruit bats don't need to chase their prey, so they have broader, thicker wings. These bats' wings tend to have the leathery look that works well for dragons.

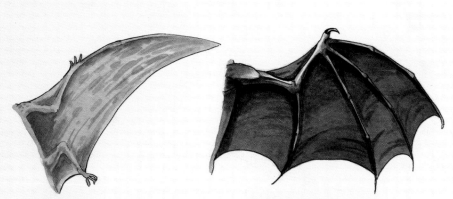

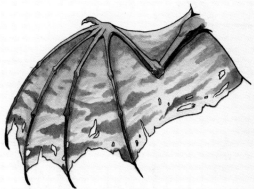

Pterodactyl

Not related to bats, the extinct pterodactyl was another flying creature with stretched-skin wings. Like bats, their wing membranes stretched to the body and leg, but unlike bats, theirs stretched between a single finger instead of between all four digits.

Alternate Designs

Though based on bat wings, dragon wings can differ with moved fingers, added or subtracted fingers or differences in the membranes. This is one example of a finger joint moved from the wrist to the elbow.

Torn Wings

Though bats' wings heal quickly, a dragon's torn wings could be a sign of age or one who's seen many battles. Think about where the tears would be; most of them would likely be around the tips of the wings, where the membrane is the most exposed and vulnerable.

Visit www.impact-books.com/wingedfantasy for free bonus content.

27

How Bat Wings Move

Bat wings are some of the most forgiving when it comes to a pose because they are so flexible. Unlike a bird wing, you don't have to worry too much about breaking a bone or feather if you want to twist or fold your bat wings. However, bats still have a certain structure to their wings, and there are limits to how far the joints bend. There are certain ways to draw their movement to make them look believable.

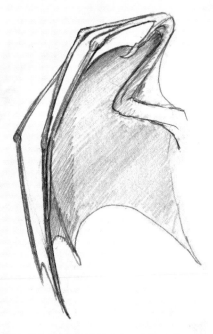

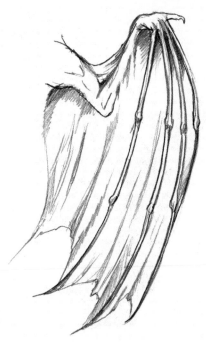

Flexibility

Bat fingers are extremely flexible, so don't feel like you have to draw them straight or at gentle angles all the time. Adding exaggerated bends can give a dramatic look to your wings. Don't forget to think about where the skin webs would move and connect.

Membranes

When stretched out, the membranes tend to be taut and unwrinkled, but when a bat (or dragon) folds its wings, folds appear in the skin. You can exaggerate these folds to really give the wings depth.

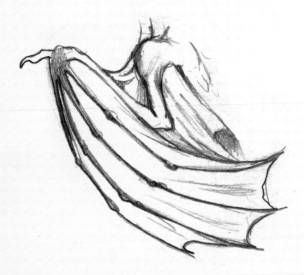

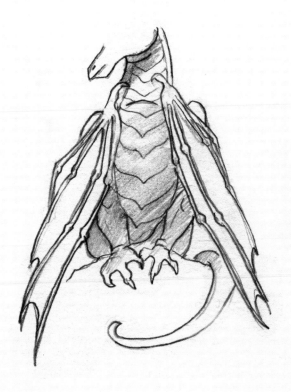

Folded and Curved Wings

Like birds, bats and dragons can fold up their wings at their sides. Bats often wrap themselves with their wings to conserve body heat, showing just how flexible these fingered wings are.

Bat Wing Dos and Don'ts

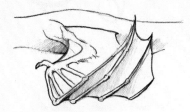

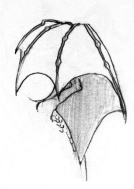

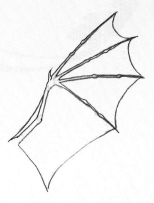

DON'T fold the finger joints upward during flight. Though flexible, the bones don't twist back while flying. To keep the bat or dragon stable in flight, the wings need to push down on the air, and folded-back fingers destroy the structure of the sails (the membranes) that keep them aloft.

DO curve the fingers down or lift the wing from the shoulder joint while your bat or dragon is flapping.

DON'T make the fingers stiff and perfectly straight.

Foreshortening

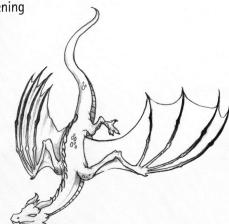

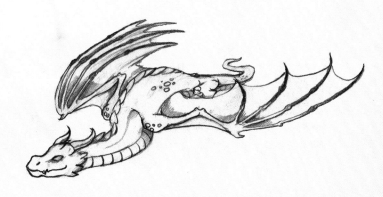

Foreshortening is the illusion of creating dramatic perspective in the angle of an object. Here, this dragon is flying toward us, but we're also looking down on him. The effect isn't very powerful.

When we shift the perspective a bit, suddenly it appears he's flying at our level. The angle of the wing is more narrow, the fingers more splayed and we can see his tail trailing off behind him.

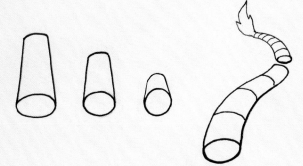

You can see examples of foreshortening with these cylindrical shapes. As you look above the object, the round surface looks more oval. When you look straight forward at the object, the long end appears shorter and the round surface appears more round. Use shapes like this to figure out foreshortening with your dragon's neck, tail and legs.

Bird Wings

The wings of birds have graced the art of fantasy, mythology and legend throughout history. Even humans don bird wings in the form of gods, goddesses and angels, so it's little surprise that we would want to give the power of flight to both real and created animals. The Pegasus is one example of an ordinary animal made otherworldly with a pair of bird wings, and wings come naturally to the eagle half of gryphons and hippogryphs. Even some dragons feature feathered wings instead of those inspired by bats.

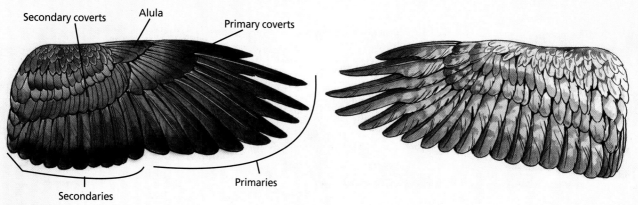

Top View

The top view of a bird's wing is easily identifiable by the order of the primaries and secondaries (flight feathers). When viewed from above, the topmost flight feather is closest to the bird's body, and the rest are stacked beneath. The same order goes for the primary and secondary coverts. The alula is a thumb flap that gives the bird control during flight and is visible from the top.

Bottom View

The bottom view is very similar to the top view, except reversed. As you can see, the topmost flight feather when the wing is viewed from below is farthest from the bird's body, and the rest stack beneath. Unlike the top of the wing, the feathers underneath tend to be more fluffy the closer to the wrist you go.

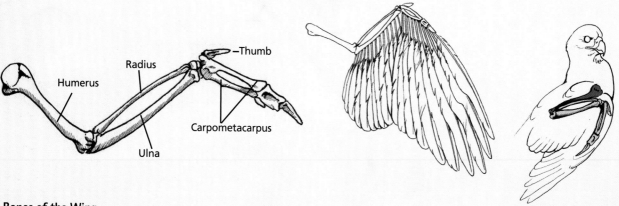

Bones of the Wing

A good way to remember the skeletal structure of the wing is to think of your own arm and hand. Just like humans, a bird has a humerus (upper arm), radius and ulna (forearm), and carpometacarpus (wrist/hand). Though we have some structural similarities, many of their bones are, of course, quite different than our own.

The strength of flight does not come from the muscles in the wings. Think about a chicken; where are its biggest muscles, in the wings or the breast? The chest muscles are attached to the sternum—in birds it is a large, ridge-like breastbone—and this gives the bird the strength to fly. Remember this when drawing a Pegasus. It doesn't need to have big, bulky wings to get lift, but adding a bit of bulk to its chest will give it the extra strength it needs.

The primaries attach directly to the hand bones, the secondaries attach to the ulna and the primary and secondary coverts provide strength and stability to these feathers. When drawing your wing, knowing where these feathers attach to the bones can be useful. When the joints bend, the feathers fold with them.

When a bird folds its wings, the humerus is closest to the body, with the radius and ulna on top. The hand bones fold down.

Parts of the Bird's Wing

The entire visible bird wing is covered in feathers, unlike the bat, where the bones and joints are visible. Understanding the feather structure on the wings is essential to creating believable wings.

This diagram shows an expanded view of the feathers of the wing, with the number of feathers in each group reduced for simplification.

COVERTS: These are the small, soft feathers layered on top of the rest of the feathers. Their order tends to be more irregular the higher up on the wing they are.

ALULA: The alula is the thumb flap that birds use while braking or making adjustments in flight.

PRIMARY COVERTS AND SECONDARY COVERTS: These stiff feathers provide stability for the primary and secondary feathers

PRIMARIES: The main flight feathers, these feathers are the longest on the bird's wing. The first few outer primaries on birds of prey have wide notches to provide lift on the downbeat of the bird's wing. On the upbeat, these feathers twist sideways to let air pass through.

SECONDARIES: These feathers are the main feathers visible when a bird has its wing closed. The primaries fold underneath the secondaries.

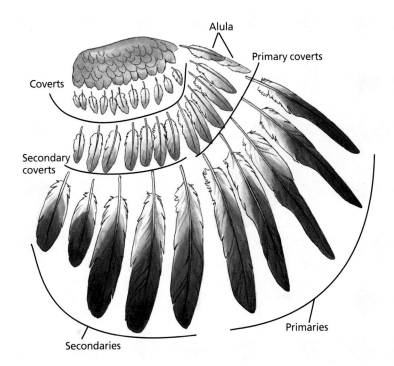

Feathers

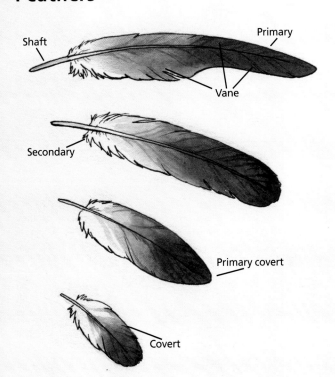

Feathers come in all shapes and sizes, stiff and soft, and in every color imaginable. Overall, feathers tend to get lighter the closer to the base they go. Even on a black raven, the base of the feather shaft is pale.

The feather consists of two main parts: the shaft and the vane. The shaft is the stiff center of the feather, and the vane is the soft section that grows from it. The vane actually has barbs that separate easily to prevent damage. When a bird preens, it zips these barbs back together. The direction the vane grows is always up and away from the base of the feather.

When drawing your feather, adding some separations in the vane can make your bird look a bit more ruffled and weathered. If you add too many, it can look scraggly, so keep this in mind if you want your gryphon or Pegasus to look well kempt.

How Bird Wings Move

Unlike bats, which have flexible finger joints, bird wings are a bit more limited in movement. Some joints are fused, such as the finger joints, so the only movement their wings have are at the shoulder, elbow and wrist joints. These limitations, however, make the rules of bird wing movement easy to learn. In addition, their slightly flexible primary and secondary feathers allow plenty of expressive movement.

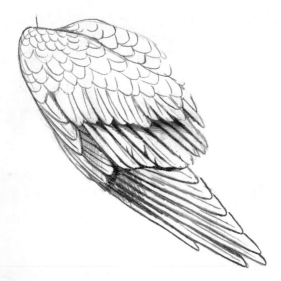

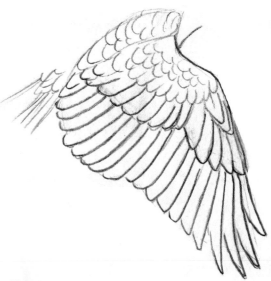

Folded Wing

When folded, the primaries and primary coverts slip under the secondaries and secondary coverts. When the wing is not entirely closed, you can see the primary coverts and alula peeking out. For most birds, the primaries are clearly visible extending past the secondaries. The shoulder feathers on the top are called the scapular feathers and cover a small part of the wing.

Flapping

The tips of the primaries are flexible and often curve when the bird pushes the wing down on the downstroke.

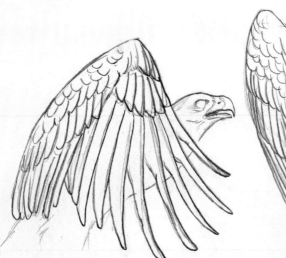

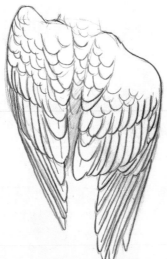

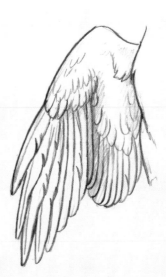

On the upstroke, the primaries twist to allow air to pass through to decrease drag. On the downstroke, they fall back in place to create lift.

When a bird droops its wing, the shoulder shifts down as well. When drawing a pose like this, remember to shift everything accordingly. The primaries and all the feathers would be lower than the other wing as well as the scapulars.

When viewed from the front, the primaries fold in front of the secondaries. One mistake many artists make is to shift the primaries behind the secondaries when looking at a bird from the front. This would be quite uncomfortable!

Wing Angle Dos and Don'ts

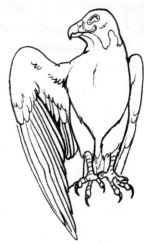

DON'T fold the primaries behind the secondaries when viewing the wing from the front. Ouch!

DO fold the primaries nicely in front of the secondaries. Your bird will be much happier!

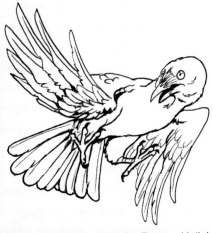

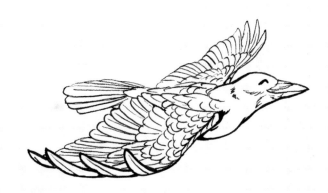

DON'T bend the wing up at the wrist joint. The poor bird's joints don't bend that way unless they're broken.

DO tip the primaries up a little if your bird is soaring. The primary feathers can flex this way without breaking.

Foreshortening

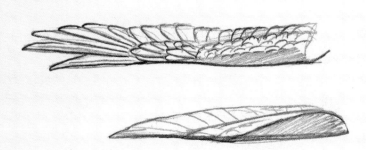

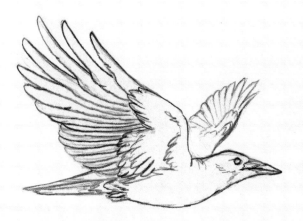

One mistake many artists make with bird wings is imagining them as flat as a piece of paper throughout the wing. In truth, the wing is thicker closer to the shoulder and then tapers off with the primaries and secondaries. When drawing the wing foreshortened from the front, keep this thickness in mind. The bottom diagram is a simplified version of the top drawing with shapes.

When drawing a flying bird, remember the object closest to the viewer will be larger than the farthest wing. The foreshortening becomes more exaggerated the wider the bird's wings are spread out.

Types of Bird Wings

Depending on the species, bird wings can look completely different. An eagle's wing looks very different from a hummingbird's wing, not just in size, but also in structure. Knowing different birds' wings will help you when designing your own gryphons, hippogryphs, Pegasi and various winged creatures. Eagle wings are fun, but perhaps your winged otter would look better with a pair of heron wings, or maybe that little mouse would look cuter with a pair of hummingbird wings.

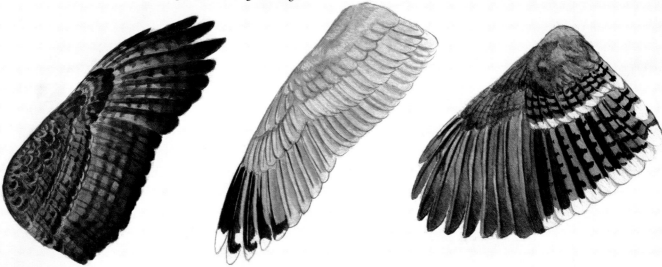

Hawk Wings
Bird of prey (also known as raptors) wings are the most commonly used for gryphons and hippogryphs, and many Pegasi too. Hawk and eagle wings are broad and have long-tipped primary feathers. Many species have barring on the feathers, as seen in this example. Different raptors have different shaped wings. A falcon, for instance, has long, tapered wings compared to the broad, short wings of a goshawk.

Gull Wings
Gulls have long, tapered wings that are perfect for effortless gliding. Many artists love adding gull wings to their creatures because of their length and simplicity. The primaries are quite long, and the secondaries are mostly covered with the secondary coverts. When a gull bends its wings, they appear pointed. Gull wings may be a good choice for a creature that lives near the ocean or any body of water.

Songbird Wings
Most songbird wings have very long primaries and secondaries compared to the rest of the feathers. Blue jays, as seen in this example, have very rounded wings. The coverts on songbirds are usually very wispy and look almost furlike over the primary and secondary coverts. The small, delicate wings of songbirds are excellent for small gryphons and even tiny dragons and mammals.

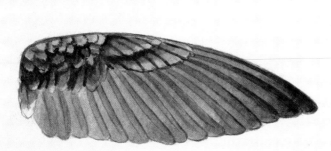

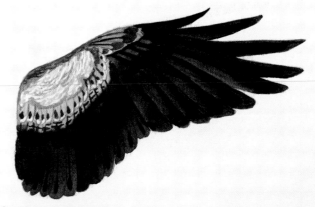

Hummingbird Wings
Most of the visible wing on the hummingbird is primaries and secondaries. The rest of the feather groups are still there, however, just very small. Generally, the brilliant color you see on hummingbirds is present on their coverts, with the primaries and secondaries being a dull brownish gray. The small, delicate wings of a hummingbird are an excellent addition to a tiny creature, such as a winged frog or a mouse.

Creating Fantasy Wings
The wings you paint on your creatures don't have to conform exactly to one specific bird. You can create fantastical wings by elongating primaries, extending secondaries, adding or subtracting feather groups and, of course, painting them any wild and unbelievable colors you want! Use what you've learned about the anatomy and structure of bird wings to exaggerate and add upon for your own unusual creations. **For more about types of fantasy feathers, go to www. impact-books.com/wingedfantasy.**

Bird Wing Mistakes

Sometimes when you draw a wing, you sit back and say, "Well, that just doesn't look right. What's wrong?" Here are some common mistakes artists make when drawing wings.

Missing Bones

It's easy to forget that the bird wing contains three main bone groups: the humerus, the radius and ulna, and the carpometacarpus. Most often, artists forget to add the humerus and connect the wing to the body directly at the radius and ulna! This mistake is most obvious when the wings are stretched.

Reversed Feather Order

This is the mistake I see most often, and it's very easy to do! If the feathers were in the order above on a real bird, it wouldn't be able to fly because on the downstroke all the primary and secondary feathers would twist and let the air pass through. Remember, when viewing the wing from above the bird, the top feather is the secondary closest to the bird. When viewed from below the bird, the top feather is the primary farthest from the bird.

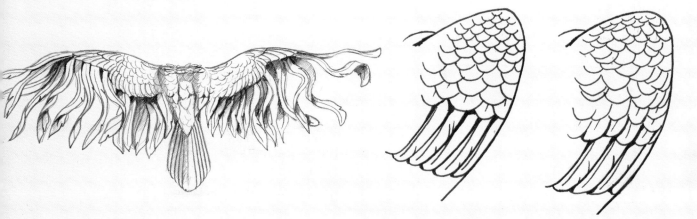

Ribbon Wings

While it creates a fun effect, twisting, twirling primary and secondary feathers don't work well on wings. For tails they're a wonderful, decorative addition, but flight feathers need to be stiff and structural.

Fish Scale Feathers

Unlike a fish, whose scales grow in a structured, geometric pattern, a bird's covert feathers lie in a more irregular order. Drawing them perfectly stacked like scales as shown on the wing on the left, looks odd on a bird. Try drawing them more irregularly, like the wing on the right, and it will make your coverts look more natural.

Drawing a Bat Wing

Using a few simple shapes to start, drawing a bat-style wing is simple to learn and remember. When you keep in mind the bat's wing anatomy—four, jointed fingers from the wrist—it's easy to draw a bat wing in many poses.

MATERIALS LIST

Pencils: 4B, HB and 4H pencils
Other materials: mechanical eraser

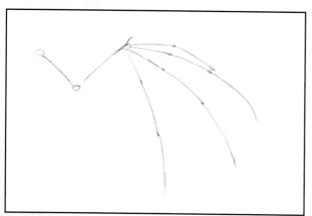

1 Sketch the Overall Shape

Using simple stick shapes for the bones and circles for the joints, use an HB pencil to draw the basic shape. Remember, a bat's wing is similar to a human arm, with a shoulder, elbow and wrist.

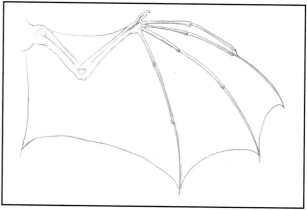

2 Draw the Wings and Fingers

Draw the arm of the wing around your original lines. If this is a dragon's wing, think about the structure of the shoulder and also give it a bit of an elbow. Look at your own arm for shape ideas. The forearm is thicker closer to the elbow and tapers near the wrist. Draw the webs of skin, which start near the tip of each finger and bow inward, finally attaching at the body. The web between the thumb and shoulder bows downward.

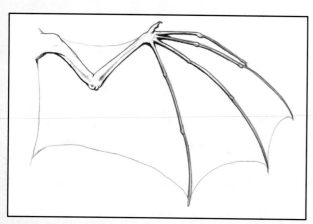

3 Details

Erase your guidelines with a mechanical eraser, and begin drawing in the details with a 4B pencil. Add some dark shadows between the fingers and under the arm and thumb. Draw a line on the forearm, suggesting where the skin is tight against the radius and ulna. In bats these two bones are very thin, but in a dragon they may be thicker. A line on the upper arm can suggest a muscle.

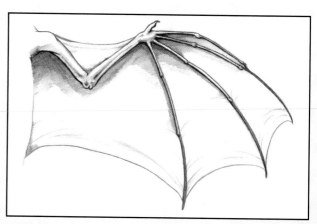

4 Shading

Use an HB and 4H pencil to shade underneath the wing, and add a few creases in the wing along the bottom and near the finger joints.

Drawing a Bird Wing

While a bit more detailed than a bat wing due to the feathers, the overall structure of a bird's wing is not complex at all. When outstretched, they're much like sails with feathers. Understanding feather placement is the biggest challenge when artists learn to draw wings, so this tutorial will focus on how to make your feathers look right.

MATERIALS LIST

Pencils: 4B, HB and 4H pencils

Other materials: mechanical eraser

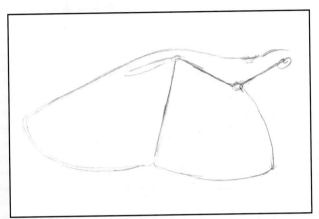

1 Sketch the Overall Shape
Sketching with an HB pencil, start with a loose bone structure. Remember, the primary feathers attach to the hand bones, and the secondary feathers attach to the ulna, so draw a rough outline for these two feather groups attaching to these bones.

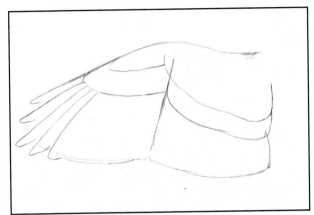

2 Start Drawing Feather Layers
Use a mechanical eraser to erase your guidelines, then start drawing guides for your upper feather layers. The primary coverts should cover the top layer of the primaries, and the secondary coverts should cover the top layer of the secondaries. Erase any extra lines and then begin drawing your feathers, starting with the primaries.

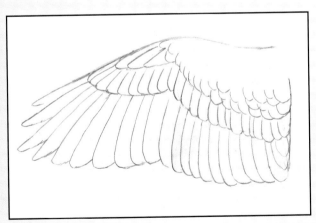

3 Finish Drawing the Feathers
Typically birds of prey have ten primary feathers, but your fantasy creature may have more or less. After you draw your feathers, erase your guidelines. Because we're viewing the wing from above, the top feather is the secondary closest to the bird. The primary and secondary coverts follow this order, too. Start drawing your coverts, remembering to make the feathers a little irregular.

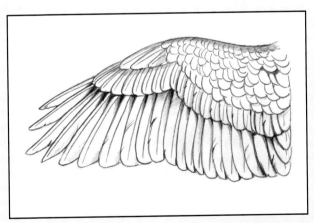

4 Coverts and Shading
Finish drawing the coverts, and then with a 4B pencil, start adding detail. Add some ruffles to the primaries and secondaries and draw in feather shafts for all the feathers except the coverts. The shaft will be closer to the outer side of the feather for the primaries and closer to the center for the secondaries. Use HB and 4H pencils to shade the wings where the feathers overlap.

Other Wings

Bats and birds aren't the only animals with wings. Insect wings can be a vast source of inspiration as well. Butterflies, bees, beetles and dragonflies are just a few of the types of insect wings that can give flight to your creatures. You don't have to limit these versatile wings to small creatures, either. If you want to give a big dragon a giant pair of butterfly wings, try it! You can even create wings out of plants.

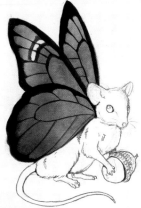

Butterfly Wings

Mice and other tiny creatures sport butterfly wings very well. Butterfly wings have two parts: the forewing and hind wing. The forewing sits on top of the hind wing, so if you're viewing the wings from above, the forewing will be on top. We're looking at the wing from below on this winged mouse, so we see the hind wing on top. Butterflies come in incredible colors. Take a look at some real butterflies to get inspiration. Many butterflies look otherworldly already!

Dragonflies and Damselflies

These two insects have gossamer wings and come in a variety of colors, from translucent to nearly opaque. This style of wing offers a streamlined, slender look that you can see through. A literal dragonfly may have these wings!

When painting translucent wings, don't go too dark, especially if you can see something through the wing. Leave streaks of white paper to suggest highlights on the wing.

Beetles

Beetles have two pairs of wings. The first pair is a hard, protective set of wings, and the second are the functional wings it uses for flight. Many beetles have a brilliantly colored pair of top wings with stunning iridescence.

Creating Wings From Fins

Fins are designed to propel a fish through water, but their design could easily turn into a tool for flight. Flying fish have very long fins that allow them to glide when they leap out of the water. Adapting these fins to a wing design could be a good complement to a sea dragon.

Creating Wings From Plants

Plants are great for nontraditional wings. Try using leaves or leaf shapes. This little forest creature blends right in with its surroundings with wings that provide both flight and camouflage.

Tips

- Rules aren't set in stone. Experiment and draw from your imagination!

- If adding multiple wings, think about where they would fit next to each other. Much like fingers, you can structure bones next to each other, even if they're larger bones like the humerus.

- Since insect wings don't involve bones or big muscle groups, they can be placed on your creature without much integration.

Attaching Wings

Adding wings to your creatures involves more than just slapping them on their backs. It's similar to how our arms connect via the shoulder and are not simply stuck onto our bodies. For gryphons and hippogryphs, the wings attach naturally to the bird half, but this can be more of a challenge for animals such as horses, who aren't anatomically built for wings. Dragons can be tricky too, particularly with four legs, plus a pair of wings.

Attaching the wings requires figuring out how they would realistically attach to the creature's existing anatomy. Because a horse with feathery wings would never get off the ground in the real world, you don't have to figure out how it would realistically gain flight, but rather focus on how a pair of wings would fit onto the body if flight were possible. In the examples below, I've included some of the wing bones and made the wing transparent in places to better illustrate how it attaches.

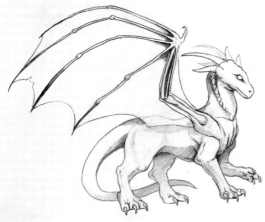

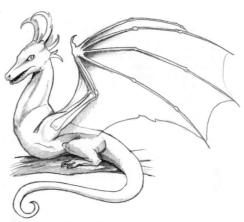

Dragons

Dragons typically have four legs plus wings. The best place to attach the wings is anywhere along the shoulder blades or upper back. Attaching wings on the middle of the back tends to look awkward. Extend the shoulder muscles of the wings over the shoulder of the forelimb (if the wings are on the shoulder blades) or behind the shoulder (if the wings are on the upper back).

Wyverns

Wyverns usually have two wings, so their wings are their forelimbs, just like bats. Draw the shoulder muscles where the humerus attaches to the body.

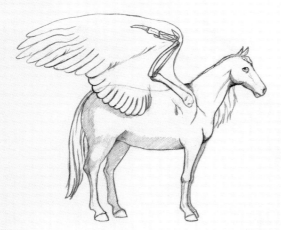

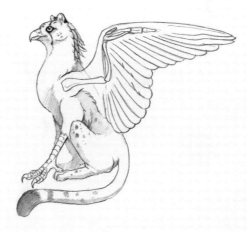

Pegasi

With a horse, the shoulder is the most logical place to put a pair of wings. As with dragons, putting them on the back looks awkward, and a pair of wings on a horse's ribcage makes less sense than if they are attached at the shoulder.

Gryphons and Hippogryphs

Adding wings to gryphons and hippogryphs is perhaps the easiest of all, because the wing anatomy already exists. The biggest difference is that with a bird, the forelimbs are the wings, and the hind limbs are the legs. With gryphons and hippogryphs, their wings become the first set of forelimbs, their hind limbs (bird legs) become the second set of forelimbs, and then they have a completely new set of hind limbs (feline legs). Because the bird leg forelimbs get pushed forward, the humerus is closer to the leg bones than in a regular bird.

3

Dragons of the World:
From Sea to Mountain to Forest

Dragons and wyverns come in all shapes, sizes and temperaments. They appear in paintings, sculpture, heraldry and architecture from western Europe to far east Asia, though the role they play differs, depending on their location and place in history. In Europe, the traditional reptilian dragon with sharp teeth and bat wings was seen as an evil beast who played the villain to be defeated by the knight or saint. The wyvern appeared commonly in heraldry. In Asia, however, dragons were seen to be more benevolent, with powers to control water in nature, and are one of the twelve creatures appearing in the Chinese zodiac. Eastern dragons have twisting, snake-like bodies and whiskered and maned heads. Although they lack wings, these dragons often were able to fly.

Drawing from the rich history of dragons, it's easy to find inspiration for your own creations. Today dragons appear in movies and books, on clothing and as figurines. They are no longer strictly seen as evil kidnappers of maidens or stealers of gold, but often are good at heart and help instead of harm. Whether your dragon is friend or foe, there are endless ways to design these fierce, cunning and elegant creatures.

Dragon Anatomy

For the most part, dragons have a mostly reptilian design. Their bodies are covered in scales, and they have long, whiplike tails similar to those of lizards or snakes. Dragon heads range in shape from heavy and large with a thick, dinosaur-like jaw, to narrow with many teeth like an alligator. Reptiles don't have to be the only source of reference for designing a dragon, though. Bird feet, particularly those of eagles, make excellent dragon feet, because of their long, sharp talons and scales. A fish's scales and fins are a good addition for an aquatic dragon.

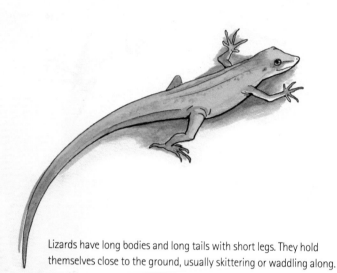

Lizards have long bodies and long tails with short legs. They hold themselves close to the ground, usually skittering or waddling along.

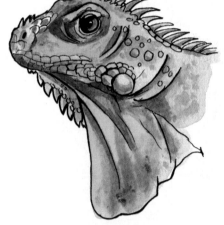

Many larger lizards, such as the iguana, have spikes and hanging frills, perfect for drawing inspiration from for a dragon.

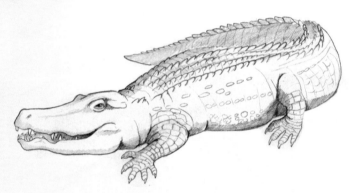

Alligators and crocodiles are large, heavily built reptiles with thick scales, stubby legs with short claws and long, massively powerful jaws. Take special note of their armorlike scales on the back and platelike scales on the belly.

Tips

- These reptiles are just a tiny sample of the thousands of species you can find inspiration from. Look through a book on reptiles to find unique body shapes, scale patterns and colorations for your own dragon inspiration.

- Don't feel like you have to stick with the exact anatomy you see. Because you're only using these animals for reference, try to make the dragon your own—elongate the tail or lengthen the legs. An iguana-inspired dragon doesn't have to look just like an iguana with wings!

- Don't forget about extinct reptiles, too! Dinosaurs are a rich source of dragon inspiration, particularly the carnivorous species.

The long, slender body of a snake makes wonderful inspiration for a dragon's tail or perhaps a wyvern's body. Snake heads also lend well for a fanged dragon.

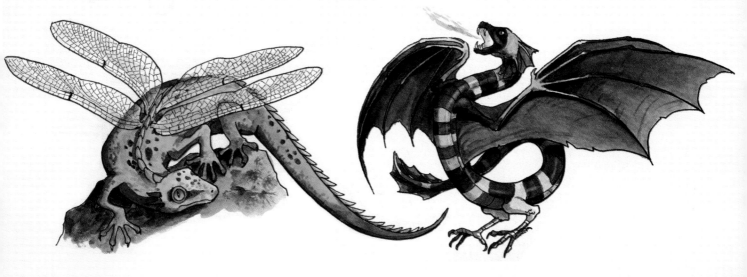

This gecko-inspired dragon is small enough for a pair of dragonfly wings to give it lift. It has a longer tail, as well as some back and facial spikes, and some tiny claws to help it catch insect prey.

This fierce wyvern's body shape and coloration are based on a coral snake. You can incorporate an animal's natural markings into the rest of the wyvern too, such as in the wings.

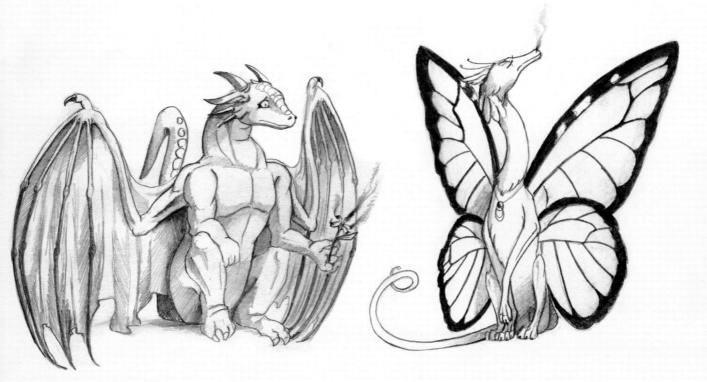

You can even give your dragons humanlike attributes. This poor, spurned dragon has a torso and forelimbs similar in structure to a human. Adding thick muscles also gives this dragon an appearance of being strong and powerful.

Elongating limbs and adding lithe curves make this dragon look elegant and nimble—perhaps for fluttering away quickly after breaking hearts.

Visit www.impact-books.com/wingedfantasy for free bonus content.

43

Dragon Heads

Dragons' heads come in all shapes and sizes. Their jaws can be thick and short, long and slender, or any variation in between. They can have scales, ridges, horns, spikes, frills, manes or anything else you wish to add.

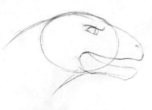 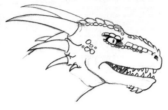 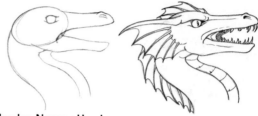

Bulky, Powerful Head

With a short, powerful jaw, this dragon can bite and crush with its plentiful teeth. Start with a wide oval for the head and draw the basic shape of the jaw. The bottom jaw will be smaller than the top. Then draw in some long, heavy horns and add stubby scales to the head. You don't have to draw every single scale; drawing in a few scales gives the impression of texture.

Slender, Narrow Head

Start with a narrower oval for the head, and draw a longer, slimmer pair of jaws. The neck is long and curvy, much like a snake's. Then draw in long, curved fangs with some shorter teeth in the back. Draw a slender horn with spines along the cheek and attach a frill, and do the same for the head and neck.

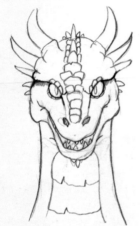 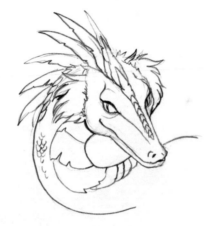

Think about what is visible from different angles. You will likely see the entire mouth on a broad-jawed dragon when viewed from the front, and when you draw a dragon at a ¾-angle, you will see part of the far eye.

Drawing Dragon Eyes

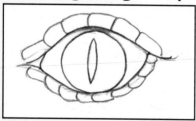 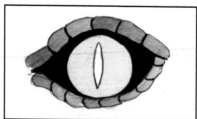 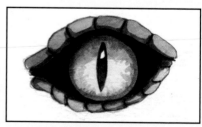

1 Draw the Eye
Start by drawing a circle. Draw the upper and lower part of the surrounding eyelid, then draw a narrow pupil. The narrower the pupil, the more fierce your dragon will look. Add a few scales around the eyelid.

2 Paint Your Base Colors
Paint the eye with a No. 6 round and Aureolin Yellow, making sure to avoid the pupil. For the surrounding scales, use a wash of Viridian. When it's dry, return with a No. 2 round and a dark mixture of Sepia and Payne's Gray to paint the black area around the eye and define the spaces between the scales.

3 Paint the Details
Layer the eye first with Cadmium Yellow and then Burnt Sienna to add depth. Be careful around the dark edges. If your wet brush touches the paint it may reactivate and bleed into the yellow. While the paint is still wet, use the tip of the brush to create lines toward the center of the eye.

Let it dry. Then mix Sepia and Payne's Gray to paint the pupil, leaving a white space for the highlight. Mix a little Dioxazine Violet into Viridian to paint the scale shadows.

Feet and Legs

Depending on what you want your dragon to do, be it clutching its treasure, grasping prey or leaping into battle, the type of feet it has can help or hinder. Many of these feet and legs are based on real animals, with a few fantasy alterations.

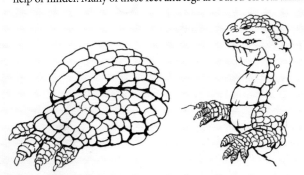

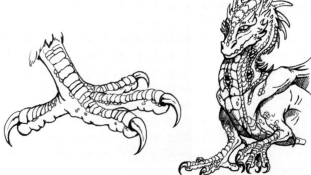

Crocodile legs are heavy and short and have stubby toes and claws. They're covered in thick, massive scales that resemble stone—excellent camouflage for a dragon who lives in the mountains or in a gravelly riverbed. These types of legs are good for dragons who do more swimming or flying than running.

Eagle feet and other bird feet are good for grasping or seizing, and their sharp talons can serve as vicious weapons as well. Because eagle feet are scaled, an artist needs to make only a few adjustments to fuse an eagle foot with a dragon body.

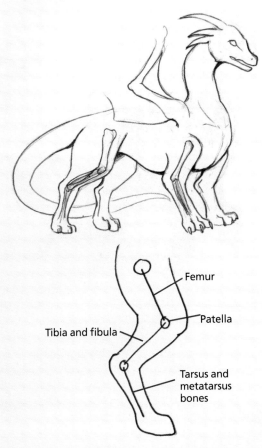

Femur

Patella

Tibia and fibula

Tarsus and metatarsus bones

Most animals, including humans, have the same hind leg bones, and they move the same way. The femur is the large bone located in the thigh, and it faces forward. The tibia and fibula are the calf bones in the lower leg, and they face backward. Finally, the tarsal and metatarsal bones move forward again. This dragon shows what the bones might look like if we had a specimen to study! The sketch below it shows a simplified way of constructing a hind leg for drawing.

Feet and Legs: Do and Don't

- Don't switch the foreleg and hind leg bones around. If you have trouble remembering which way the joints bend, think of your own arm or leg. The elbow on a human is the same as on an animal; it's the joint between the humerus and the radius and ulna.

- Do exaggerate shape and length, and experiment with different types of legs and feet on your dragons.

- Don't feel like you have to stick with reptile or bird feet. Mammal feet work perfectly well, too! Or maybe a dragon would look interesting with a pair of mantis legs.

- Do explore the natural world for inspiration for your dragons' legs and feet. As they say, sometimes reality is stranger than fantasy!

Creating Tails and Scales

Depending on where your dragon dwells, its tail and hide can differ from habitat to habitat. A tail is more than a decorative trail; it serves as a rudder in flight and as a weapon to defend itself. The same goes for scales. In arid climates, a dragon may have rough, rock-like scales. In a wet habitat, they may be softer and smoother to allow the dragon to slide through the water with ease. When drawing scales, it's not necessary to draw every single one. A few scales here and there are enough to suggest texture.

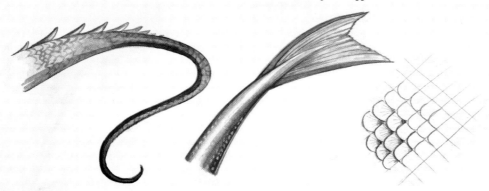

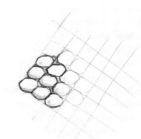

These tails are just a couple of the many ideas for your dragon. A long, whip-like tail is good for snapping at intruders who get a bit too close to a dragon's roost.

A tail with a fin at the end can help a dragon propel itself through the water.

Fish scales are cleanly and geometrically layered on top of one another. The easiest way to get straight, layered fish scales is to draw a criss-cross pattern, then draw your curved scales in the corner of each box.

Snake scales follow the same grid rule as fish scales, but depending on the type of snake and the location of the scales, can be less layered and more like studs.

Creating a Basic Tail

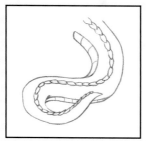

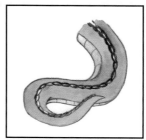

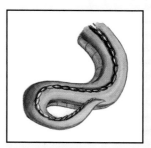

1 Draw the Basic Shape
When drawing a tail, start with a line for the basic shape and then draw circles around that line. Continue by drawing the sides of the tail following those circles, tapering as you get to the end.

2 Draw the Details
Draw the spinal scales along your central line, and use your circular guidelines to help you draw the curve of the belly scales. Erase your guidelines.

3 Paint the Base Colors
With a No. 8 round, paint a layer of Aureolin Yellow mixed with Turquoise for the tail. Let dry completely. Then paint Naples Yellow for the belly and switch to a No. 2 round to paint the back scales with a light wash of Thio Violet, leaving some white for highlights.

4 Final Details
With a No. 4 round, paint in a dark layer of Turquoise on the bottom and sides of the dragon's tail for shadow. While the paint is still wet, blend the edges gently. Add shadow to the belly scales with a mixture of Raw Umber and Ultramarine Violet. With a No. 4 round, wet a line along the body and lift with a paper towel to make the hide look shiny.

Drawing and Painting Horns

A dragon's horns are its pride and joy. Not only do they serve as natural adornment, but they are also formidable weapons. When artists think of dragon horns, they usually think of straight or slightly curved goat-like horns. These work well for dragons, but there are many other types of horns you can give your dragons, including antlers! Horns and spines can go anywhere on a dragon, they don't have to be only on the head.

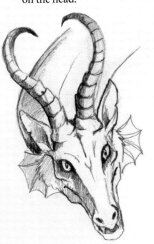

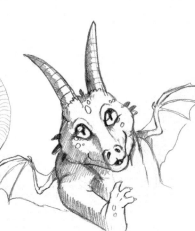

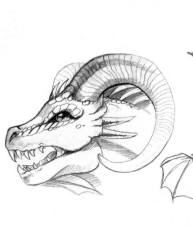

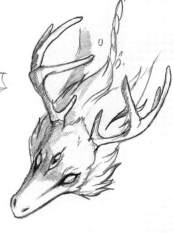

Horns based on a springbok, an African antelope.

A ram has thick, curved horns. You can place them anywhere on the head, such as reversed so they curve up instead of down.

This baby dragon is just starting to grow into a pair of goat-like horns.

A pair of antlers gives this magical dragon a mystical look.

Creating Multiple Horns

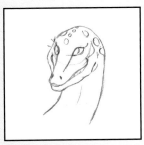

1 Draw the Dragon
Start by drawing your dragon, and decide where you want to put the horns. Small circles are a good way to figure out where they would fit on the head.

2 Draw the Horns and Details
For ram-type horns, drawing striations in the horn not only gives it interesting texture, but also helps show the direction the horn is curving. Pay attention to the order of the horns; the top horns curve back and the ram horns curve forward, so the tip of the far ram horn will go over the top horn.

3 Paint the Base Colors
With a No. 4 round, paint the dragon with a very light wash of Cadmium Orange. Mix Raw Umber with Van Dyke Brown and paint the ram horns with a No. 2 round, leaving white for highlights. For the shiny black, use a dark mixture of Sepia and Payne's Gray. To shade the white horns, mix Naples Yellow with Ultramarine Violet and paint only the far edge. Paint the eyes with a little Phthalo Blue. After it's dry, go back with Payne's Gray for the outer eye, pupils and nostrils.

4 Final Details
Use a No. 2 round to paint the horns with Raw Umber. With a mixture of Cadmium Orange and Burnt Sienna, paint shadows on the face and neck. Let it dry. Paint deeper shadows with a wash of Burnt Sienna and Ultramarine Violet. Finish with a light wash of Aureolin Yellow over the skin.

Visit www.impact-books.com/wingedfantasy for free bonus content.

47

Dragon Expressions

A dragon's personality, like a human's, is reflected in its face as well as its body. Dragon faces can be just as expressive as ours. Furrowing brows, snarling lips and wide eyes all depict rich emotions on a dragon, as do a head held low, ears pulled back or cowering shoulders.

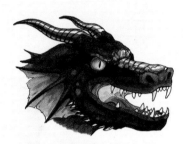

Anatomy of a Furious Dragon
- Lips pulled back to show bared teeth
- Slitted pupils
- Wide eyes
- Furrowed brows
- Ears pinned back
- Throat glowing with fire
- Frill extended

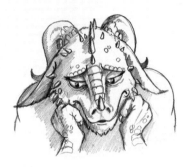

Disappointed
This poor, let-down dragon has downcast eyes and drooping ears. The upper lid comes over the eye when someone is sad, and if the dragon is very upset, the eyebrows will pinch together and up. Dragons can even frown, and resting its head on its claws with hunched shoulders is the final touch to show crushing disappointment.

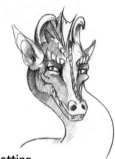

Plotting
This good-for-nothing wyvern is planning something rotten. You can tell by its squinting eyes and wide, mischievous smirk, and the way it stretches its ear out to grasp every last drop of juicy gossip that may contribute to whatever it's plotting.

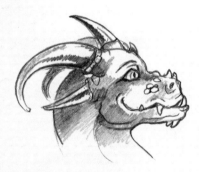

Pleased
Upturned eyebrows and an upward curve to the mouth suggest happiness. Body language is important, too. This pleased dragon holds its head up high.

Surprised/Alert Sleepy Angry

The eyes can be the most expressive part of the face. Depending on how you draw them, the eyes alone can indicate the dragon's mood. A wide-open eye shows surprise, whereas a heavily lidded eye with a dilated pupil expresses sleepiness. A downturned brow with a wide-open eye and a slitted pupil shows anger.

Tips on Drawing Expressions

- If you're stuck on how an expression would look, try making it yourself and looking in a mirror. Many artists, myself included, end up making the very face they're trying to draw while drawing it!

- Adding human elements like eyebrows can help with expressions, though it may make your dragon look more cartoony.

- Little changes can have big effects. The size and shape of the pupil, for example, can make an otherwise angry dragon look docile.

Putting It All Together

You've learned about all the individual parts of the dragon, but how do you build your own? Dragon bodies are similar to real animals in a number of ways, such as the direction the bones and joints in the forelimbs and hind limbs move. Using guidelines can help you flesh out basic proportions before adding detail. Think about what type of dragon you want to create. Is it a sea dragon or a mountain dragon? Does it use its claws to create or destroy? The design of your dragon depends on where it dwells and what it does. Each dragon can be different!

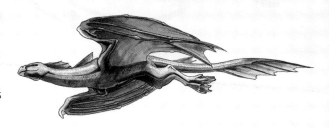

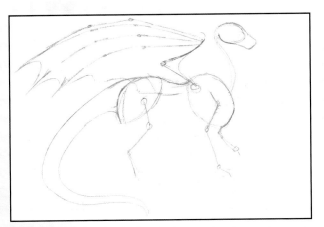

1 Draw the Basic Structure
Ovals for the head, chest and rump will help with shape. Connect the head to the chest with a curving line. For the legs, remember the direction the bones and joints go, and sketch them using lines and circles. At this stage, don't worry about erasing. Drawing rough will help you focus on the shapes instead of getting everything perfect.

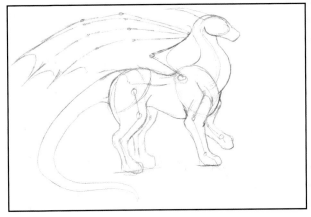

2 Flesh Out the Form
Connect your guidelines and start fleshing out the dragon. Drawing the neck at this stage is easy because you already have a line showing the curve of the neck. This is where you add your creativity to make the dragon unique. Is it heavy? Light? Long and snakelike or short and stout?

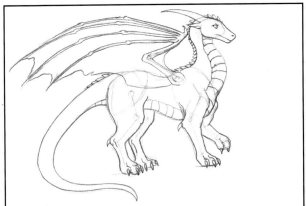

3 Final Details
When you draw a dragon in steps, it solves the problems of odd perspective and anatomy early on. Instead of adding lots of detail to the leg only to realize it's bent the wrong way, you can catch these problems at the rough sketch stage. When you finally start on the detail, everything is in place.

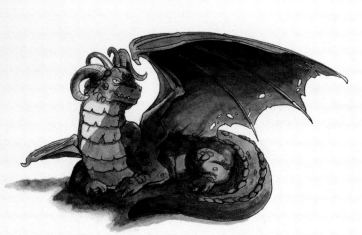

Dragon of the Deep: Ocean Dragon

Rising from the depths of the sea, the Ocean Dragon spreads its wings to leap from waves to wind. True to its habitat, this dragon slips through the water with fish-like scales and propels itself with webbed feet and a finned tail. The colors of the ocean contain more than just blue; greens, purples, even some yellows and browns are what make water look alive.

MATERIALS LIST

Paper: cold-pressed watercolor paper

Brushes: Nos. 2, 4, 6 and 8 rounds, ½-inch (13mm) flat, 1-inch (25mm) flat, ¾-inch (19mm) mop

Paint: Caput Mortuum Violet, Cerulean Blue, Cobalt Blue, Dioxazine Violet, Green Gold, Naples Yellow, Payne's Gray, Phthalo Blue, Prussian Blue, Quinacridone Rose, Turquoise, Van Dyke Brown, Viridian

Other materials: white gel pen, paper towels, white gouache

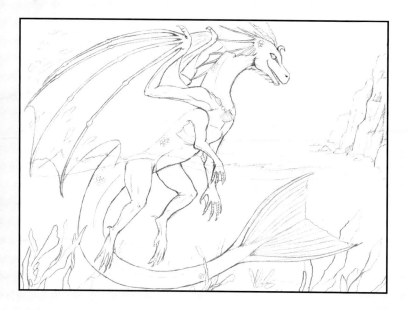

1 Draw the Dragon

Choose a dynamic pose to show the dragon emerging from the sea. Droplets of water fall from its wings as it rises in flight. At this angle, we can see both worlds—the ocean bottom, teeming with plant life, and the earth and sky above, marked by the ocean extending to the horizon and flanked by cliffs. Add some suitable accessories, such as a shell necklace.

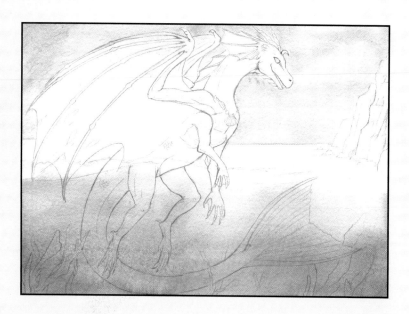

2 Add Washes to the Sea and Sky

With a ¾-inch (19mm) mop, wet the underwater part of the paper with clean water. Load a 1-inch (25mm) flat with Cerulean Blue and paint along the top, then switch to Phthalo Blue and paint a layer beneath it. Do the same with Cobalt Blue at the bottom, then Dioxazine Violet. Don't worry about painting around the dragon and the seaweed; by painting over them now, they will match better with the underwater tones later.

Leaving a patch of white beneath sea and sky, wet the sky with your ¾-inch (19mm) mop and clear water, then use a ½-inch (13mm) flat to paint in a mixture of Cerulean Blue and Phthalo Blue, getting lighter as you go down. At the base of the sky, paint in a single layer of Naples Yellow. Blot some clouds with a paper towel.

3 Start Adding Shadows

Prussian Blue is a good unifying shadow for your dragon. Use a No. 2 round and mix Prussian Blue with Turquoise for the shadows on the dragon's body, and mix Prussian Blue with Dioxazine Violet for the shadows on the wings. Underwater, use Prussian Blue mixed with Phthalo Blue to shade the legs. Pay attention to the muscles when painting; you can create believable dimension by painting the crevices of muscles darker and leaving the bulge of muscles lighter.

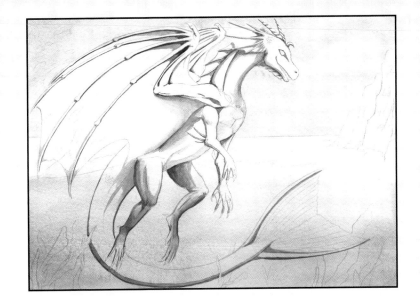

4 Paint Base Colors on the Wings and Water

With a No. 6 round, mix Cerulean Blue with Quinacridone Rose and paint the membranes of the wings and fins. Paint the surface of the water with Turquoise and a No. 8 round, being careful to leave some white of the paper showing for highlights. While still wet, paint the water farthest away with Phthalo Blue. Paint the seaweed with a No. 4 round and Viridian.

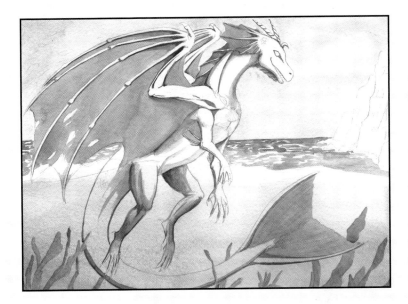

5 Ocean Floor Washes and Cliff Shadows

Starting about midway down, use a No. 8 round and carefully paint a light wash of Dioxazine Violet all the way to the bottom, avoiding the dragon and seaweed. Once dry, paint a light wash of Dioxazine Violet and Caput Mortuum Violet below that. Once that is dry, switch to a mixture of Van Dyke Brown and Dioxazine Violet, and create some jagged ridges. This will create a sense of depth for your ocean floor.

Use a No. 2 round and Payne's Gray to lay in shadows on the cliffs, going lighter the farther back you go.

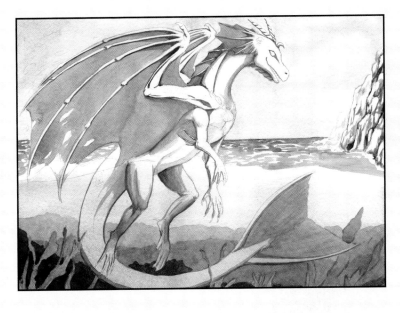

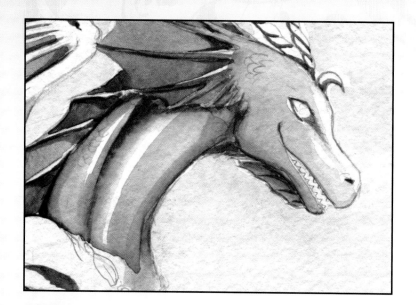

6 Blending Blues and Greens

To get a smooth transition between blues and greens, paint the skin with a loose wash of Phthalo Blue and a No. 4 round. While still wet, touch the paint with a brush loaded with Green Gold. When the paper dries, it will result in a smooth gradient.

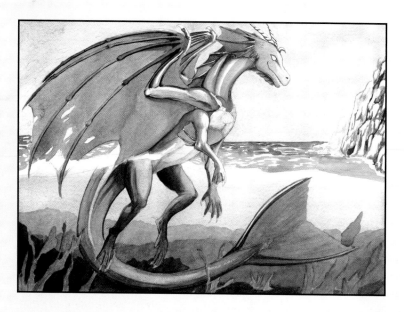

7 Dragon Base Color

Continue painting your dragon, using a No. 4 for smaller areas like the forearms and a No. 6 for larger areas. Use Phthalo Blue mixed with touches of Green Gold on the upper half of the dragon, and gradually switch to Cerulean Blue with touches of Quinacridone Rose the farther down you go.

When you paint the tail, lift a little bit of the wet paint off with a No. 6 round for the highlight. Objects underwater won't have the sharp, bright white highlights that shiny objects have above water because the sunlight is diffused by the water, so the highlight doesn't have to be sharp. Use Dioxazine Violet to deepen the shadows under the legs.

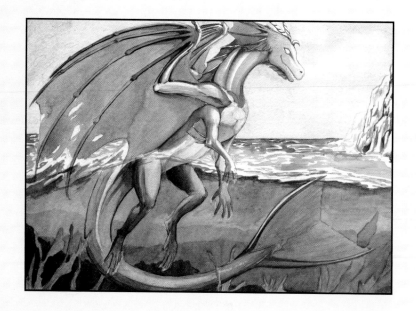

8 Water Details

Use a No. 2 round to paint Viridian mixed with Phthalo Blue along the white patch you left between the underwater and the surface, and in spots mix in a little Green Gold. Switch to a No. 8 round and paint Phthalo Blue to darken the water, painting around the dragon and seaweed, and covering the first two layers of the undersea surface. While the paint is still wet, use Viridian to push the top greener, then use Prussian Blue to darken right beneath the surface.

9 Cliff and Sea Bottom Details

Use a No. 4 round and a wash of Naples Yellow for the cliffs, adding a little Van Dyke Brown while still wet. Use lighter washes the farther back you go.

Use a No. 6 round and wet various spots on the closest part of the sea floor, then lift with a paper towel to create light spots. Mix Payne's Gray with Caput Mortuum Violet and paint dark crevices and shadows with a No. 2 round, then use a lighter mix for the ground farther back. Add detail to the seaweed with Viridian and some Dioxazine Violet, and add a few additional pieces of seaweed throughout the ocean floor.

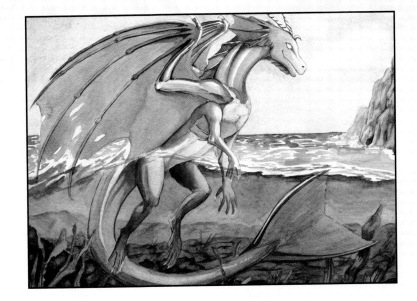

Painting Seascapes and Water

1. Draw a wave with some flowing water beneath. The shape isn't important; what matters is that it flows. Water doesn't have hard corners or edges—everything is a curve.

2. Use a No. 4 round and loosely add washes of Phthalo Blue and Turquoise. Leaving white patches is a good way to suggest highlights. Don't worry if it bleeds; that matches the unpredictable nature of water.

3. Use some Prussian Blue mixed with Phthalo Blue for the really dark areas and use lighter washes of Turquoise to blend. Add oddly shaped flows of water where you think they're needed.

4. Glaze some Green Gold over the Turquoise and Quinacridone Rose over the Phthalo Blue to push the values even more.

Because water is clear, the color we see in water is a result of the scattering of light as well as a reflection of the sky. The ocean at sunset is not going to contain the vibrant turquoise that an ocean at high noon does. Keep this in mind when painting ocean scenes.

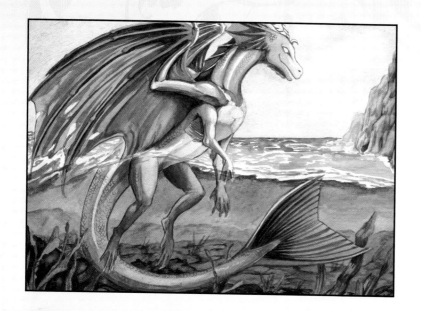

10 Wing and Body Details

For the details on the wings and fins, combine Quinacridone Rose with a small amount of Prussian Blue and paint in the folds with a No. 4 round, making sure to paint around the water droplets. Do the same on the tail and body fins, using a No. 2 round. For the deep shadows, go back with Dioxazine Violet.

For the body, paint some scales with mixtures of Prussian Blue and Quinacridone Rose, going more blue or more purple depending on the hide color. Use Prussian Blue to deepen the shadows, such as under the wing shoulder and behind the cheek.

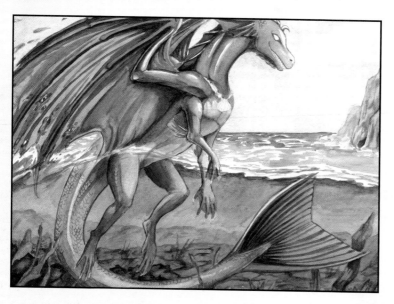

11 Final Washes

To make the colors pop, add light washes of Phthalo Blue with touches of Gold Green and Viridian with a No. 4 round over the face, neck and side. On the chest and belly, use washes of Cerulean Blue with Cobalt Blue anywhere you want to push the shadow.

Use a No. 2 round and Phthalo Blue and Viridian to paint the flying water droplets, and add washes of Green Gold to parts of the seaweed.

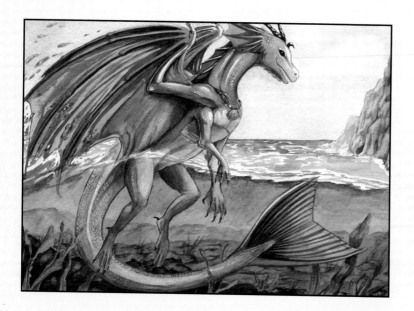

12 Paint the Face, Horns and Final Touches

With a No. 2 round and a thick mixture of Dioxazine Violet and Prussian Blue, paint the horns, eye and claws, and outline the mouth and add a little shadow to the teeth. Use Van Dyke Brown mixed with a little Quinacridone Rose to paint the shell on the necklace. You can paint the other shells with mixtures of Van Dyke Brown and Prussian Blue.

To give your dragon a bit more shine, wet narrow lines in the tail and lift with a paper towel to add highlights. Use a white gel pen to draw a few scale highlights on the scales that are out of the water. Add a shadow on the ground under the tail with a No. 4 round and a wash of Prussian Blue mixed with Caput Mortuum Violet.

13 Add Underwater Shells and Bubbles

Add a few details to bring life to the ocean floor. Using white gouache and a No. 2 round, paint in some shells and clumps of seaweed. After it's dry, glaze over with various colors such as Quinacridone Rose, Naples Yellow and Phthalo Blue. For bubbles, use a No. 4 round and wet the paper and lift with a paper towel. Then add some detail with a bit of Turquoise on the bigger bubbles.

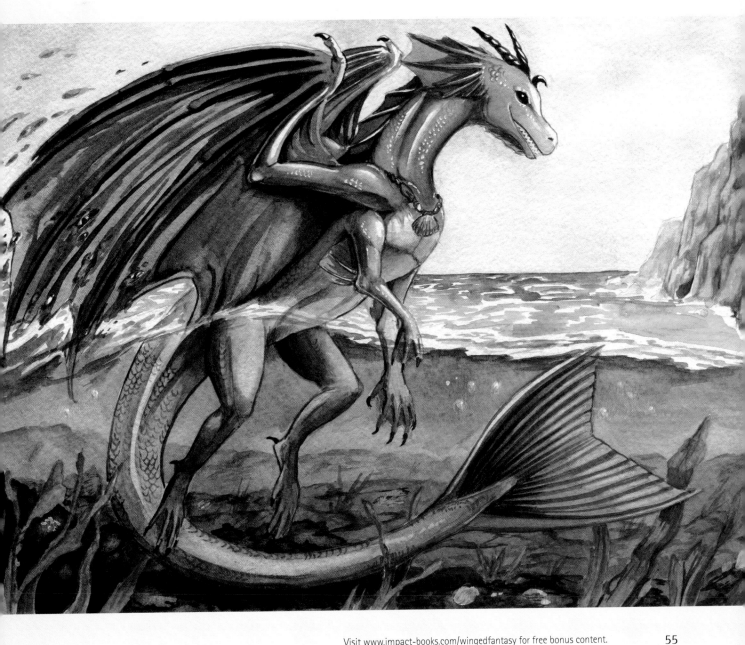

Guardian of the Mountain: The Gold Hoarder

Eyes wide with greed, there's never enough gold for the Guardian of the Mountain. He keeps track of every single coin, and if he finds anything missing, he erupts with rage and fire. Many adventurers have ventured into his cave trying to strike it rich with a bag of treasure, and few have returned.

MATERIALS LIST

Paper: hot-pressed watercolor paper

Brushes: Nos. 2, 4 and 6 rounds, ½-inch (13mm) flat, ¾-inch (19mm) mop brush, old bristle brush

Paint: Aureolin Yellow, Burnt Ochre, Burnt Sienna, Cadmium Orange, Cadmium Yellow, Dioxazine Violet, Indigo, Naples Yellow, Payne's Gray, Permanent Green, Prussian Blue, Quinacridone Rose, Raw Umber, Scarlet Lake, Sepia, Thio Violet, Ultramarine Blue, Ultramarine Violet, Van Dyke Brown, Yellow Ochre

Other materials: paper towels, white gel pen, white gouache

1 Sketch the Dragon

Draw your fierce and protective dragon. This dragon is not just guarding the mountain, but the treasures inside. When sketching, think about what this type of dragon would look like. Maybe all his battles to guard his gold have resulted in some cracked scales. He is a strong, protective creature who is as cunning as he is fierce!

2 Sky Wash

Take your ¾-inch (19mm) mop brush and brush a wash of plain water in the sky for a wet-on-wet wash. While your paper is still wet, load a ½-inch (13mm) flat with Prussian Blue and brush horizontally across the wet paper. While still wet, load your brush with Ultramarine Blue and brush along the top of the sky.

Take just a little Naples Yellow and brush the very bottom of your sky near the horizon. This will give you a nice gradient of blue to cyan. To add clouds, take a paper towel and lift some of the paint away very gently while it is still wet.

3 Base Washes

With your ¾-inch (19mm) mop brush, cover the whole cliff with a clear wash of water except for the inner cavern. With a No. 6 round dab the paper with Raw Umber, Van Dyke Brown, Sepia and Ultramarine Blue to get splotches of color. Add texture with an old, bristly brush.

When the cliffs are dry, add Aureolin Yellow to the dragon's body with a No. 4 round. While the yellow is still wet, paint the head, neck and tail with Scarlet Lake. On the far wing, paint a layer of Scarlet Lake and overlay the tips with Thio Violet. For the underwings, paint a layer of Burnt Ochre with Burnt Sienna at the tips.

Using an old, bristly brush, roughly dab Aureolin Yellow where the gold will be. To show the glow of the gold in the cavern, paint a wash of Cadmium Orange and add a bit of Raw Umber at the top while your Cadmium Orange is still wet.

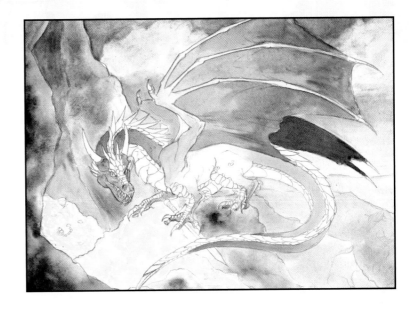

4 Base Washes for Details

For the underscales, paint a base layer of Quinacridone Rose with a No. 4 round. The horns, claws and back scales can be painted with a base of Dioxazine Violet. Use Aureolin Yellow for the small scales along the dragon's body and legs, and make the gold scales pop with Dioxazine Violet in the crevices.

With a fine-point No. 2 round, use a mixture of Payne's Gray and Sepia for the inside of the dragon's mouth, being careful to paint around the teeth. Use a light wash of Indigo for the blade of the sword, leaving white highlights. Paint a light wash of Burnt Ochre and Burnt Sienna for the metal guard and wrapped grip. Add Permanent Green for the eyes.

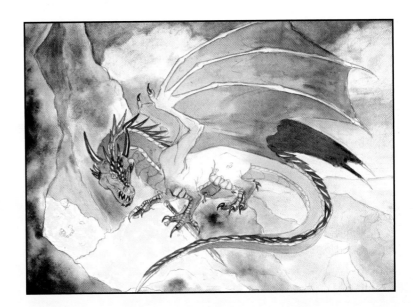

5 Cliff Details

To paint the cracks and ridges in the cliff, take a No. 2 round and mix a thick, dark mixture of Payne's Gray and Sepia. Using the tip of your brush, paint in vertical lines with some horizontal or diagonal ledges. Use the variations of dark and light in your initial wash as a springboard for divots, cracks and shapes. Paint in some loose rocks near the bottom.

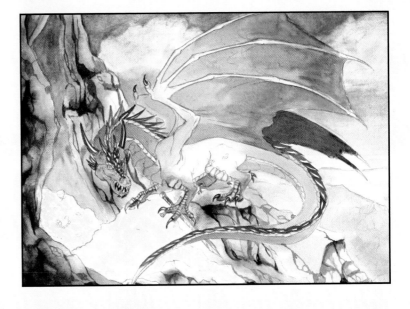

6 Background Cliff Details

Because objects lose contrast the farther back you go, use lighter and lighter washes the farther into the background you go for the cliffs. You can mix Ultramarine Violet and Sepia for the farthest hills.

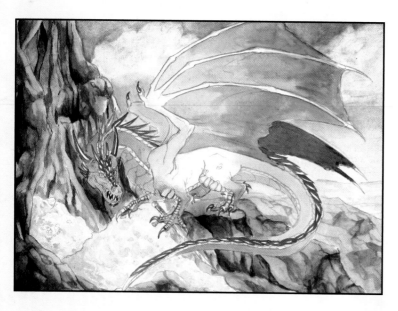

7 Cliff Shadows, Detail and Gold

Mix a wash of Van Dyke Brown and Burnt Sienna to deepen the shadows on the cliff with a No. 4 round. Because the primary light source is from above, the shadows will be under the ledges and within the crevices. Make sure not to paint over the edges of the cavern, because the gold glow will illuminate them. Take a wash of Raw Umber and paint over the cliff.

Inside the cavern, paint a mixture of Van Dyke Brown and Burnt Sienna for the crevices and cracks. As you get closer to the bottom, switch to Burnt Sienna and wet your brush to blend it a little. Because this cavern is glowing from the gold, you want to keep the colors warm. For the gold, load a No. 4 round with Cadmium Yellow and dab like you did with the first wash to deepen the yellow.

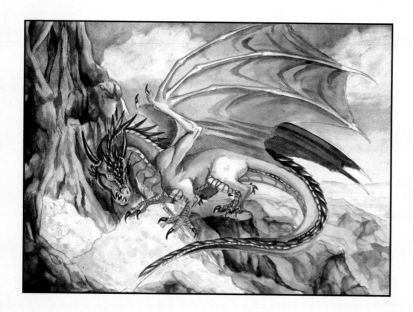

8 Shading the Dragon

With a wash of Dioxazine Violet, paint in some shadows on the belly scales with your No. 4 round. Use a mixture of Burnt Sienna and Ultramarine Violet for the shadows on the body, legs and wings and to suggest folds and wrinkles. For the head, neck and tail, paint a mixture of Thio Violet and Burnt Sienna. Remember to leave a patch bare for the reflected light from the gold. The shadows on the far wing can be a mixture of Dioxazine Violet and Thio Violet.

With a fine No. 2 round, paint the horns, scales and claws with Indigo. Outline the gold scales and belly scales with Dioxazine Violet.

Drawing a Landscape

Whether you're drawing a mountain range or a field or a forest, you need to understand how depth affects your colors and values. Objects farther away will appear more faded and less saturated than objects closer to the viewer, due to naturally occurring clouds or haze. This effect is referred to as atmospheric perspective.

Far-away mountains will appear more blue than cliffs in the foreground or middle ground, even if they are made of the same stone.

The details on trees appear to fade the farther away you go. Shadows are sharp and deep close up, and are dull and faded farther away.

To create a believable habitat for your creature, you will need to be able to draw and paint a suitable landscape for it to live in. Here, in this vibrant autumn scene, even the brilliant hues of the leaves become dull as the trees recede into the distance.

1. Use thicker, darker lines for the objects in the foreground and middle ground. Draw the trees and mountains in the background with lighter lines. This helps you remember which levels of the drawing need more or less contrast.

2. Add in the shadows. Use Payne's Gray and Van Dyke Brown for the deep shadows of the tree and the light shadows of the cliff. Dab Burnt Sienna on the leaves in the tree. Use a No. 4 round and a very light mix of Dioxazine Violet and Van Dyke Brown to paint the shadows of the mountain.

3. Layer Cadmium Yellow and Cadmium Orange for the tree foliage. Add Quinacridone Rose on the foreground tree. Paint the layer of forest with Burnt Ochre and Cadmium Orange for a dulled-down yellow. Mix Cobalt Blue with Van Dyke Brown for the mountain and Raw Umber and Cobalt Blue for the tree and cliff. Add a loose wash of Sap Green for the grass.

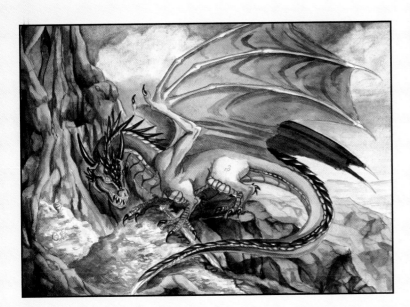

9 Gold Details and Rock Shadows
Paint in the shadow of the gold with a loose wash of Burnt Sienna with a No. 4 round. Once dry, go over it with a light wash of Cadmium Orange. Add a shadow where the dragon's tail is, and add a few stray coins on the rock with a No. 2 round, using Burnt Sienna and some Cadmium Yellow.

Darken the rock beneath the dragon with Sepia, and blend in a little Indigo, then take your No. 2 round and deepen the crevices and shadows of the cliff with Indigo. As you darken the crevices, you may find you need to deepen the rock shadows. Use the same wash of Van Dyke Brown and Sepia with your No. 4 round to deepen the rock shadows.

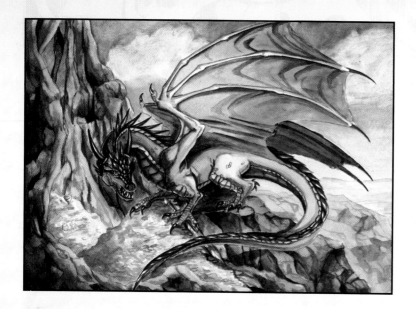

10 **Dragon Details**
Add the darkest shadows to the dragon using Dioxazine Violet mixed with Indigo. Use a No. 2 round to darken the crevices of the belly scales, the back scales and the spines at the very tips of the wings. This mixture of color, as well as a mixture of Dioxazine Violet and Burnt Sienna, is useful to define shadows and crevices, such as where the leg and the shoulder of the wing attach to the body. Using your No. 2 brush, carefully paint around the eye of the dragon to give it a dark outline, add pupils in the eyes and fill in the nostrils.

Deepen the purple on the belly scales with another wash of Dioxazine Violet, and deepen the shadows of the underwings with a Burnt Sienna and Ultramarine Violet mixture, using your No. 4 round. Paint the sword blade and the blade-like tip of his tail with Payne's Gray using a No. 2 round, and use Van Dyke Brown for the shadow of the hilt wrapping.

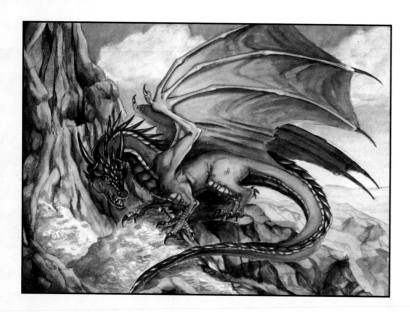

11 **Final Washes and Reflective Color**
Using your No. 4 round, go over the dragon with thin washes of color to make him vibrant. Let your previous wash dry completely before putting down another wash. For the red of the dragon's face, tail and outermost wing, use washes of Quinacridone Rose. Go over his body with additional washes of Aureolin Yellow. At the ends of the underwings, lay down a wash of Cadmium Orange, then while still wet, extend the wash with Yellow Ochre at the middle and Aureolin Yellow at the base. A wash of Burnt Sienna on the purple underscales will help them blend in better with the overall color of the dragon.

The light from the gold will reflect off the closest parts of the dragon and cliffs. Use a No. 4 round brush to paint a light wash of Aureolin Yellow over the bottom of the jaw, belly, tail and edge of the cavern. Add another light layer of Prussian Blue to the sky using a No. 4 round.

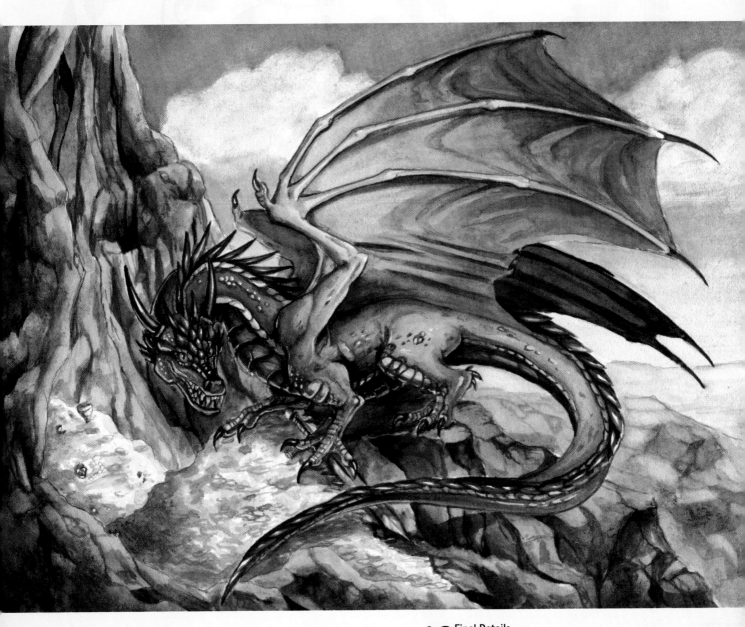

12 Final Details

Using a No. 2 round, paint scales or texture on the body using a mixture of Burnt Sienna and Ultramarine Violet. With a white gel pen, create highlights within the scales. Also put a dot of white in the eyes as a highlight and anywhere you want extra reflection, such as on the edge of the jaw and the underscales. After the gel pen dries, you can gently place a wash of Aureolin Yellow over it for an even brighter reflection of the gold. With an old, bristly brush, dab some white gouache in the cliffs, as well as some Sepia, to bring texture to the stone.

Add a few jewels to the pile of gold using Quinacridone Rose and a dab of Prussian Blue, which will create a vibrant green when placed on the yellow.

Forest Hunter: Wyvern of the Woods

Deep in the tangled forest, a hungry wyvern stalks her prey. She is perfectly camouflaged among the trees and leaves with her bark-textured scales and leaflike mane and tail-tuft. She climbs from branch to branch using her tail and claws, freezing when a butterfly flutters close. But it is too late; dinner is served!

MATERIALS LIST

Paper: cold-pressed watercolor paper

Brushes: Nos. 2, 4, 6 and 8 rounds, ½-inch (13mm) mop

Paint: Aureolin Yellow, Burnt Sienna, Cobalt Blue, Dioxazine Violet, Green Gold, Hooker's Green, Indigo, Payne's Gray, Permanent Green, Phthalo Green, Quinacridone Rose, Raw Umber, Sap Green, Ultramarine Violet, Viridian, Van Dyke Brown, Winsor Green

Other materials: paper towels, salt (regular grain), white gouache

1 Draw the Wyvern

Use curved lines to give this wyvern a sleek appearance. This hunter uses sneaking and stealth to find her prey, so she is lithe rather than bulky. Add some basic texture on the branches and her scales. Because she has a bark-like hide, she has quite a bit of texture.

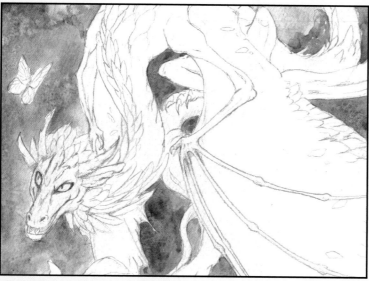

2 Lay in Background Washes

With a ½-inch (13mm) mop, lay down a layer of clear water on the bottom two-thirds of the background, then use a No. 8 round to paint in blotches of Viridian. The more irregular, the better. Go back with Hooker's Green at the top of this wash, blob in some color, and sprinkle some salt over the entire wash. Once dry, wet the top one-third of the background with water and a ½-inch (13mm) mop and lay in Green Gold and Sap Green with a No. 8 round. Sprinkle salt around to bring in more texture. Gently brush off the salt once the paint is dry.

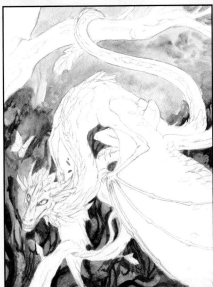

3 Paint Lower Background Detail

With a mixture of Indigo and Viridian, use a No. 4 round to paint vine and branch shapes in the lower half of the background, wetting the edges in places where you want them to blur into the background. Use the splotches left by the salt as a guide on where to draw your twisting vines; it will help you create an organic look instead of a planned one. Use Viridian at the upper half to paint bushy leaf shapes. While still wet, use a No. 2 round to paint crevices in the vines and branches with your Indigo and Viridian mixture.

4 Paint Upper Background Detail

Using a No. 4 round, wet the upper background and darken around the random splotches caused by the salt to create leaf textures with Sap Green. While still wet, go back with a No. 2 round and a mixture of Sap Green and Ultramarine Violet to paint in the hint of leaf shapes. The more varied and spontaneous your shapes are, the more natural it will look. Use a No. 4 round and Green Gold in the upper left to suggest branch shapes. Wet and lift areas to soften your color and create highlights.

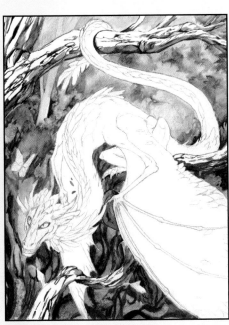

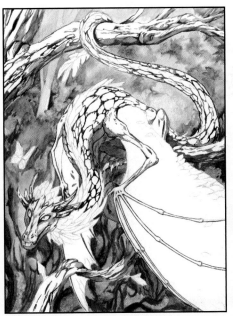

5 Add Tree Texture and Shadows

With a No. 2 round, paint in a dark mixture of Indigo and Van Dyke Brown for the bark. Create jagged, twisting lines, and add a few darker crevices for the bark texture. Use a lighter wash and a No. 4 round for the shadows.

6 Paint the Wyvern's Scale Details

Because your wyvern has bark-like scales to blend in with the surroundings, use the same dark mixture of Indigo and Van Dyke Brown. Randomly shaped scales work best for getting that organic bark look, but you can also use a pencil to draw in the scale shapes before painting. Use a No. 4 round to lay a lighter wash of your Indigo and Van Dyke Brown for the scale shadows.

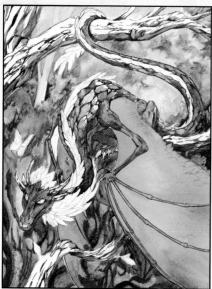

7 Add Base Color to the Body

Using wet-on-wet with a No. 6 round, add Raw Umber and Cobalt Blue unevenly to the wyvern's body. Add a few dabs of Permanent Green. Start with Burnt Sienna on the snout, then paint Raw Umber on the forehead. Use a No. 2 round to paint Sap Green on the wing fingers. Once dry, paint the wing membranes with Permanent Green and a No. 6 round, then paint the underside of the wings with Hooker's Green while they are still wet.

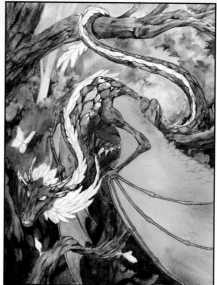

8 Paint the Trees and Add Detail to the Background

Darken the bottom background with a wash of Phthalo Green, then Indigo in the shadows. Don't be afraid to lose some of your detail; even if it's not prominent, it helps provide depth under your washes. Dab some Green Gold very sparingly in the lighter areas. Do the same with the upper background with Sap Green and Ultramarine Violet.

Paint the tree with the same mixture as the wyvern. Paint wet-on-wet washes of Raw Umber, Cobalt Blue and Permanent Green.

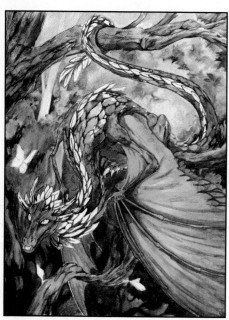

9 Add Shadow to the Leaf-Scales and Wings

With a No. 2 round, mix Sap Green and Ultramarine Violet to paint the shadows of the leaflike scales around the wyvern's neck, back and tail. Switch to a No. 4 round and shade the wings with Winsor Green, with a little Sap Green at the base of the fingers. When dry, paint over the wrinkles in the wing with Permanent Green. Paint the leaflike tips of the wings with Green Gold.

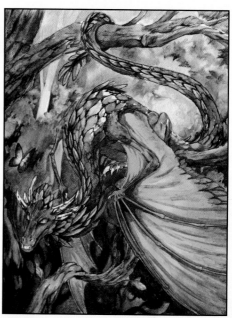

10 Paint Leaf-Scales and Butterfly

Use a No. 2 round and paint Sap Green at the base of each back scale. Paint Green Gold at the tips and on the leaves of the branch. When dry, lift a highlight off with a paper towel, then add deeper shadows with Dioxazine Violet. Paint the butterfly with a No. 2 round and Aureolin Yellow. While still wet, paint the tips of the wings with Quinacridone Rose and let the colors mix. Use the same mixture for the wyvern's eyes. Once dry, use Dioxazine Violet to paint in the tips of the butterfly's wings and antennae.

Trees and Foliage

The key to creating realistic trees and forest scenes is to embrace the spontaneous nature of watercolor. Using random splotches from painting wet-on-wet is the best way to get an organic look for your leafy canopies and bushy branches. Adding salt or rubbing alcohol can also give you random shapes to help find the shadows and shapes within your forest.

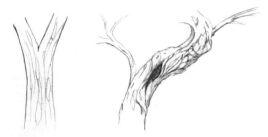

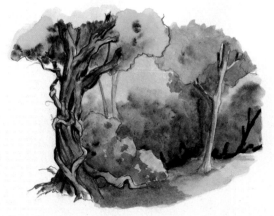

Avoid plain Y-shaped trees. Practice drawing twists and unusual curves for your trees. Get inspiration from the trees around you; apple trees and old oaks often have very unusual branches and bark. Draw different types of bark, as well as knots, bumps and cavities.

Using Salt for Foliage

A smooth wash is ideal for solid colors, but for a forest scene, texture and irregularities will help you find the hidden leaves within your colors.

1. Wet the paper with a ¾-inch (19mm) mop, then lay down irregular splotches of Cadmium Yellow, Permanent Green and Sap Green with a No. 8 round. While your paint is still wet, sprinkle with salt, letting it build up in spots.

2. When your paint is completely dry, brush off the salt and look at where the salt left textures and edges. Add darker colors where you see the hint of leaves to flesh out the shapes. Paint leaves out of positive and negative space as well.

Leaves

The easiest way to draw leaves is to start with their vein structure.

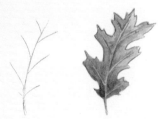

For an oak leaf, start with the center vein, then draw the smaller veins tiered on each side. Oak leaves are lobed and can have sharp ends or rounded ends.

Unlike the oak, maple leaf veins do not alternate on each side of the center vein. Draw the center vein, then a straight line along the bottom, then two lines diagonally connecting at the base.

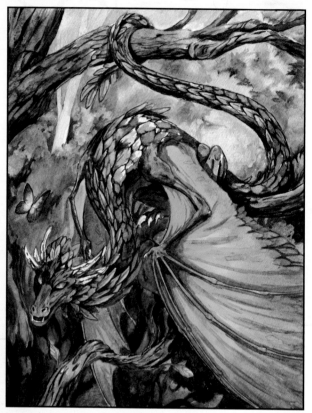

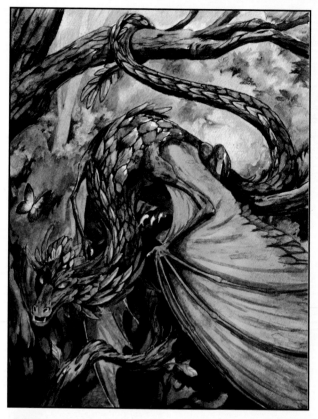

11 Add Final Shadows

Darken the crevices on the tree bark and the wyvern's scales with the same mixture you used before: Indigo and Van Dyke Brown and a No. 2 round. Paint inside her mouth with this mixture as well. Shade the branch and wyvern with Raw Umber and Cobalt Blue with a No. 6 round.

12 Final Washes

Add washes of Raw Umber and Burnt Sienna to the scales with a No. 4 round. Paint the horns with Burnt Sienna, and use a No. 2 round to add a wash of Dioxazine Violet to the tips of the fingers. For the background tree, use a No. 4 round and a wash of Raw Umber. Add one last wash of Indigo to the lower background to really make the wyvern pop, and add a shadow under the far wing with a No. 6 round. Add shadow anywhere you think needs more contrast, such as on the trees, with a mixture of Van Dyke Brown and Indigo. More layers help bring out the colors and contrast.

13 Final Details

Add a little white gouache to the bark on the tree and the bark-like scales with a No. 2 round. As it dries, it will go darker, so make sure to use a concentrated amount if you want it lighter. Use Payne's Gray for the pupils, claws, in the scale and bark crevices and to outline the eyes. Mix Van Dyke Brown with Payne's Gray for the holes on the wing up top. Use Indigo for the lower holes, and lift paint away on the wing around the holes to add dimension.

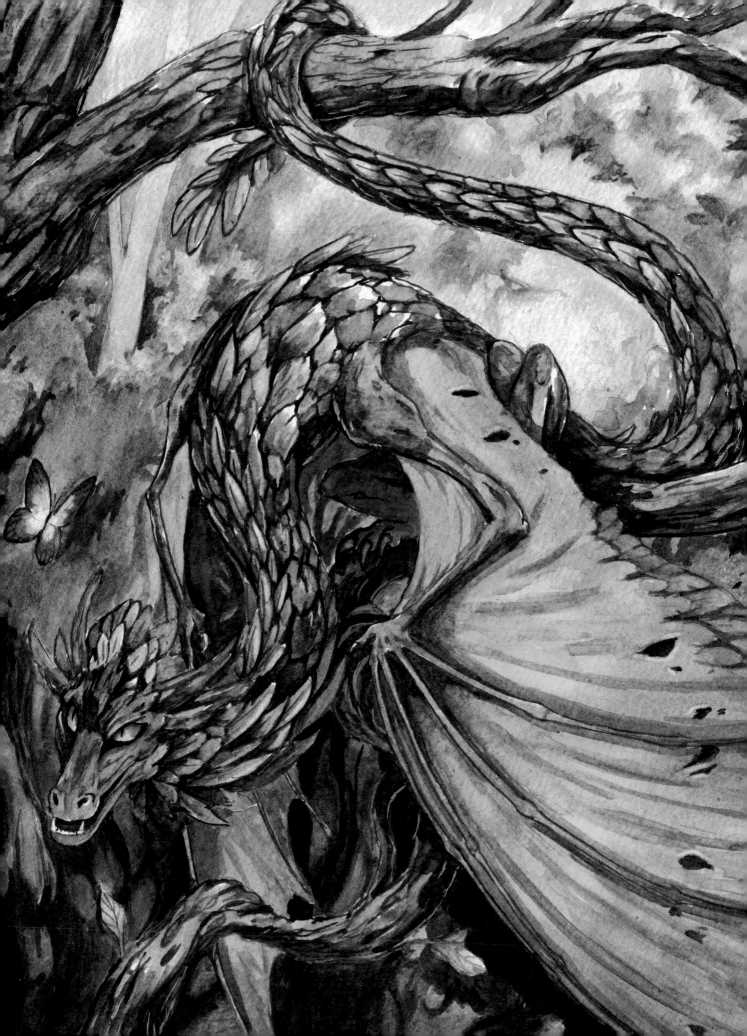

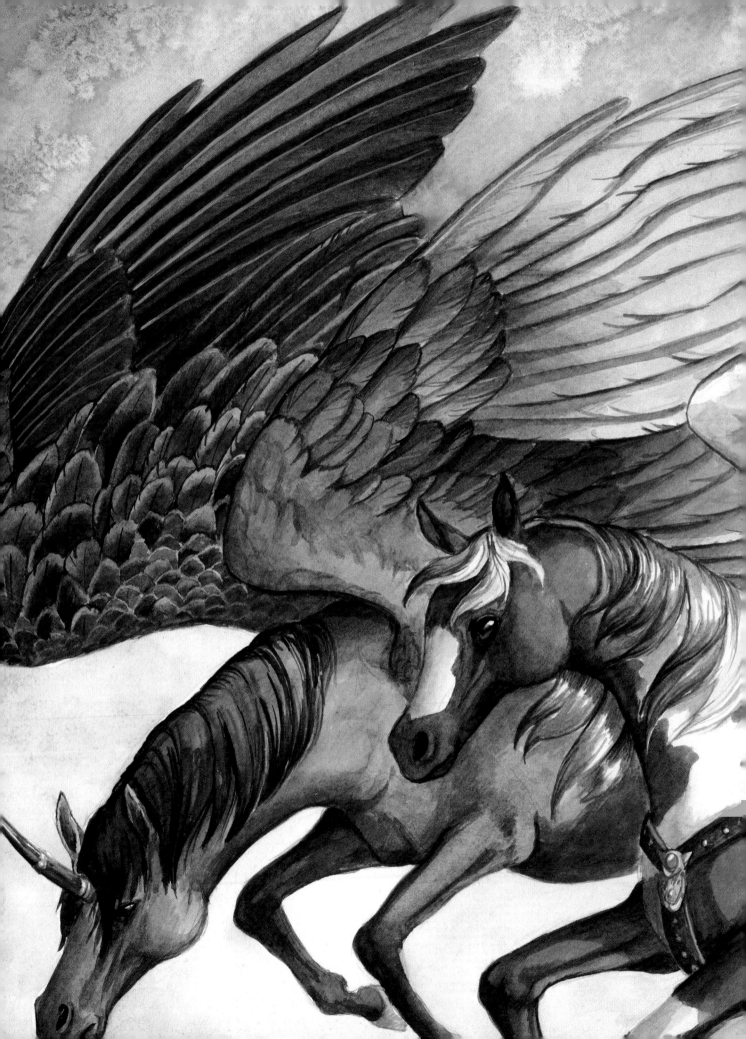

4

Equines: Hooves of the Sky

The role of the horse throughout human history has been one of companion, traveler, worker and warrior. They are one of the few animals domesticated for riding, and even today, with cars, trains and other faster methods of transportation, people ride horses for the sheer joy of it. It should come as no surprise, then, that we give horses wings in our stories and art. In Greek legend, the winged horse—named Pegasus—was the winged steed who Bellerophon rode to slay the Chimera. Today, we use the term Pegasus as a term for any winged horse, and there are variations, including winged unicorns.

The historical reach of the unicorn is even wider than that of the Pegasus. The traditional unicorn appears in Europe, where it had a spiral horn and the body of a goat or horse. It had religious significance and was seen as a symbol of purity, and appears in medieval tapestries and a number of coats of arms for countries and provinces. In Asia, the kirin is a unicorn-like creature which varies in appearance from deerlike, to that of a tiger, or even dragonlike. Its appearance, while vastly different from tale to tale, usually has hooves and either horns or antlers, giving it the title of Unicorn of the East.

Today, Pegasi and winged unicorns appear in movies, books and even corporate logos. Though traditionally the Pegasus is a white horse with white wings, modern Pegasi appear in every color imaginable. These noble beasts can be guardians, mages, steeds for human heroes or warriors in their own right.

Horse Anatomy

Drawing the horse can be daunting at first. Its proportions and anatomy can be a bit confusing. When drawing your Pegasus, knowing proper equine anatomy can be helpful, particularly if you're going to exaggerate the body. Because these are fantasy creatures, it's okay to paint them with unique proportions as long as it all fits together.

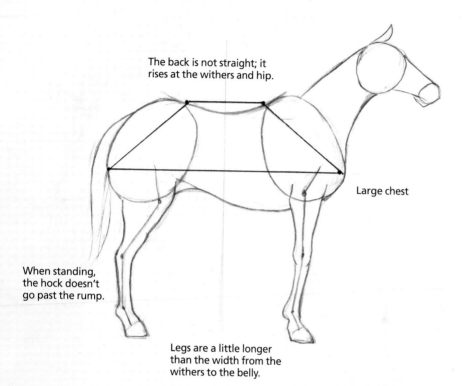

The back is not straight; it rises at the withers and hip.

Large chest

When standing, the hock doesn't go past the rump.

Legs are a little longer than the width from the withers to the belly.

The Trapezoid Method of Construction

The proportions of a horse are referred to as its conformation. A horse with good conformation is balanced and generally fits within a trapezoid shape. The length of the dip in the back between the withers and hip should be one-third of the length from the rump to the chest. This is a great tool to use when sketching out your horse to help with overall proportions.

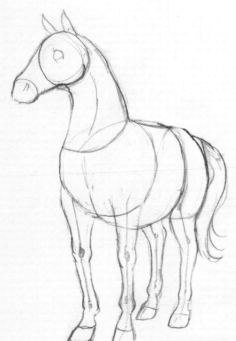

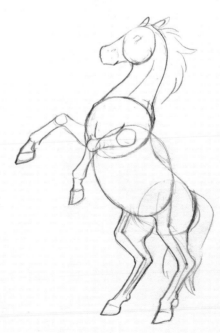

Use circles and ovals as guides for the body when drawing your horse from the front: one for the chest, one for the belly and one for the rear.

While an unusual angle for a terrestrial horse, you may want to draw your Pegasus from a bird's-eye view. Use a long oval for the body with smaller ovals for the chest and rear.

A rearing horse has an arch to its back. Use an oval as a guide for the curve of the belly, but draw a reverse curve for the back.

Legs and Hooves

Legs are one of the most expressive parts of a horse, but their complexity sometimes scares artists away from drawing horses. The structure is not as difficult as you may think once you learn a bit about it.

The Foreleg

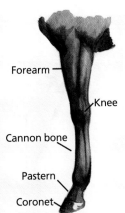

Forearm

Knee

Cannon bone

Pastern

Coronet

The Hind Leg

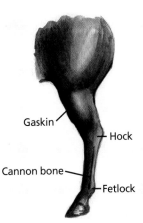

Gaskin

Hock

Cannon bone

Fetlock

Just like the bat, bird and human, the foreleg of the horse has the same bones, but they are structured differently. The knee is actually the carpus—the wrist—and the bones beneath that are essentially what would be the bones of the hand. The same is true for the hind leg; the hock is the heel.

Use guidelines for the bones and joints of the foreleg. Think of it as a human arm, but with very elongated fingers. Although the second joint is called the elbow, if we compare the joints to a human arm, the equivalent would make the top joint the elbow, the next joint the wrist and the last joint the knuckles.

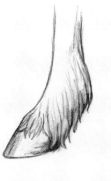

Do the same for the hind leg. If thinking of it like a human leg, the first joint would be the equivalent of a human knee, the next joint would be the heel, and the last joint would be the toe joints.

Dos and Don'ts

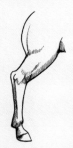

Don't extend the hock beyond the rear; it's very easy to do, but it's not natural horse anatomy. If you've drawn the leg and the hock goes too far back, the rest of the leg won't look right.

Don't reverse the joints. This foreleg is bent the wrong way and may work well for a mismatched monster, but not for a Pegasus!

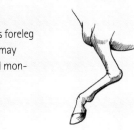

Do elongate and exaggerate! Long, delicate legs on a Pegasus or a more slender neck can give a touch of magic and grace to your creatures.

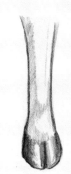

Feathered hooves will give your Pegasus a sense of magic and majesty. The feathering can be as light or as heavy as you like. Very heavy hoof feathering can completely obscure the hoof, as seen in heavy draft breeds such as Clydesdales.

For a dainty creature, cloven hooves can make your Pegasus look light-footed and delicate.

Visit www.impact-books.com/wingedfantasy for free bonus content.

71

The Head

Different breeds of horses have different heads, primarily in the shape of their noses. Arabian horses, for example, have a dish-shaped nose that many artists love for unicorns and Pegasi. Other breeds have bulkier, larger noses. Draft horses have heavier faces than Thoroughbreds, for example. Regardless of the breed, you can use the same steps to draw most heads.

From the side, the length of the horse's face is prominent. Horses have a heavy cheek, long jaw and large eyes. Their ears fold in at the bottom, creating a tapered look.

When viewed from the front, the head becomes very slender. Turning the head slightly will show more of the bulk. This view shows how dramatically the horse's eyes are pointed to the sides. Being herd animals, their side-facing eyes help them spot predators from any angle.

Drawing and Painting the Head

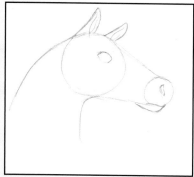

1 Sketch the Head
Use an HB pencil to draw a circle for the head, following the curve of where the cheek will be. Draw a straight line from the top of the circle, with a smaller circle at the end. Connect the two circles at the bottom, and draw in eyes, ears and the bottom lip.

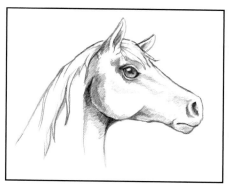

2 Finish the Drawing
After you have the overall shape, you can refine the head with a 6B pencil by adding shading and details. Pay special attention to shading on the cheek, neck and the long nose. Horse faces are not smooth and have quite a bit of dimension.

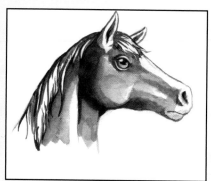

3 Add Shadows
For a chestnut-colored horse, use a mixture of Van Dyke Brown and Dioxazine Violet to add shadow with a No. 4 round. Use a No. 2 round and a dark mixture of Indigo and Van Dyke Brown to add shadow to the mane and eye. Horse pupils have a slightly sideways shape and are not entirely round.

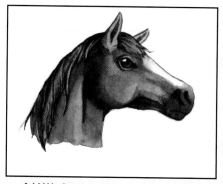

4 Add Washes
To get a deep, rich chestnut color, combine Burnt Sienna with Cadmium Yellow and lay a wash over the entire head, except for the white blaze, mane and eyes. Paint the mane and nose with a lighter mixture of Indigo and Van Dyke Brown. Paint the eye with a No. 2 round and Van Dyke Brown. Enhance the darkest shadows with a dark mixture of Dioxazine Violet and Van Dyke Brown.

Tails and Horns

A long, spiraled horn and a flowing tail braided with feathers and jewels can transform your Pegasus from a simple unicorn with wings into a magical storybook creature. There's no reason to stick with a traditional straight horn or horse tail, either—take inspiration from lions, goats, antelope or even deer. You can also add small adornments to the tail and mane. Shells, pearls, stones, feathers and other baubles are perfect details to include.

Tails

The horse's tail is not just a length of hair growing from the skin. A tailbone extends about one-third of the way down, which is what flicks the tail. Traditionally horse hair is not silky smooth like human hair, but unicorns and Pegasi are not traditional creatures! Add braids, waves and curls to the tail and make it as shiny as you like.

Lions have long, smooth-furred tails with a tuft of hair at the end, which many artists love to use for unicorns. Elaborate this tuft with long, flowing hair and make it as long as you want.

Braids are very easy to draw. Start with two parallel lines, and draw a lowercase y at the bottom. Continue drawing y shapes to the top, and then flesh out the braid with rounded curves and hair texture. Be sure to curve your diagonal lines slightly.

Horns

Just like for dragons, you're not limited to one traditional type of horn for your winged Pegasi. The spiral horn is a beautiful classic for unicorns, but you may find other styles that suit your own creations better.

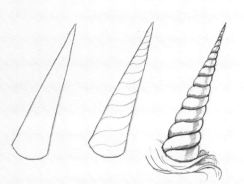
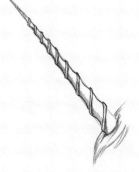

Create a spiral horn by drawing a basic, sharp cone shape, then draw S curves along the horn. Finish by adding curves at the end of each spiral and deepening the shadows within the curves.

You can create a variation on this horn by adding a raised ridge along the spiral.

Horns don't have to be straight or pale, either. This dark, curved horn is just one of many possibilities.

Visit www.impact-books.com/wingedfantasy for free bonus content.

73

Ready for Battle: Winged Warrior

This Pegasus is adorned with gleaming horse-armor for both protection and attack. This Pegasus isn't the delicate, pale creature we typically think of, but strong, brave and not afraid to get its hooves dirty! We will give this warrior a reddish brown coat to create a beautiful contrast of warm brown against the bright blue of the sky.

MATERIALS LIST

Paper: cold-pressed watercolor paper

Brushes: Nos. 2, 4 and 6 rounds, ¾-inch (19mm) mop, old toothbrush

Paint: Burnt Ochre, Burnt Sienna, Cadmium Yellow, Caput Mortuum Violet, Cobalt Blue, Cerulean Blue, Dioxazine Violet, Payne's Gray, Raw Umber, Sepia, Ultramarine Blue, Ultramarine Violet, Van Dyke Brown, Viridian

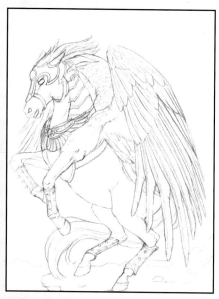

1 Draw the Pegasus
Start by drawing your Pegasus. Choose a challenging pose. A Pegasus standing calmly on all four hooves in the grass certainly wouldn't be as exciting as one leaping into the air from the edge of a cliff! For its armor, think not only about design, but functionality, and pay attention to how it would let the Pegasus move.

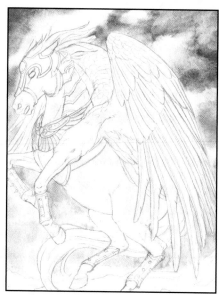

2 Sky Wash
Using a ¾-inch (19mm) mop brush, lay a wash of water in the sky, avoiding the edges of the Pegasus and ground. While your paper is still wet, load the brush with Ultramarine Blue, and blot in color in the upper half of the sky. Let some white remain for clouds. Load your brush with Cobalt Blue and add this to your still-wet Ultramarine Blue. At the bottom, do the same with Cerulean Blue, since the sky is a richer blue the higher up you go. You can also take a paper towel and blot areas of the sky you want to lighten, such as in the upper right.

Pegasus Construction

When drawing wings, how big is big enough? The wings should look large enough to give your Pegasus lift, even though in the real world a horse couldn't fly even with a 50-foot (15m) wingspan! Tiny wings are cute, and look adorable on a Pegasus foal, but will look out of place on a bulky adult. On the other hand, drawing gigantic wings isn't necessary, so don't feel like your composition needs to be determined by how you can fit a pair of giant wings on your paper! Find a good balance and see what looks right to you.

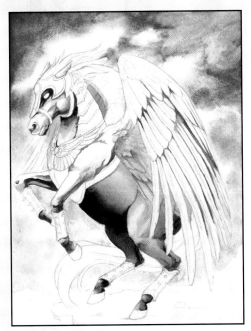

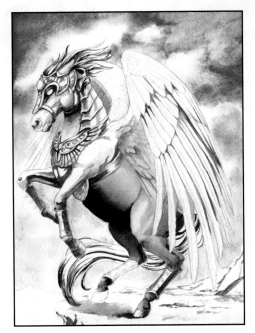

3 Shading the Body and Wings

After the sky is completely dry, begin shading the body of the Pegasus with a mixture of Caput Mortuum Violet and Dioxazine Violet. For areas such as the belly, wet the paper lightly with a No. 6 round and make sure to use a concentrated mixture for the very bottom. The color will get lighter as your brush loses pigment. It's okay if the transition doesn't end up perfectly smooth—horses aren't perfectly smooth anyway!

Continue to shade the rest of the body. As your washes dry, go back with the tip of your No. 6 round and add deeper shadow to folds and crevices, such as in the tendons in the legs. For the wings, lay a very light wash of Ultramarine Violet mixed with a little Sepia on the underside of the wings. Use a darker mixture to add shadows to the feathers.

4 Adding Shadow Details

For the bronze armor, use concentrated Van Dyke Brown and the tip of a No. 2 round to paint in the crevices, with a lighter wash for the details. Switch to Payne's Gray for the details on the silver of the chestplate wings. This fine brush is also good for adding some dark strands to the mane and tail, as well as shading the hooves, using a mixture of Sepia and Payne's Gray. Add some crevices to the cliff and a bit of shadow under the Pegasus with this dark mixture. Use Sepia and a No. 4 round for shading the leather of the leg guards and armor straps.

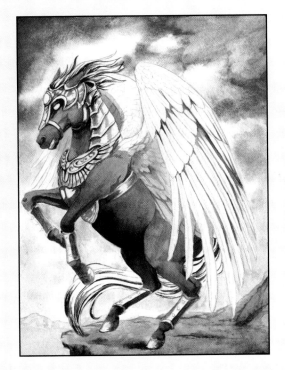

5 Adding Color to the Body, Cliff and Background

With a No. 6 round, add Burnt Sienna mixed with a little Raw Umber to the horse's body. After this layer is dry, make sure your brush is clean and put a wash of clean water on the cliff. Then randomly brush in some Ultramarine Blue, Raw Umber and a little bit of Burnt Sienna onto the wet paper. Because the rock of the cliff is textured, you want it to be a bit blotchy and imperfect.

After your cliff is dry, use water and your No. 4 round to wet the paper where the background mountains and ground are, and lay in a very light wash of Cobalt Blue mixed with a little Dioxazine Violet. Let dry, and then paint the hills with a very light mixture of Viridian and Dioxazine Violet, going slightly darker the closer to the foreground you get. Once dry, you can go back and add some light shadows to the mountains with Cobalt Blue and Dioxazine Violet.

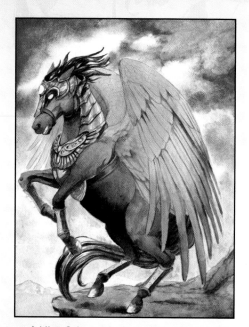

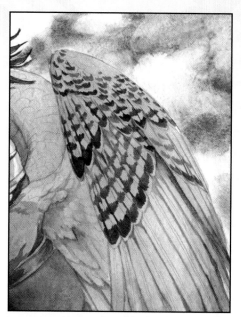

6 **Adding Color to the Rest of the Horse and Armor**
With a mixture of Burnt Sienna and Raw Umber, lay a wash down for the outer wings with a No. 6 round. While the paint is still wet, go back with a little Sepia and a No. 4 round on the tips of the flight feathers to make them gradually darker. For the inner wings, use a light wash of Raw Umber. Paint the mane and tail with a No. 4 round and a mixture of Sepia and Payne's Gray. Make sure to leave some white for highlights.

For the armor, use a mixture of Cadmium Yellow and Burnt Ochre to paint the bronze neck plates and chest plate, leaving white for highlights. Use a more concentrated mixture for the edge borders of the armor. For the winged breast plate, use a wash of Cerulean Blue to give it a silver look.

7 **Starting the Feather Markings**
To paint in the barred markings on the feathers, use your No. 4 round and a mixture of Van Dyke Brown and Sepia to paint a thicker bar at the base, then paint thinner bars the higher up the feather you go. Remember to leave a little space between the base bar and the tip of the feather.

Metal Painting Tips

Being shiny, metals reflect light and color. One mistake artists make is only painting gold with a yellow paint, or painting silver with a basic gray. If your metal is next to something colorful, a bit of that color will reflect onto the gold. If you have light shining on your gold, sometimes it will cast a bit of yellow light. Silvery metals, such as silver and iron, have a bluish tint, but reflect light and color just the same.

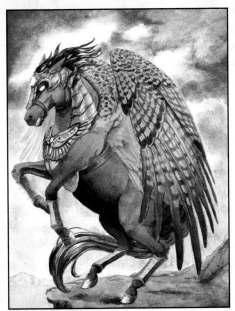

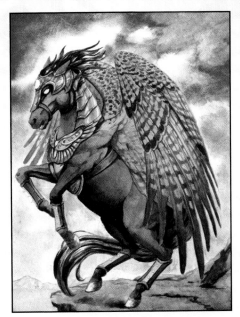

8 Paint the Feather Markings

Continue to paint the feather markings on the outside of both wings, using your Van Dyke Brown and Sepia mixture and a No. 4 round. The sharp tip of your No. 4 round is good for painting thin detail around the central shaft of the feather on the primary feathers. For the inner wings, a light wash of Sepia is good for the markings. Remember, the markings on the inner wings are lighter than those on the outer wings.

9 Deepen the Shadow Details

For the body, use a No 4. round to deepen the shadows with a concentrated mixture of Dioxazine Violet and Sepia. Focus on the darkest shadows, such as where the horse's head overlaps the leather strap. Deepen the shadows of the muscles, using clear water to blend the darker mixture. Use this mixture for the shadows on the wings and bronze armor as well. Sepia mixed with Payne's Gray is good for darkening the shadows of the silver metal, the tail and the cliff.

For the inner wings, use a light wash of Sepia to further define the feathers. Add a bit more muscle definition to the face, front legs and where the wing attaches to the body with Van Dyke Brown and Dioxazine Violet.

Equine Armor

Armor Dos and Don'ts:

- Don't create solid tubes or sheets of metal over joints. A solid piece of metal over the chest is fine, but it shouldn't interfere with the shoulders or neck. The same goes with legs. Armor needs to bend with the horse.

- Don't create floating armor. Your Pegasus needs to be able to fly and fight without its armor falling off! Think about how the armor would stay on with heavy movement. In the neck armor example, the armor is held on with a bridle on the head and a leather strap at the bottom of the neck. Clip-on armor will look like an adornment instead of a protective covering.

- Do decorate your armor with carvings, jewels and designs, or even simple ridges or studs. Armor doesn't have to be plain metal or leather; little bits of color in the armor can enhance the story your painting is trying to tell.

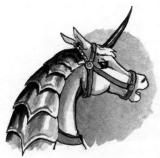

Neck armor needs to be very flexible, because horse necks have a very wide range of motion. A straight, solid sheet of metal would render a Pegasus unable to move, which would certainly be a problem for a warrior! When designing armor that needs to move, create segmented sheets.

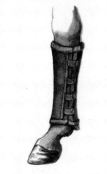

You can protect your Pegasus' legs with leg armor. Leg wraps are used for real horses to prevent or heal injuries and are short enough that they never interfere with the knee or fetlock.

Visit www.impact-books.com/wingedfantasy for free bonus content.

77

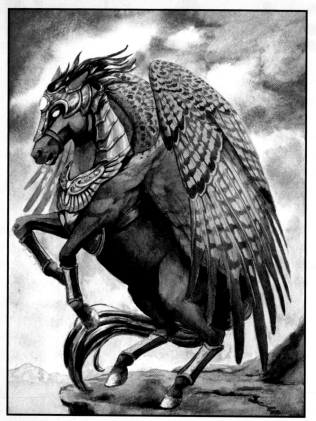

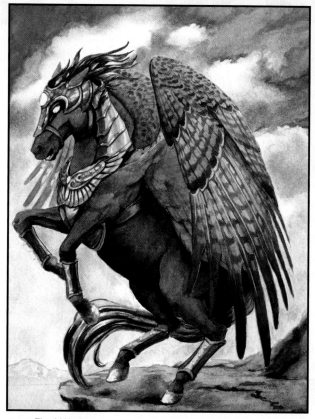

10 Final Shadows

Add shadow from the wings to the belly and rear leg with a No. 6 round and a mixture of Van Dyke Brown and Dioxazine Violet. Blend out into the lower part of the belly and leg to avoid getting a hard line. For the underwings, use a light wash of Sepia mixed with a very small amount of Payne's Gray. Use a darker mixture of Sepia and Payne's Gray with a No. 4 round to darken the shadows of the tail closest to the body and to paint the inside of the mouth and the cliff shadow beneath the Pegasus.

On the cliff, a simple mixture of Ultramarine Blue and Sepia will let you darken areas of the rock. Add a little more shadow to the bronze armor with a light wash of Ultramarine Violet, and use Van Dyke Brown to add shadow to the leather straps.

11 Final Washes

With a mixture of Burnt Sienna and Raw Umber, use your No. 6 round over the horse's entire body to make its coat bright and rich. Use the same mixture on the outer wings. For the long primary feathers, use a little Raw Umber at the base of the feathers while the paper is still wet. Because metal reflects, adding a little Burnt Sienna in the bronze armor will let it reflect the color of the Pegasus.

To finish the sky, use a light wash of Cerulean Blue with your No. 6 round. Use a little Cobalt Blue around some of the clouds to harden the edges, and use a paper towel to soften the other edges.

12 Final Details

Paint the eye with a No. 2 round and Van Dyke Brown, while leaving a small circle of white for the highlight. Dab a bit of concentrated Payne's Gray on the top and blend down. With a bit of Viridian, paint around a highlight in the jewels on the armor, and blend a bit to soften the bottom highlights. For the spikes on the leg guards, use Payne's Gray with the tip of your No. 2 round, then add a few stray strands of mane and tail with this color. Lift some paint off the face and legs to create highlights.

Load an old toothbrush with a mixture of Sepia and Payne's Gray. Use your thumb to splatter the paint on the cliff to create rock texture, then lift the paint using a No. 4 round to create more value in the rock. Complete the background hills with another light layer of Viridian and Dioxazine Violet. Finish the painting by adding a bit of feather detail with Van Dyke Brown and Sepia and a No. 2 round to the feather bars. Add just a little extra shadow to the underwings and the upper wings.

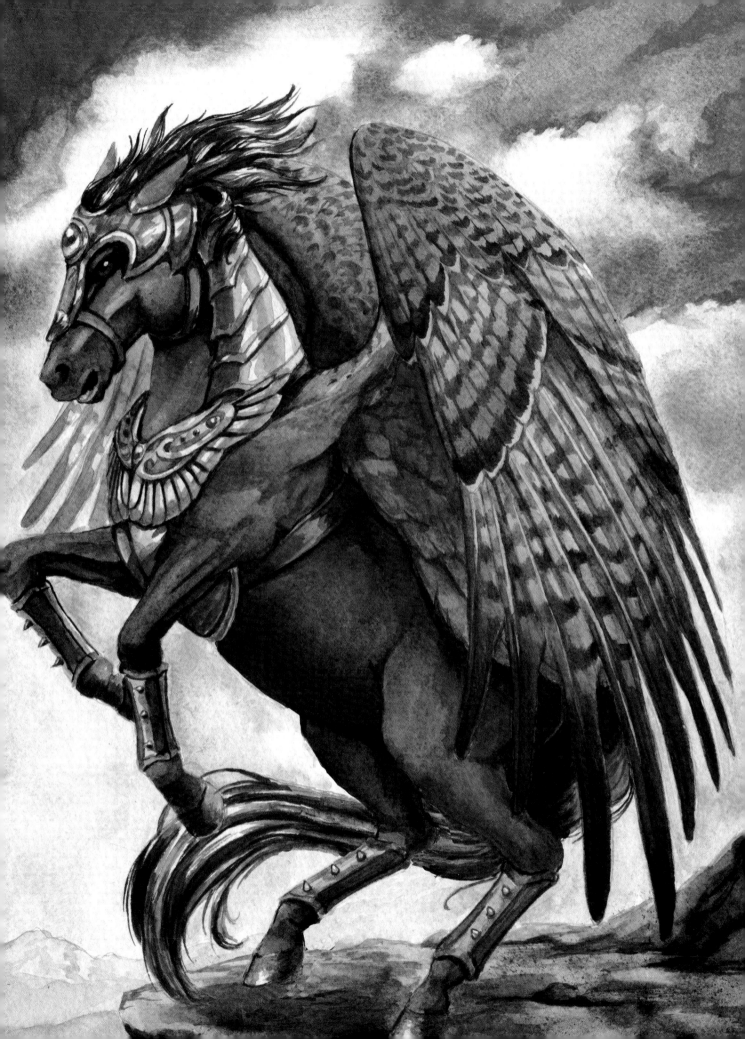

Northern Lights: Arctic Unicorn

At home in the frigid northern lands of snow and ice, the arctic unicorn has a thicker body than the typical unicorn and strong, feathered legs. This unicorn is based on the powerful form of a draft horse with a large, barrel-like chest and thick neck. A creature like this not only survives in the bitter cold and biting winds of the blizzard-stricken plains, but also draws its power from the land through its ice-like horn. This frigid habitat is the one place it truly calls home.

In this painting, with a white creature soaring above moonlit, snow-covered mountains, you will discover how to paint white without using gray. There are many colors that go into shading white, and by utilizing a dark background, you can really make this pale unicorn stand out.

MATERIALS LIST

Paper: hot-pressed watercolor paper

Brushes: Nos. 2, 4, 6 and 8 rounds

Paint: Burnt Umber, Cerulean Blue, Cobalt Blue, Dioxazine Violet, Indigo, Naples Yellow, Payne's Gray, Phthalo Green, Prussian Blue, Quinacridone Rose, Ultramarine Violet

Other materials: paper towel, white gel pen, white gouache

1 Draw the Unicorn

Because this unicorn is flighted, the position of the legs serves as a running start; doing a bit of research on cantering horses will make your legs look more natural, even when your unicorn is in flight. The wings are in midflap and bent slightly, so keep this in mind when adding your feather layers. Draw some icy mountains lightly in the background. By drawing the line of the mountains at an angle instead of straight across, you add some movement in an otherwise straight and static composition.

2 Paint in the Background Wash

With a No. 8 round, lay down a wash of clear water over the sky and the farthest mountains, then load your brush with Prussian Blue and paint a wash on the entire section of wet paper. While your wash is still wet, paint in irregular washes of Quinacridone Rose along the top and a wash of Phthalo Green at the bottom. Use a No. 4 round to push the paint into narrow areas, such as between the feathers. Take a paper towel and wipe away some of the paint around the horn to create an aura effect and in the sky to suggest the northern lights.

3 Paint the Mountains

Once your sky is completely dry, use a No. 6 round to paint a loose layer of Cerulean Blue for the middle layer mountains, and while still wet, go back with a No. 4 round and paint shadows with Cobalt Blue. Painting down in an angle from top right to bottom left will give an angle to your mountains. Once this layer is dry, paint the closest mountains using a No. 6 round and Cerulean Blue, but leave the lightest areas completely white, and add shadows with Prussian Blue. Because they are closer, they will have greater contrast than the mountains behind.

4 Add Base Shadows to the Unicorn

To keep the coat looking white, you will want to create very soft shadows. Do this by using a No. 6 round and a wash of Cerulean Blue, Burnt Umber and Ultramarine Violet mixed together. Paint in the darkest shadows, and then with a slightly damp brush, wet the edges and blend into the white. You may find you get areas that are more blue or more purple or more brown. This is okay. The variation in color will make it look more like a pearlescent shadow for the unicorn's white coat. Keep layering; as your first layer dries, deepen the shadows with another layer of your three-color mixture, going darker as needed. Switch to a No. 2 round to add this same mixture to the mane and tail.

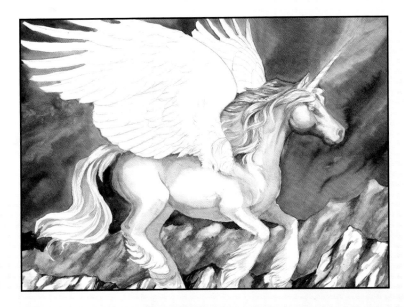

5 Add Base Shadows to the Wings

Use the same mixture of Cerulean Blue, Burnt Umber and Ultramarine Violet and a No. 4 round to add shadow to the wings, keeping in mind where the bent wing would create a shadow.

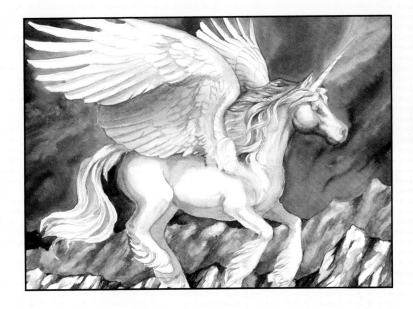

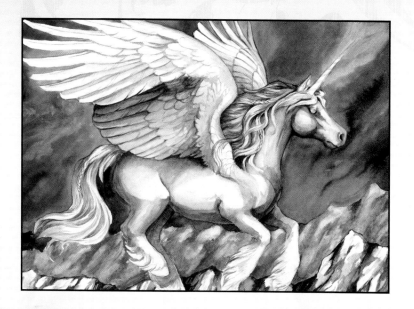

6 Deepen the Shadows

For the secondary feathers, use a No. 2 round and Indigo to paint in the darkest shadows. Go over these shadows with a bit of your Cerulean Blue/Burnt Umber/Ultramarine Violet mixture to blend them in with the rest of the feathers, and add Indigo to other feathers to add shadows. You don't have to add deep shadow to every single feather; adding it to a select few will make the feathers look soft rather than ruffled.

For the body, mane and tail, deepen the shadows with Cerulean Blue mixed with Ultramarine Violet, and use a bit of Indigo with a No. 2 round for the darkest sections.

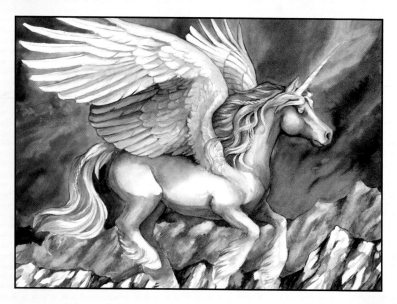

7 Add Warm Colors and Smooth the Shadows With White Gouache

Adding some warm colors to your unicorn will separate it from the monochrome blue of the mountains, but glazing browns or pinks over the blues and purples you used to shade the body will result in mud. Using white gouache will not only create a semi-opaque layer that your colors sit on top of, but it will also smooth your shadows and make your unicorn look softer.

Use a No. 6 round and mix Burnt Umber with Quinacridone Rose and some white gouache. Paint this over your shadows. You may think it looks too opaque or too bright, but remember: white gouache always darkens, and when it does, you will still see the shadows beneath. If you paint too thick with the gouache, you can easily lift it by wetting it again. Use a No. 2 round and this mixture to add color to the mane, tail and small feathers.

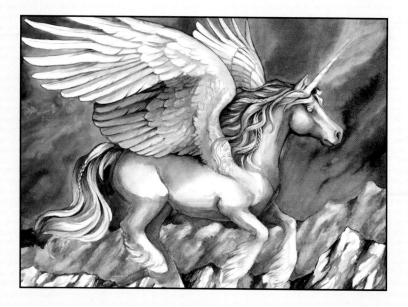

8 Add Mane, Tail and Feather Details

Use a No. 2 round and paint details into the mane and tail with a mixture of Dioxazine Violet and Burnt Umber. Focus on the darkest shadows and blend out to add contrast and texture to the hair. For the wings, add detail around the feather edges with this mixture, and use Payne's Gray in the deepest shadows.

9 Face and Horn Details

With your No. 2 round, use Payne's Gray to paint detail around the eye and for the eyelids, nostril and mouth. Paint an outline of concentrated Prussian Blue for the eye, then wet your brush and blend the blue toward the center of the eye, leaving a white highlight. For the horn, use your No. 2 round and paint the horn in sections: for the base, use a mixture of Quinacridone Rose and Prussian Blue, going to pure Prussian Blue in the center, then gradually mixing Phthalo Green until you reach the tip of the horn. Blend the paint with a wet brush to soften the edges.

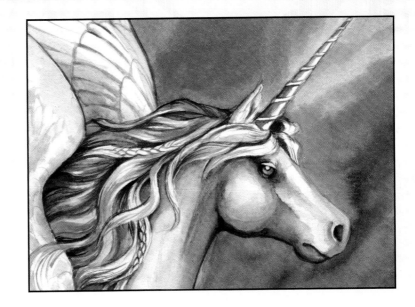

Painting White

The first mistake many artists make when painting white objects with watercolor is to use gray for the shadows. Plain gray shadows, using a gray paint such as Payne's Gray or Ivory Black, look very artificial and flat. The shadows of white objects are always tinted with a little color, even if it is very subtle. By adding a bit of color to your shadow, you can make that object or creature look more alive.

The feathers on the left are shaded with Raw Umber and Burnt Sienna, with a little Cerulean Blue. The darkest shadows are Indigo, and I used a little Viridian Green for extra color. The feathers still look white, but vibrant. The feathers on the right, however, only contain Payne's Gray, and they look dead and lifeless.

Blue Shadows
Snow and ice often have blue or purple shadows. Cerulean Blue mixed with Ultramarine Violet creates a good snow shadow.

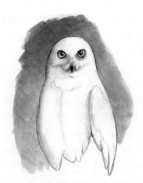

Yellow or Brown Shadows
Animals with a white coat often have buff shadows, which is a pale brown or yellow. I shaded this snowy owl with Raw Umber mixed with a little Van Dyke Brown, and used a light wash of Indigo for the far left shadow.

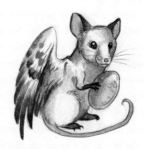

Reflected Colors
White objects will often reflect colors very close to them. This little white mouse has shadows of Raw Umber and Ultramarine Violet, with a little Indigo, and Sap Green reflecting on its chest from the tidbit it holds in its paws.

Visit www.impact-books.com/wingedfantasy for free bonus content.

83

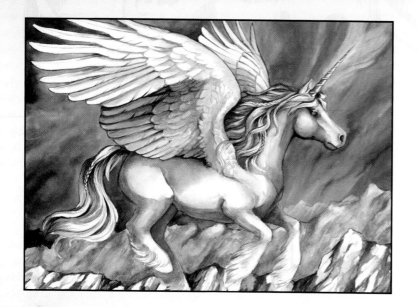

10 Background Details
Begin painting in the northern lights with a No. 6 round and white gouache tinted with Phthalo Green at the bottom, extending upward. At the top, mix Quinacridone Rose with the white gouache and create waves around the horn. The more white gouache you use, the more milky your sky will look. Lay a light wash of white gouache over the middle layer of mountains, then go back with Cobalt Blue and push the shadows. Paint in some very pale mountains behind them with pure white gouache and a No. 4 round.

11 Final Details
With a No. 6 round, add a final shadow beneath the unicorn and under the wing with Cerulean Blue, and add a very light wash of Naples Yellow in some of the highlight areas on the body and wings. Paint the hooves with a No. 2 round and a mixture of Payne's Gray and Burnt Umber, then use this mixture to add some dark shadows around the body and wings. Take a white gel pen and add a few stars in the darkest sections of sky, and put some sparkling magic around the horn. Finish the mane, tail and hooves by drawing some stray strands of hair with the gel pen.

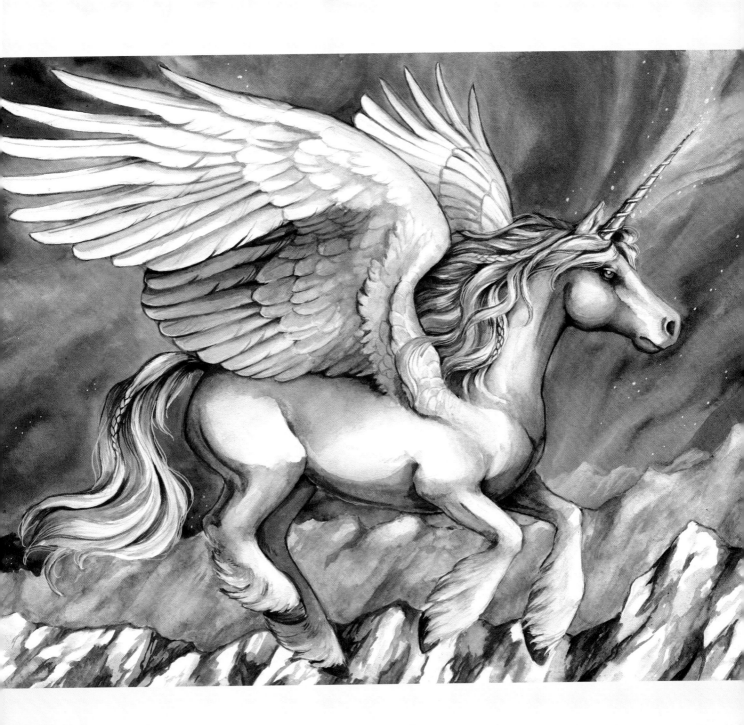

Learning to Land: Zebra Winged Unicorn

In the African savanna, these zebralike winged unicorns with antelope horns are surprisingly hard to spot in the grasses, but a little easier to see when soaring against the blue sky. This mother unicorn has already taught her foal the basics of how to fly, but now comes the hard part—learning how to land! This youngster is a little unsure of how to come back down, but his mother is there to guide him and make sure his landing isn't too rough.

MATERIALS LIST

Paper: illustration board

Brushes: Nos. 2, 4, 6 and 8 rounds, ½-inch (13mm) flat, ¾-inch (19mm) mop

Paint: Burnt Ochre, Burnt Sienna, Cadmium Yellow, Cerulean Blue, Payne's Gray, Phthalo Blue, Raw Umber, Sap Green, Ultramarine Blue, Ultramarine Violet, Van Dyke Brown

Other materials: paper towel, white gouache

1 Draw the Winged Unicorns and Background
While the mother unicorn is confident in her landing ability, her child is still learning the coming back down part, so be sure to show this in their body language. The parent is relaxed and gracefully gliding down, wings outspread, while the foal is slamming on the brakes and flailing his hooves in every direction! Foals have long, spindly legs and short tails, so their lankiness adds to the feel of this particular youngster's unsure landing. The African savanna is a vast expanse of grassland with sparse, thin trees, so add a few trees and bushes to break up the scenery.

2 Paint a Background Wash
With a ¾-inch (19mm) mop, wet the foreground with clear water and switch to a No. 8 round to paint clear water in the background grass. Use the No. 8 round to paint Burnt Ochre on the wet board, then go back with Cadmium Yellow to paint random sections in the foreground. Leaving an uneven wash will make your grass look more natural when you begin to paint. For the trees, blot in Sap Green and use Ultramarine Violet for the shadows on the still-wet paint. Use a lighter wash for the background trees.

3 Begin Painting the Grass

The trick with painting grass is to not only paint the positive space (the object), but also to paint the negative space (the area around the object). Look where your blotchy wash has left light areas and dark areas. Keep the light areas as brighter blades of grass and paint the area around them, and paint darker blades of grass in the darker sections. Start with a No. 2 round and paint a mixture of Burnt Sienna and Van Dyke Brown for the darkest negative space around the blades of grass, then blend with water. For the areas around the blades of grass above, use Burnt Ochre mixed with Raw Umber. Paint the darker blades of grass at the bottom with Raw Umber.

4 Continue Painting the Grass

Using the same technique as before, find the light and dark areas in your initial wash and paint in the grass. Remember that the grass in the foreground will be longer and more defined than the grass farther back, and the background grass will have only a hint of texture. By exaggerating darker areas with washes of Burnt Sienna and Van Dyke Brown, you will make the grassland look dimensional instead of like a flat blanket of grass. Add washes of Cadmium Yellow in areas to push the color in the foreground.

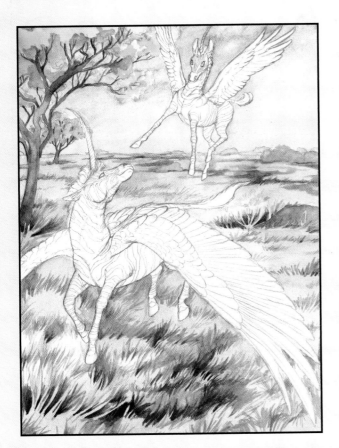

5 Add a Base Wash to the Tree, Rock and Sky

With a No. 4 round and a mixture of Ultramarine Blue and Raw Umber, add a base wash to the tree trunks and rock; lift with a paper towel for lighter areas. Use a ½-inch (13mm) flat to lay a gradual wash of Cerulean Blue in the large sky to the right, going lighter as you approach the horizon. Switch to a No. 6 round for the sky around the tree. While still wet, switch to Phthalo Blue and lay a very light wash at the bottom of the sky. Lift clouds from the top of the sky with a paper towel. Soften the edges of the clouds with white gouache. When the sky is dry, go back with a No. 2 round and your Ultramarine Blue and Raw Umber mixture to add more thin branches to the tree.

Painting Grass and Fields

Many artists think the only color that needs to go into painting a grassy field is green. Though green is usually the dominant color in a lush field, in reality other subtle colors are mixed in there. The ground is never completely smooth, and grass is even less so. In this grassy hill, painting in shadows suggests the presence of slight divots and inclines. The grass should be more yellow closer to the viewer, and more blue farther back. Add some yellows and browns to your grass, especially in the foreground.

Permanent Green blended with Hooker's Green at the top

Viridian Green

Phthalo Blue for the darkest shadows

Hooker's Green

Burnt Sienna

Cadmium Yellow

Paint blades of grass in the foreground with Hooker's Green

1. If you're drawing an up-close scene on the ground, be creative with what's among your grass. Fields rarely have only grass and can include clover and small flowers. Add a rock or two to create a mouse-eye landscape!

2. Use various greens for the grass. Alternate between Sap Green, Permanent Green, Cadmium Yellow and mixtures of each. A rich brown such as Burnt Umber works well for the ground, and mixing brown and blue makes a good, rich gray for the rock.

3. When your grass is dry, paint the background grass a dark green, such as Hooker's Green, and add Prussian Blue at the bottom while still wet.

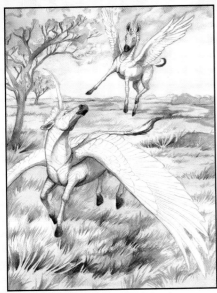

6 Add Shadows to the Winged Unicorns

Using a No. 6 round and a mixture of Van Dyke Brown and Ultramarine Blue, begin painting light layers of shadow on the underside of the winged unicorns' bodies. You want this shadow to be slightly more brown because the bright yellow-brown grass is reflecting on the white of their hides. The shadows on their bodies cast by the wings can be slightly more blue, using a bit of Cerulean Blue. Paint the black muzzles, tail tufts and hooves with a mixture of Payne's Gray and Van Dyke Brown.

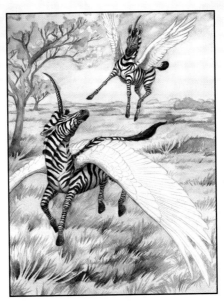

7 Paint the Stripes and Horn

For the black stripes, use a concentrated mixture of Payne's Gray and Van Dyke Brown with a No. 2 round. Remember that even these dark stripes have value, so use a darker mixture for shadowed areas, such as under the belly and under the neck. Extend the stripes to the mane and paint the tail tuft black. Use this same mixture and brush to paint the horns, placing a dark shadow on each twist line of the horn, and then painting a light wash on one end. Keep the middle white for highlight.

8 Begin Painting the Wing Stripes

True to their black-and-white coloration, these zebra winged unicorns have stark black-and-white wings. Start by painting a broad bar at the tip of each primary feather with a mixture of Payne's Gray and Van Dyke Brown using a No. 2 round, and paint a line where the shaft of the feather would be. Then paint thinner stripes along each feather, and do the same with the coverts.

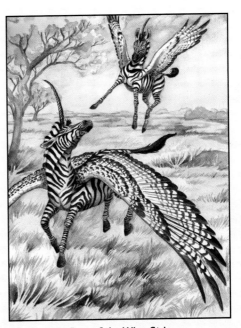

9 Paint the Rest of the Wing Stripes

Continue painting the wing stripes with the same mixture and brush as before. Add detail to the white feathers with a mixture of Ultramarine Blue and Raw Umber.

Visit www.impact-books.com/wingedfantasy for free bonus content.

89

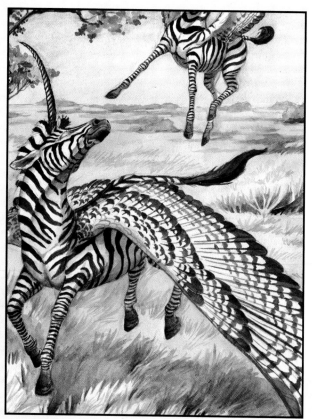

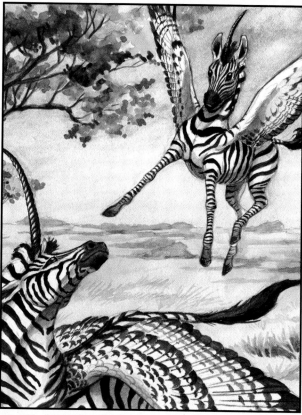

10 **Add Final Details to the Trees and Ground**
With a dark mixture of Payne's Gray and Van Dyke Brown, paint details on the rock and closest tree with a No. 2 round. For the leaves, darken the shadows with a mixture of Sap Green and Ultramarine Violet and a No. 8 round, then add more definition to the lighter branches with a light wash of Sap Green and Burnt Ochre. Do the same with the background trees, but with looser washes. Add a slight shadow under the mother unicorn with a very light wash of Van Dyke Brown mixed with a small amount of Ultramarine Blue and a No. 8 round.

11 **Final Head Details**
Paint the eyes with Van Dyke Brown and a No. 2 round, using a dark mixture of Payne's Gray and Van Dyke Brown for the pupils and area around the eyes. Touch up the nostrils, mouths and ears with this mixture, and use a light wash of Van Dyke Brown over the muzzles and horns to make them a bit more brown.

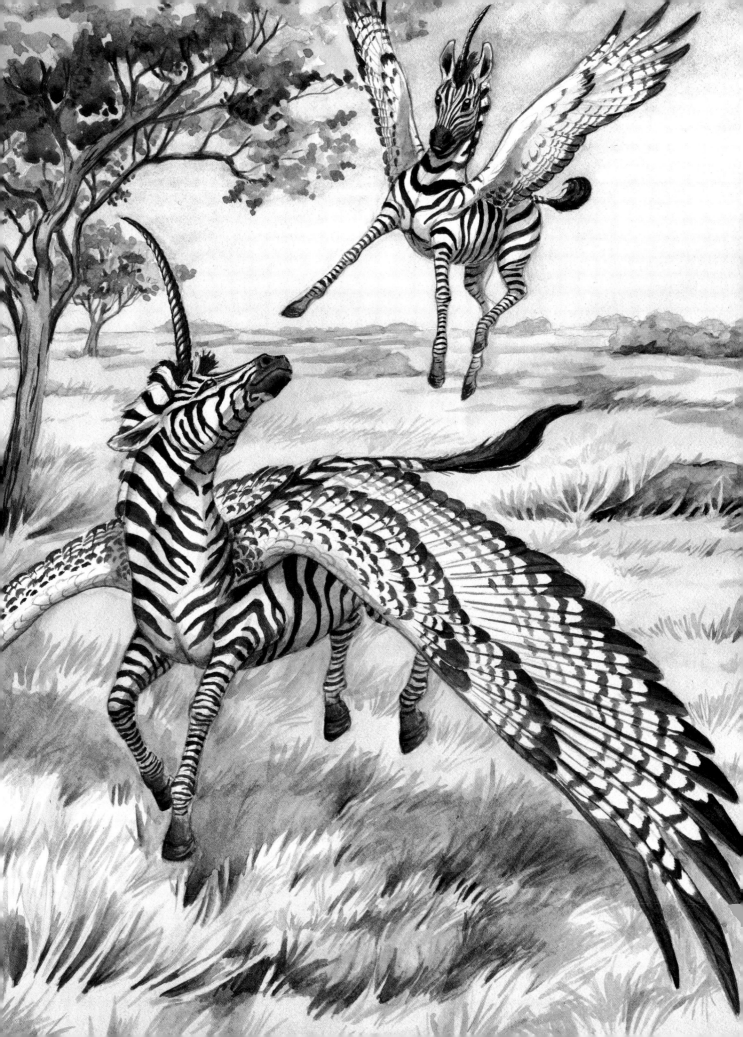

5

Winged Animals

Any real creature, be it a cat, dog, deer, elephant, fish or platypus, can be made fantastical with wings, but a painting is more than just an image. A good painting is visually pleasing, but an excellent painting also tells a story. Why do your animals have wings? What is their story? What tale are you trying to tell with your soaring salamanders and fluttering ferrets? After you have your story in your imagination, your artwork will come to life and transform from a simple portrait to an illustration.

Like mythological creatures, you can give real animals personality with facial expressions and body language. In this chapter, you will learn how to draw winged animals so you can tell your story, focusing on how to draw heads and bodies in a way that brings a bit of otherworldly intelligence to otherwise normal creatures.

Feline and Canine Anatomy

Cats and dogs have been human companions for millennia, with cats appearing in Egyptian art as fellow hunters, companions and even goddesses. Dogs helped ancient humans with everything from hunting to guarding, and of course were a loveable pet. It's only fitting that they also have a place in our fables and stories, from centuries past to modern day.

If you have a cat or dog of your own, it's easy to study their anatomy up close. Knowing their basic structure will help with constructing certain poses and angles, especially since references of flying cats and dogs are a bit difficult to come by! Though these anatomy tips focus on domestic cats and dogs, the anatomy is very similar for wild felines and canines.

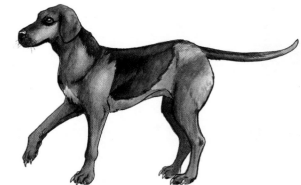

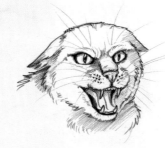

An angry, hissing cat will have its ears pinned back and its teeth barred, often showing the lips and gums. The brows furrow together and down, causing the skin to bunch on the nose and between the eyes.

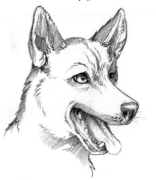

When a dog's mouth is open, usually only the bottom canines and other teeth are visible. Its tongue will sit on top of the canines or fall to the side.

Use basic shapes for the face. Use a circle for the head and eyes, and triangles for the ears and nose. Long-haired cats tend to have wider heads because of their fur, and short-haired cats have rounder faces.

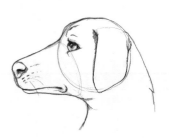

To draw a dog's head from the side, start with a circle, then draw a rectangular shape for the muzzle. The ears typically have an overall triangular appearance. Unlike cats, dogs have looser mouths that sag at the edges.

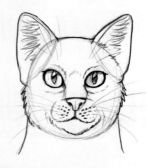

Cat claws are actually an extension of their outermost digit. For a human, it would be as if part of our fingertip (the bone, not just the fingernail) was a claw.

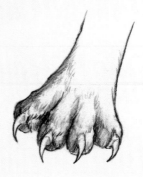

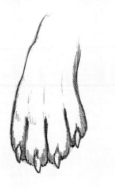

Unlike a cat, dogs can't retract their claws, so they are always visible. Though they can grow long, they are not sharp like a cat's.

Painting Fur

For fur, simpler is often better. Painting every strand of fur is usually unnecessary and can make your creature look overworked. Drawing simple tufts of fur or painting fur only on a ridge or fold of skin looks more natural. Unless we are studying an animal up close, we usually don't see every single piece of fur, but rather the overall coloration and texture. Keep this in mind when you paint, and think about where adding detailed fur is complementary to the overall design.

Painting Smooth Fur

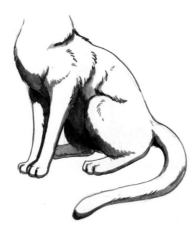

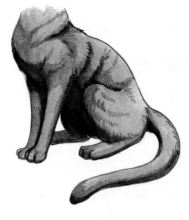

1 Sketch the Overall Shape
Even if an animal has a smooth coat, fur is visible in areas such as curves, joints and folds in the skin. Painting a perfectly smooth coat without any ruffles of fur will make your creature look less furry and more like a wet seal.

2 Paint the Shadows
Add your shadows, putting the darkest shadows where you have folds, such as on the bend of the leg. You can use lighter shadows for the general fur texture along the body.

3 Add Color and Texture
For orange fur, paint a base layer of Burnt Ochre, then paint in Burnt Sienna to enhance the shadows and fur. Adding a few more short ridges of fur creates texture, but still makes the animal's coat look short.

For more on fur textures and patterns, go to www.impact-books.com/wingedfantasy.

Painting Rough Fur

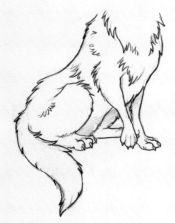

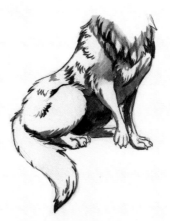

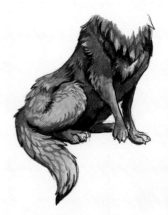

1 Sketch the Overall Shape
With rough coats, often the fur isn't a uniform length all around. Fur around the neck and tail tends to be longer than fur on the body. Remember that fur changes direction on an animal's body. So when sitting, the tufts of fur will follow the leg.

2 Paint the Shadows
Unlike smooth fur, with rough fur you want to paint your darkest shadows under the longer tufts of fur. Make the mane of fur around the neck even fuller by pushing the shadows.

3 Add Color and Texture
Add a base color, then a secondary color to enhance your fur texture. In this case, Cerulean Blue is the base color, and Cobalt Blue is the secondary color. Fur tends to gather in small tufts or clumps, and adding a few of them can make your fur look longer and more textured.

Moonlight Guard: The Winged Wolf

Though they are among the apex predators in the aerial food chain, this pack of winged wolves needs to be ever vigilant against the nighttime attacks of other hunters. Particularly with the pack's pups sleeping peacefully in their cliffside den, the pack's night guardian must be constantly alert for any threats toward their most vulnerable members.

MATERIALS LIST

Paper: cold-pressed watercolor paper

Brushes: Nos. 2, 4, 6 and 8 rounds, old toothbrush

Paint: Burnt Sienna, Cadmium Yellow, Dioxazine Violet, Hooker's Green, Indigo, Naples Yellow, Phthalo Blue, Prussian Blue, Raw Umber, Sap Green, Ultramarine Blue, Ultramarine Violet, Van Dyke Brown

Other materials: white gel pen, white gouache

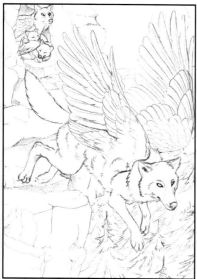

1 Draw the Wolves and the Scene
If wolves had wings, likely their den would be somewhere up high, so a cliffside den makes a good, dynamic setting for your wolf to leap from. Draw the moon in by using a compass or tracing a small, round object such as a bottle cap. When drawing the cliff face, it may help to lightly shade in the shadow with your pencil to establish the rock planes. Keep in mind which direction the light is coming from (the moon) to help you with your shadows.

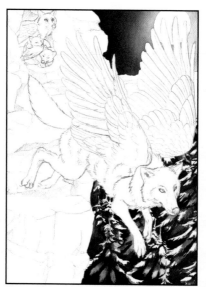

2 Paint the Sky and Tree Shadows
Wet the sky with a No. 8 round and clear water. Start with the sky farthest from the moon and paint a wash of Phthalo Blue, getting lighter as you go closer to the moon. Switch to Prussian Blue, and while the wash is still wet, paint and blend halfway to the moon. Finish with a small amount of Dioxazine Violet for the darkest part of the sky.

For the trees, use a simple mixture of Hooker's Green and Dioxazine Violet and a No. 4 round, with a darker mixture for the deepest shadows. Because the moon is a single, bright light, your shadows and highlights will be sharp. Wherever a bough casts a shadow on another bough, paint a sharp shadow.

3 Paint the Darkest Cliff Shadows
Using a concentrated mixture of Indigo and Van Dyke Brown, paint the darkest shadows and crevices in the cliff with a No. 4 round, and use a No. 2 round for the thinnest cracks. Think of the cliff in three-dimensional planes, and use the direction of your cracks to suggest dimension in the rocks. A cliff is not a stepped layer of stairs; there are shelves and overhangs of rock.

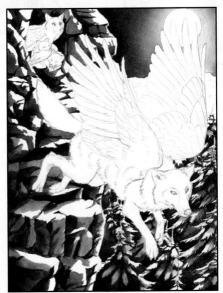

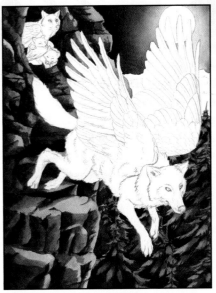

4 Add More Cliff Shadows

When you paint in the regular shadows, remember that the lightest areas will be the horizontal planes of rock, because those are the places the moonlight will hit. The farther left you go, the more the rock will be shadowed by the rest of the cliff. Use a No. 6 round and a mixture of Van Dyke Brown and Ultramarine Blue to paint in the shadows.

Work in layers. After your first wash dries, go back and deepen the darker shadows with another wash. Continue layering until you have a dimensional cliff face.

5 Add Cliff and Tree Washes

A simple wash of Raw Umber with a little Ultramarine Blue over your cliff with a No. 8 round will complete your cliff face. Paint in a bit more Ultramarine Blue in the shadows while your wash is wet; it's okay if the paint bleeds into your highlights because it will add a bit of variation to your stone color.

Paint a wash of Hooker's Green mixed with Sap Green over the trees with a No. 8 round. Use a No. 2 round to paint the topmost part of the trunk with a light wash of Van Dyke Brown once your green wash is dry.

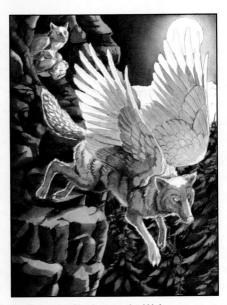

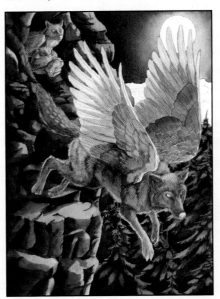

6 Paint the Shadow on the Wolves

Because the wolf is in front of the moon, most of its body will be in shadow. Paint in the shadow with a No. 6 round and a mixture of Ultramarine Violet and Raw Umber. Be sure to keep the paper white anywhere the moonlight hits, including a thin edge glow on the belly and the bottom of the legs and tail. The primary and secondary feathers, being so thin, let some light pass through. Add shadow to the areas where the feathers overlap.

After your first layer dries, go back with the same mixture to deepen your shadows, and add a bit of Indigo for the darkest shadows.

7 Begin Laying Fur Washes

Wolves have varied color coats, but this coat is the most common for the gray wolf. Lay wet layers next to wet layers so they blend together. Start with Naples Yellow and a No. 6 round for the belly, legs and inner wings, then use a Burnt Sienna and Raw Umber mixture for the side, ears and tail. Switch to a Raw Umber and Ultramarine Blue mixture for the gray parts. For the far wing, use a light wash of Raw Umber, then switch to a No. 2 round to paint the feathers with a mixture of Ultramarine Blue and Raw Umber to add variety. Do the same for the wolves in the den.

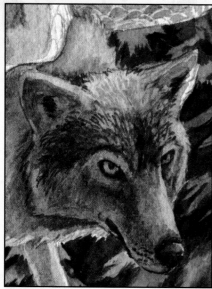

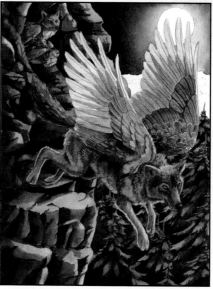

8 Paint the Face and Begin Adding Fur Details

Use a No. 2 round for detail. You don't have to paint in every single piece of fur, but on areas such as the head, you want to add texture. Short strokes on the muzzle suggest fur, which you can make darker with another wash of Ultramarine Blue and Van Dyke Brown since it's in shadow. Use Cadmium Yellow mixed with a little bit of Van Dyke Brown for the eyes. Let it dry, then use Indigo mixed with Van Dyke Brown for the pupils, area around the eyes, mouth, ears, claws and nose.

9 Finish Adding Fur and Feather Details

You only need two mixtures for the fur and feathers: Ultramarine Blue with Van Dyke Brown (for the gray fur) and Van Dyke Brown with Indigo (for the darkest shadows). You can use pure Van Dyke Brown for the buff fur and feather detail in varying concentrations, including to paint in the feather vane on the flight feathers. Because fur is so textured, you will need to go back and paint many layers at this point to deepen shadows and push highlights. Use a No. 2 round for all these details.

10 Cliff Texture

Use an old toothbrush to flick an Indigo and Van Dyke Brown mixture onto the cliff. Be sure to protect everything you don't want splattered. If you end up with big, wet splotches, you can either leave them to dry or smear them with your finger—unusual textures and spots will make your stone look more realistic.

Switch to white gouache and flick this on the cliff except for the darkest shadows. Use concentrated white gouache and a No. 2 round to add a few highlights to the lightest area of the wolf's tail, hind legs and belly.

11 The Moon and Background

Paint the background forest with a layer of Hooker's Green and Prussian Blue. While it's still wet, paint in layers of trees with Hooker's Green mixed with Ultramarine Violet, switching to a darker mixture of Hooker's Green and Prussian Blue for the farthest layer.

Wet the moon with a No. 6 round and clear water, being careful not to go all the way to the edges because the blue of the sky will bleed in otherwise. Blot with your No. 6 round and a very light mixture of Ultramarine Blue and Van Dyke Brown. Complete the sky by drawing stars with a white gel pen.

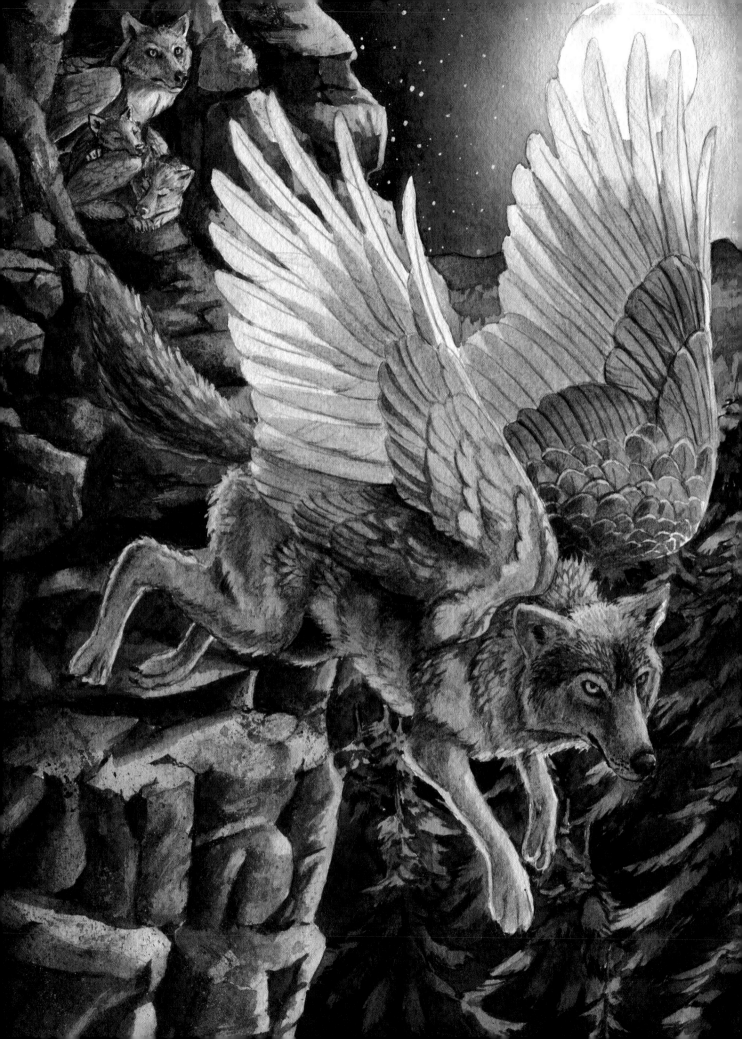

Prowl on the Wing: The Winged Cat

Usually when a cat climbs a tree, it needs help getting down, but not this kitty. In fact, treetops are its favorite vantage point to spot something fun to chase. These birds seemed to have thought they were out of range ... until they realized this feline has feathers, too! This winged cat is on the hunt during a gorgeous autumn day, with bright yellows and oranges to contrast with its fur. Try a spring or winter scene for a different variation.

MATERIALS LIST

Paper: illustration board

Brushes: Nos. 2, 4, 6 and 8 rounds

Paint: Alizarin Crimson, Aureolin Yellow, Burnt Sienna, Cadmium Orange, Cadmium Yellow, Green Gold, Indigo, Naples Yellow, Phthalo Blue, Raw Umber, Ultramarine Blue, Ultramarine Violet, Van Dyke Brown

Other materials: white gel pen

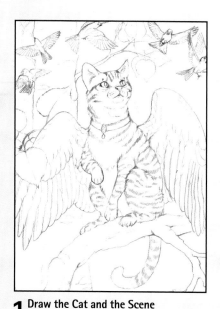

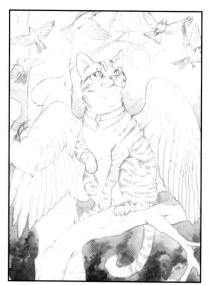

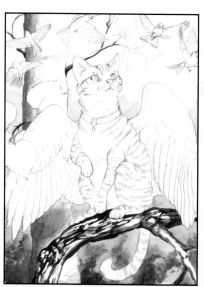

1 Draw the Cat and the Scene

When drawing a scene, remember to pay attention to the composition. It's tempting to just draw your subject and be done with it, but expanding the scene and adding other elements will make it much more interesting. The cat is front and center, so adding a tree to the left will make your background look less symmetrical and thus less static. Overlap some aspen leaves from the far tree over the cat's wing to add more depth to the image. Drawing the birds with the same outspread wings isn't very interesting; drawing them twisting in all directions suggests more movement.

2 Paint the Background Foliage

Because this kitty is going on the prowl during a bright autumn day, wet the bottom two-thirds of the background with a No. 8 round loaded with clear water, and paint the background foliage with a wash of Cadmium Yellow at the bottom. While still wet, add splotches of Cadmium Orange and Burnt Sienna at the bottom. For the topmost leaves, use Aureolin Yellow and let it blend into your still-wet Cadmium Yellow layer. Blot some stray leaves with your No. 8 round and Aureolin Yellow at the top of your background leaves.

After this layer dries, go back with your No. 8 round and brush in some leaf texture with your Cadmium Orange and Cadmium Yellow.

3 Add Tree Shadows and Texture

Because aspen trunks are white and their branches brown, shade the trunk with a mixture of Ultramarine Violet and Van Dyke Brown with a No. 8 round and blend with clear water toward the center. Add shadow to the branches with a mixture of Van Dyke Brown and Indigo, using a No. 2 round for the smallest branches. Switch to a No. 4 round to add shadow and bark texture to the branch the cat is perched on with Van Dyke Brown and Indigo. When dry, go back and add another layer of Ultramarine Violet and Van Dyke Brown to the aspen trunk.

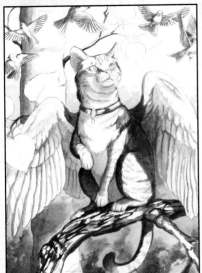

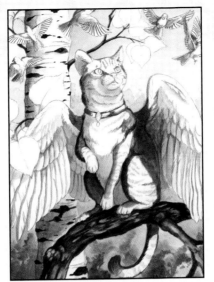

4 Add Shadows to the Cat and Birds

Use a mixture of Ultramarine Violet and Raw Umber with a No. 6 round to add shadow to the undersides of the wings, working in layers to add more shadow after your first layer dries. For the gray-brown fur, use a mixture of Van Dyke Brown and Indigo. Use this mixture for the shadows on the collar, too. Use the same Ultramarine Violet and Raw Umber mixture with a No. 4 round to add shadow to the birds, with a thicker mixture of Van Dyke Brown and Indigo to add darker shadow to the flight and tail feathers.

5 Paint Tree, Leaves and Sky

Mix a wash of Raw Umber and Ultramarine Blue for the branch, adding Burnt Sienna to areas with a No. 8 round. While still wet, take a No. 4 round and push the shadows and bark texture deeper with Van Dyke Brown and Indigo. Take this mixture to the aspen and paint the dark spots in the trunk. Go back to the white of the aspen and add a few lines in the bark with a mixture of Raw Umber and Ultramarine Violet.

Wet the sky with clean water and a No. 8 round and carefully paint in a light wash of Phthalo Blue, going lighter the farther down you go.

6 Paint Bird Details

With Van Dyke Brown mixed with a little Indigo, begin painting the flight feathers, tail feathers and belly stripes with a No. 2 round. While the paint is wet, paint Cadmium Yellow on the base of the flight feathers and the tail. Use Raw Umber for the heads and backs, leaving some white areas for plumage. Use your No. 2 round to carefully paint in a dark mixture of Van Dyke Brown and Indigo for the eyes, legs and the inside of the beaks.

Painting Cat Eyes

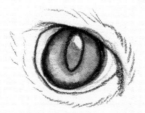

1. Although cats have a very distinct, angled eye shape, the eyeball itself is just a sphere. The surrounding skin and fur give it that shape. Start by drawing a circle for the eye, then draw the black skin around it. This extends beyond the eye and gives it the oblong appearance. Draw the brow at an angle and sketch in fur texture.

2. Paint the iris color first; otherwise the black can bleed into the eye color. Mix Green Gold with Raw Umber and paint the entire eye, but leave a small white area for the highlight.

While it's wet, take a No. 2 round and paint a ring of Burnt Sienna and Phthalo Green around the outer ring, painting thicker under the brow for shadow. Paint pure Phthalo Green around the pupil. It will bleed into the wet base layer, creating irregular edges like a real eye.

3. Let the previous layers dry. Then use a No. 2 round and a mixture of Van Dyke Brown and Indigo for the black. Paint the fur around the eye and extend the black of the surrounding eye down toward the nose.

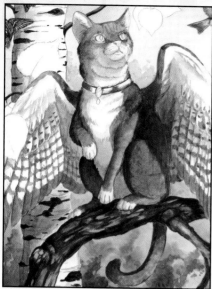

7 Add Wing and Fur Washes

Use a No. 8 round and add a wash of Raw Umber mixed with Ultramarine Blue to the body, legs, tail and head, leaving the muzzle, belly and paws white. Add a little Burnt Sienna to the nose area while your wash is still wet. Lay a wash of Naples Yellow over the shadow on the belly and wings. When dry, use a No. 2 round to paint bars on the feathers with your Raw Umber and Ultramarine Blue mixture.

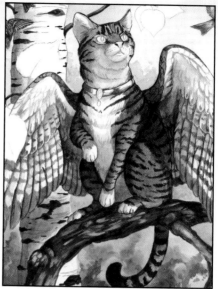

8 Paint Cat Details

Paint in the stripes with a dark mixture of Van Dyke Brown and Indigo and a No. 2 round, being sure to paint in the direction of the fur. Use this mixture to push the darkest shadows of the feathers. Add more shadows to the smaller, fluffy feathers with Van Dyke Brown. Paint a wash of Naples Yellow over the white fur and feathers with a No. 8 round, leaving some areas bare for highlights, and use a mixture of Naples Yellow and Ultramarine Violet with a No. 2 round to push some of the white feather shadows.

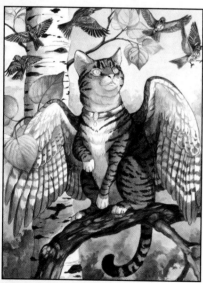

9 Leaf and Forest Details

Wet the leaves with a No. 6 round and clean water, and paint with Aureolin Yellow. To get a yellow to red gradient, add Cadmium Orange at the tip and blend up, then paint Alizarin Crimson at the very tip of the leaf. Paint the veins while still wet. Paint some of the wet leaves with Green Gold. Shade the yellow leaves and add holes with Raw Umber, and shade the red leaves with a light wash of Burnt Sienna. Add detail to the background leaves with a No. 4 round and Burnt Sienna at the bottom, and Cadmium Yellow at the top.

10 Face and Collar Details

With a No. 4 round, mix Alizarin Crimson and Naples Yellow for the nose and ears. Paint the eyes with a mixture of Green Gold and Raw Umber, and while still wet, rim the eyes with Burnt Sienna. Once dry, use a No. 2 round to paint a dark mixture of Van Dyke Brown and Indigo around the eyes, mouth and nose and for the pupils.

Use Raw Umber and Van Dyke Brown for the leather collar, then paint Cadmium Yellow for the gold. Use Burnt Sienna for shadow and Alizarin Crimson for the jewel. Draw in the whiskers with a few strokes of Van Dyke Brown and Indigo with a No. 2 round and a white gel pen. Add a few strokes of fur to the inner ears as well.

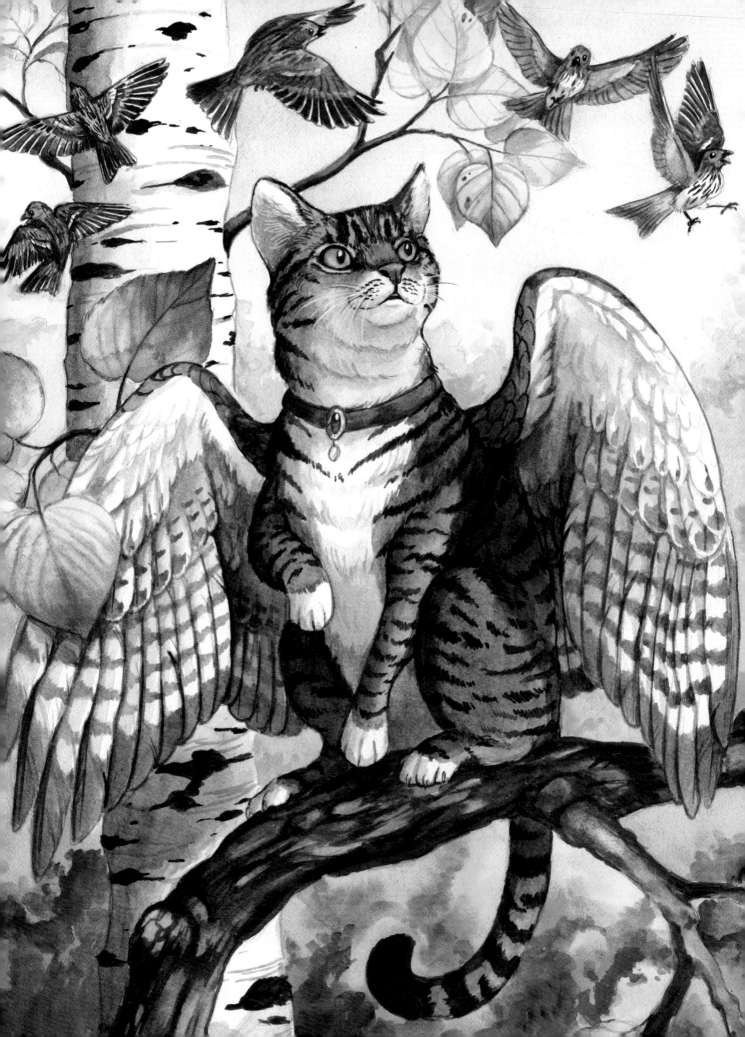

Other Winged Animals

Like the felines and canines covered in the previous pages, these winged creatures each have their own story. When you give an animal wings, think not only about why it has wings, but what kind of wings it would have. How would those wings best suit its habitat? Does it need camouflage? Here are just a few examples of how you can create winged creatures well suited for their individual worlds.

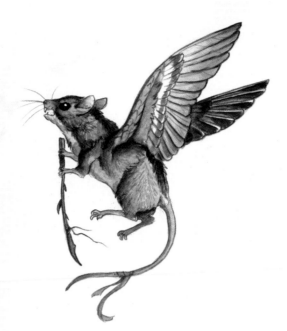

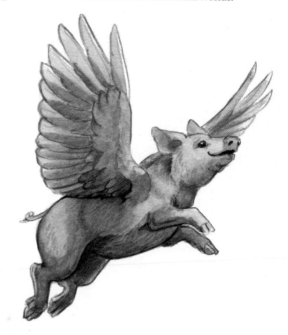

Mice are just the right size to have bird wings or insect wings, but even if they can fly, they still need to protect themselves from larger creatures who want them as a snack! Who is this winged mouse fighting? A bird? A cat? Fashion weapons for these fierce little creatures out of sticks and thorns.

This fellow is taking the phrase "when pigs fly" literally! Pink feathers match its rosy skin as it soars by, proving the impossible for onlookers down below.

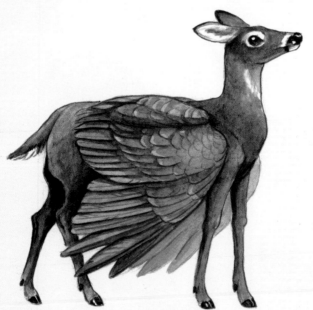

Similar to the Pegasus, the winged deer is as elegant on the ground as it is in the air. Its wings are short and rounded to give it better control when flying through dense forests.

Not all winged reptiles are dragons! This little creature is proud to be a lizard and chases its insect prey on the wing.

Be Whimsical

Choose wings that match your animal's habitat and behavior. A quick, speedy weasel may have a falcon's wings, whereas a rabbit may have the soft wings of an owl to flutter away silently. A cat could have bat wings to maneuver quickly in the air to catch bugs that are out of reach on the ground. Don't be afraid to try different combinations!

Although you can be creative with the size of your wings, basic proportion is still important. Huge wings on a tiny animal or tiny wings on a huge animal are fine if your aim is to create an awkward or amusing creature. Otherwise, the wings should fit the size of your animal.

Just as with dragons and Pegasi, you should attach wings to animals in a way that would make sense anatomically if these creatures actually had wings. Generally, attaching them just behind the scapulae (shoulder blades) makes the most sense anatomically and aesthetically. Imagine if this winged squirrel's forelimbs were wings instead; you would cover up the forelimbs, and the wings would look like arms.

Mix and match! Add fur or feathers to bat wings, and add the animal's natural markings to its wings. You want wings that look like they're a part of the animal instead of just stuck on, so be sure to take any spots, stripes or natural coloration and add them to the fur, feathers, membrane or skin of the wings.

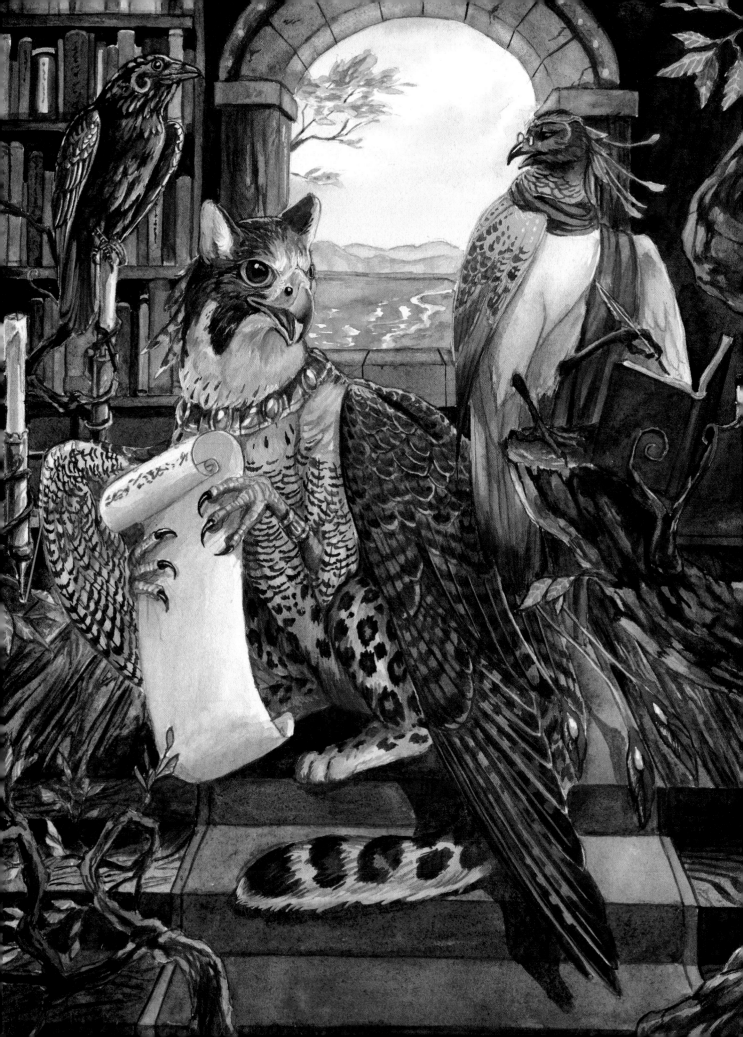

6

Feathered Fantasy:
Phoenixes, Gryphons, Hippogryphs and Otherworldly Birds

In countless cultures across every continent, birds soar through accounts of history, creation myths, fables, legends of heroes and the personification of deities. Why do we admire birds so? Perhaps we are intrigued by their variation; birds come in all shapes, sizes and colors. Some fill our neighborhoods and wilderness with song, others hunt, and while most fly, a few have traded the use of their wings for strong legs that allow them to run. Many birds we keep as pets or invite into our yards with birdhouses and feeders, and others we even train to hunt from the glove.

The Romans carried a sculpture of an eagle, called a standard, with each of their armies. This eagle was a symbol of Rome's pride and strength. If a legion lost its eagle, it would do anything to get it back. In the western United States, the Thunderbird was the embodiment of thunder and lightning. Its form was inspired by the real, soaring form of the largest raptors, such as the bald eagle. Ravens and crows also have a place in North American legends because of their intelligence. In Norse mythology, the World Tree was topped by the figure of an eagle, atop which sat a falcon, both of which could see beyond all else. Even mythological birds such as the Phoenix appear from East Asia, across the Middle East to Europe. Gryphons and hippogryphs, creatures combining an eagle and lion or an eagle and horse respectively, appear in sculpture, heraldry and contemporary fiction. From history to present day, birds continue to adorn our stories and legends.

Bird Heads

Though some fantasy avian creatures are based on specific birds, it's much more fun to create your own versions. Gryphons, for example, are typically based on an eagle and a lion, but contemporary artists often combine different birds of prey with different felines, or even mix it up entirely with nonraptor birds and nonfeline mammals. Phoenixes traditionally have their basis in peacocks, birds of prey and even roosters, but that doesn't mean you can't create one based on a heron or robin! Understanding how to draw different bird heads will help you create your own fantastical avians, whether you want to stay with the traditional or let your imagination go wild.

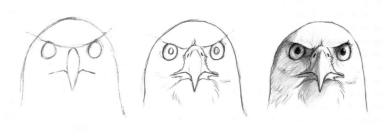

Raptors

Raptors have sharp, hooked beaks for tearing into prey. Typically they have a pronounced brow, which gives eagles and hawks that fierce, glaring look. It's important when drawing a raptor beak to remember to include the cere, which is the waxy area around the nostril. The mouth also extends below the eye.

Drawing a Front View Raptor

Drawing a raptor's beak from the front is a difficult angle with the foreshortening. Start with a basic inverted teardrop shape and draw the lips, then draw the eyes and shape of the head. Remember that at a straight-on angle like this, the top of the eyes are about level with the top of the beak. Suggest dimension with shadow.

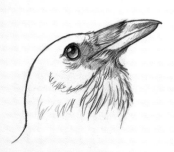

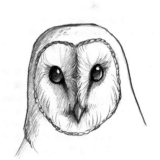

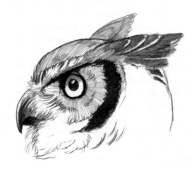

Ravens and Crows

Corvids such as ravens, crows and jays have long beaks that they can use to hammer, carry things and pry things open. Corvids have nasal bristles. These bristles cover the nostril and extend down the top part of the beak.

Owls

Although they look like they have flat, squished faces, an owl's beak actually protrudes quite a bit, which is more obvious when viewed from the side. The feathers that cover much of the beak make their beaks look tiny. The fine, hairlike feathers on an owl's face create a facial disc that helps bring in sound and gives owls their unique facial appearance.

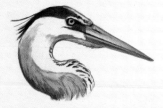

Shorebird

The line of a heron's mouth extends past its eye, making its daggerlike beak look even longer.

Other Birds

Beaks are built mostly for finding, catching and obtaining food. The short beak of the European robin is excellent for grabbing insects, whereas the long, slender bill (complete with a full-length tongue!) of the hummingbird allows it to reach deep into flowers and drink nectar.

Feet and Tails

Just like beaks, the design of a bird's foot is specific to its habitat and the food it finds or hunts. Birds of prey have extremely powerful feet with sharp talons. Ducks have webbed feet to propel them through the water. Corvids have feet that help them perch on nearly all surfaces, and birds that live mostly on the ground such as turkeys and chickens have stubbier feet more suitable for walking. When designing your creature, decide which feet would best suit its habitat and purpose.

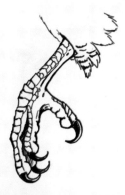

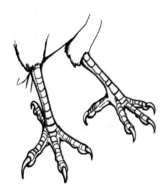

The feet of hawks, eagles and falcons are usually scaled to protect them against bites from their prey. For an old, battle-hardened gryphon, try making the scales larger and cracked.

Ravens and crows have slender legs and toes with hooked claws. They also have scales on their legs, but they are much smoother than raptor legs. These feet suit a scribe or mage quite well, as they could help a tricky raven craft something together, or a clever jay write a spell.

Even songbirds have claws on their tiny toes. Their feet aren't as strong as a hawk's feet, but are perfectly suited for perching on everything from tiny branches to wires to flat walls.

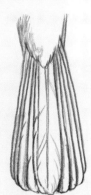

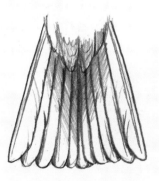

The best way to draw a tail is to imagine it as a segmented fan. When closed, the feathers fold in on each other, and when open, they spread in order, just like a wing. When viewed from above, the two center feathers are always on top with the other feathers layered beneath them on each side.

When viewed from below, the order is reversed. The two top feathers are those on the edges, then they layer underneath toward the center.

Creating Your Own Tail

Combine aspects of different types of tails to create your own. Lengthen the center feathers for a diamond shape or lengthen the side feathers for a forked tail. Long, flowing loose feathers like the ones that grow off the back of a peacock are perfect for Phoenixes or to add a bit of flair to a regular bird.

Full of Mischief: Raven the Trickster

The raven's striking intelligence isn't the only trait people admire; ravens often interact with other animals in seemingly mischievous ways. They have been seen tugging on coyote's tails and yanking on the feathers of larger birds, such as eagles! In the Pacific Northwest, the raven was seen as a trickster, and across the continents where these birds are found, their tendency to tease and play is found in fables and tales.

In this painting, the raven is preparing for a morning full of mischief. He loves to make masks mimicking the faces of other creatures—coyote, eagle, fox and bear—and then play pranks while dressed up as his friends. One day the other animals hope to out-smart him, but the raven is always ten steps ahead!

MATERIALS LIST

Paper: hot-pressed watercolor paper

Brushes: Nos. 1, 2, 4, 6 and 8 rounds.

Paint: Burnt Sienna, Burnt Umber, Cadmium Yellow, Caput Mortuum Violet, Cerulean Blue, Dioxazine Violet, Indigo, Raw Umber, Sap Green, Sepia, Ultramarine Blue, Ultramarine Violet, Van Dyke Brown

Other materials: HB and 6B pencils, white gel pen

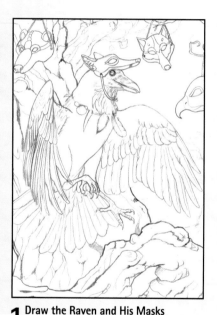

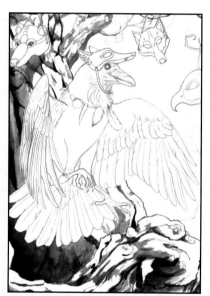

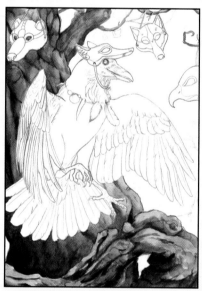

1 Draw the Raven and His Masks

When drawing the raven, it's important to show his personality. A bird sitting static on a branch doesn't show his playful personality, so give him a little grin. The leaping pose shows he's ready to make some mischief. Draw a little necklace of trophies that he might collect, such as a tuft of fur from a coyote, a tooth from a bear and a feather from an eagle. Add other items, such as shells and seeds. Draw the foreground and add bark detail with a 6B pencil for the tree and use a lighter HB pencil for the background.

2 Paint Base Shadows in the Tree and Branch

Using a No. 8 round, paint a mixture of Ultramarine Blue and Sepia anywhere there is shadow on the tree. Remember that the bark is dimensional and also casts a shadow, so use a more concentrated mixture in the crevices of the tree. When mixing your paint, it's okay if you add more blue or more brown, because it will add variation to your shadows. Switch to a No. 4 round and use a lighter wash when painting in the shadows of the top branch since it's farther away.

3 Tree and Branch Washes

Use a No. 8 round and loosely lay in washes of Raw Umber on the side of the tree not in shadow, and paint in Caput Mortuum Violet to add variation to the color. Use a little bit of Dioxazine Violet to push the bark shadows. On the shadowed side of the tree, paint a wash of Van Dyke Brown with Dioxazine Violet for variation.

Paint splotches of Sap Green on the branch for bits of moss, and when dry, paint the branch with the same colors as the tree.

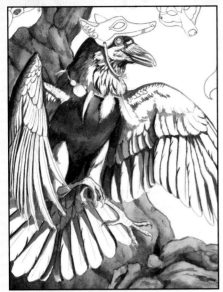

4 Raven Shadows

Just as you don't want to use gray to shade white, black looks best when you use a mixture of colors instead of straight black watercolor. Mix Indigo with Dioxazine Violet to create a dark blue-violet, then begin painting the shadows on the raven with a No. 4 round. Switch to a No. 2 round and an even darker mixture for the darkest shadows, such as between the feathers and under the chin.

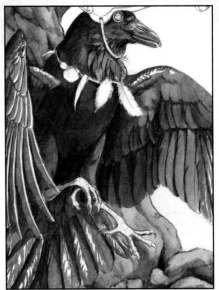

5 Add a Wash of Color to the Raven

To even out the bluish-purple the raven has right now with the shadows, paint the body with a warm wash of reddish purple. By combining cool (blue) with warm (red), you create a more neutral overall tone. The feathers of birds with black plumage often take on a warm tint in sunlight. Use a No. 6 round and paint a mixture of Burnt Umber and Dioxazine Violet on the chest. Switch to a No. 4 round to paint this mixture on the rest of the raven, leaving some glossy highlights on the primaries and tail feathers.

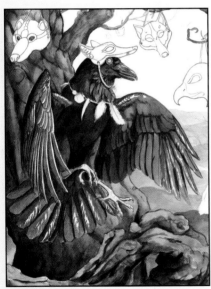

6 Paint the Background

Because this is an early winter scene, the grass will be dull and slightly yellowed. Use a No. 8 round to paint a light wash of Raw Umber along the entire background landscape. When dry, use a No. 6 round to begin adding darker, more vibrant layers of ground; below the farthest layer, paint Raw Umber all the way to the bottom. When that is dry, paint a mixture of Sap Green mixed with Raw Umber. Then for the closest hill, paint a darker mixture of Sap Green and Raw Umber, and while still wet, add Ultramarine Violet for the shadows beside the tree and around the hill. Finally, add a very light wash of Ultramarine Blue to the farthest hills.

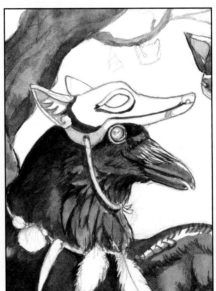

7 Paint the Mask Shadows

Because the masks are different colors, you will want to use different colors for the shadows. For the brown bear mask, use a No. 4 round and paint a mixture of Dioxazine Violet and Sepia for the shadows. Use Van Dyke Brown mixed with Dioxazine Violet for the orange on the fox mask. Paint the white shadows of the eagle, fox and coyote masks with a mixture of Cerulean Blue and a tiny amount of Raw Umber. Then use a mixture of Ultramarine Violet and Raw Umber for the shadow on the coyote mask.

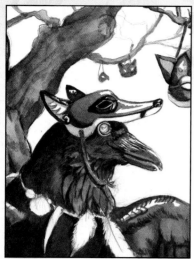

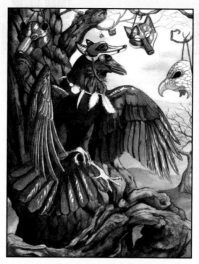

8 Paint the Masks

For the orange on the masks, use a No. 4 round and a mixture of Burnt Sienna and Cadmium Yellow. Use Cadmium Yellow to paint the eagle's beak and around the eye. Use Raw Umber for the bear's nose, around the eyes, and for the markings on the coyote mask. Mix Ultramarine Blue with a little Raw Umber for the gray on the coyote mask and to paint some feather texture into the eagle mask. For the black on the noses, ears, and for the shadow of the far masks, mix Indigo with Sepia and use a No. 2 round. Use Sepia for the mask strings.

9 Add Tree Details and Paint the Sky

For an overcast sky, wet the paper using a No. 8 round and clean water, and add light clouds of Ultramarine Blue mixed with a tiny bit of Raw Umber.

Using a No. 2 round and a dark mixture of Indigo and Sepia, darken the crevices in your bark texture. Use variations to suggest bark and drybrush moss detail with a No. 6 round and Sap Green mixed with Ultramarine Violet. Once the sky is completely dry, paint the far branches with a No. 1 round and Sepia. Paint the background tree with a No. 4 round and a wash of Raw Umber and Ultramarine Blue. Add Caput Mortuum Violet while wet, then paint the branches with Sepia.

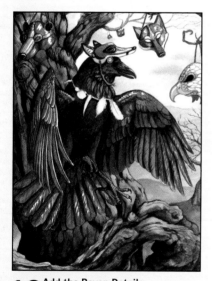

10 Add the Raven Details

With a No. 2 round, paint a dark mixture of Indigo and Sepia for feather details, such as on the belly and head, and to darken the darkest shadows. Add washes of Burnt Umber mixed with Dioxazine Violet to deepen the feather color, and also to add feather vane texture to the primaries and secondaries.

Paint the feet and legs with a No. 2 round and a layer of Dioxazine Violet mixed with Burnt Umber, then darken the shadows with your Indigo and Sepia Mixture. Use a white gel pen to draw the lines for the leg scales.

11 Add Face and Necklace Details

Paint the eye with Van Dyke Brown and a No. 2 round, leaving a highlight for the eye. For the ring around the eye and to add texture lines, use a light mixture of Indigo with Sepia. When dry, paint a pupil with Indigo.

For the necklace, paint the white feather with the same mixture of Cerulean Blue and Raw Umber that you used for the eagle mask with a No. 2 round. Paint the tuft of coyote fur with Raw Umber and Ultramarine Blue, with Van Dyke Brown for strands of fur. Paint the long tooth with Raw Umber, and use Ultramarine Blue for the shadow. Use Sap Green for the pieces of stone with an Ultramarine Blue shadow. Use Burnt Sienna for the shell with Ultramarine Violet for the shadows, then paint the string with Raw Umber. Add details to the feather and tuft of fur with a white gel pen.

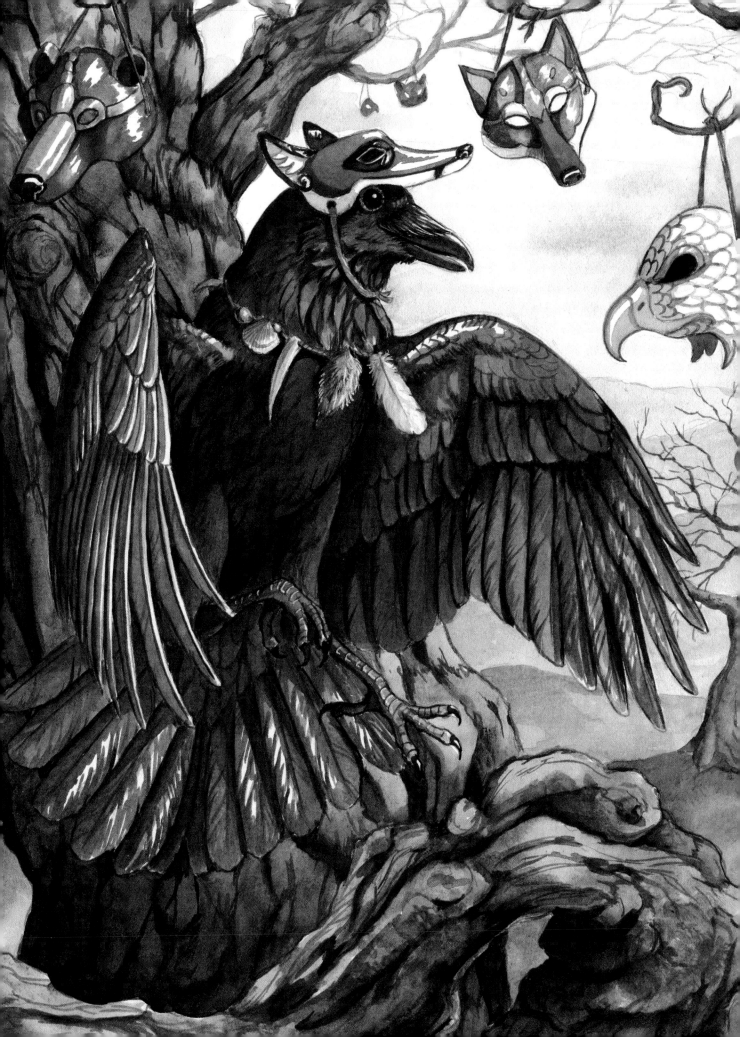

Bringer of Storms: The Thunderbird

Many cultures had their own beliefs about what caused a storm's deafening thunder and blinding lightning. Surely the being behind such overwhelming forces in the heavens must have been powerful indeed. The Thunderbird was one of the creatures who emerged from these stories. With such huge wings, it could create a crash of thunder, and lightning shot from its eyes—truly a mythical being to be admired.

MATERIALS LIST

Paper: illustration board

Brushes: Nos. 1, 2, 4, 6 and 8 Rounds, ¾-inch (19mm) mop, old brush (for masking fluid)

Paint: Aureolin Yellow, Burnt Ochre, Burnt Sienna, Burnt Umber, Cadmium Orange, Cerulean Blue, Cobalt Blue, Indigo, Payne's Gray, Phthalo Blue, Quinacridone Rose, Raw Umber, Ultramarine Violet, Van Dyke Brown

Other materials: paper towel, masking fluid, white gouache

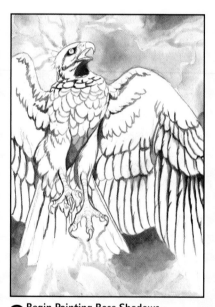

1 Draw the Thunderbird and Apply Masking Fluid

Though traditionally the Thunderbird shoots lightning out of its eyes, you can depict this creature in any imaginative way. Here, its form is part of the lightning. Because its beating wings are responsible for thunder's deafening crash, draw them massive and powerful.

Because you want your lightning to remain white with sharp edges, use masking fluid. Keep in mind you will probably end up with dried masking fluid on the brush, so don't use any of your watercolor brushes. For very fine tendrils of lightning, use a fine-tipped stylus, such as the wooden handle of a brush.

2 Paint Sky Washes

Wait until your masking fluid is completely dry, then use a ¾-inch (19mm) mop to wet the entire background with clean water. Use the tip of a No. 6 round to push water into the corners. Mix Cobalt Blue with Raw Umber to create a greenish gray, and use a No. 8 round to paint the sky. Concentrate more paint between the bolts to suggest glow. Blot paint with a paper towel while your wash is still wet to suggest clouds.

3 Begin Painting Base Shadows

Start by using a No. 2 round to paint feather layer shadows. On the head, neck, tail and secondary feathers, use a mixture of Burnt Sienna and Ultramarine Violet, and on the chest, belly and underwings, use a mixture of Burnt Ochre and Ultramarine Violet. Use Indigo to paint the darkest shadows on the primary feathers and coverts. Use lighter washes of these colors to add overall shadow to the body and wings.

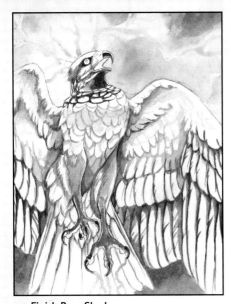

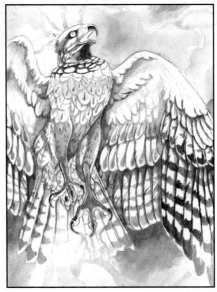

4 Finish Base Shadows
When painting your shadows, think about where the light source is coming from. The lightning is below the Thunderbird and behind its head, so areas such as the top of the legs are going to be in shadow. Continue using a mixture of Burnt Sienna and Ultramarine Violet for the shadows on the head and secondaries, a mixture of Burnt Ochre and Ultramarine Violet for the chest, belly and underwings, and Indigo for the primary feathers, beak and talons.

5 Paint Feather Markings
Paint raindrop shapes with a No. 2 round and Phthalo Blue on the chest and underwing feathers. Then paint blue barring on the secondary feathers, tail and crest. Use Indigo to paint bars on the primary feathers, using a lighter wash for the feathers closest to the lightning.

Painting a Stormy Sky

Gray is the color most people think of when they picture storm clouds, but most gray objects contain a bit of color. Blue is a good base for storm clouds, and adding just a little brown will dull the blue without turning it plain gray.

1. Storm clouds are big and billowing. From the ground, you see the undersides of the clouds. Draw the closest cloud, then the layers behind it. Try to draw your clouds irregularly and not all billowing in the same direction.

2. A stormy sky is usually lighter than the clouds. Wet the entire paper with clean water, then paint the bottom of each cloud with a mix of Cobalt Blue and Sepia. It's okay if the color bleeds; this will make your clouds look softer. While the wash is still wet, darken the bottom of the clouds with Sepia.

3. Once your paint is dry, go back with a No. 4 round and Payne's Gray to paint the bottoms of the clouds. Be sure to leave a gap between the shadow and the edge of the cloud to suggest light glow, and blend the Payne's Gray up with clean water. Paint the ground with a dull, subdued color.

4. The best way to show lightning is to mask the bolt with masking fluid before painting or to paint around the bolt. If you decide after you've painted your clouds that you want a bolt of lightning, use a No. 1 round and white gouache (straight from the tube) to draw the bolt. Highlight the clouds and ground with white gouache to suggest glow.

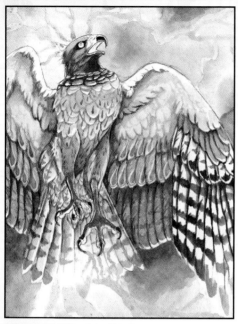

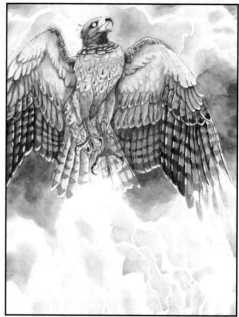

6 Begin Adding Color Washes

Use Aureolin Yellow to paint the entire Thunderbird except the beak, legs, primaries and covering feathers with a No. 4 round. Leave white highlights on the areas that would be illuminated by the lightning, and paint only very light washes on areas very close to the lightning, such as on the tail. Once dry, go over the lower wing feathers and secondaries with a light wash of Cadmium Orange. On the raindrop feathers, leave an outer ring of yellow.

7 Finish Adding Color Washes

Remove the masking fluid using either an old kneaded eraser or your thumb. Paint washes of Phthalo Blue on the primary feathers and covering feathers with a No. 6 round, and while wet, paint Cobalt Blue at the tips of the primary feathers. Use Phthalo Blue to add color to the shoulders of the wings and to darken the blue bars on the orange feathers.

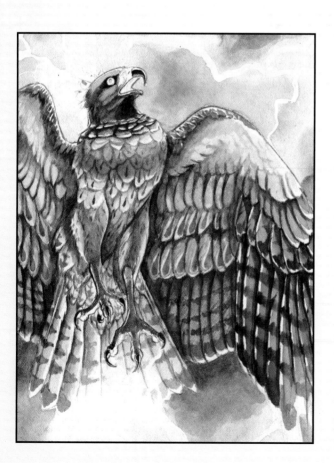

8 Deepen the Shadows

Because the light is so bright, it creates dramatic shadows. Push your shadows even more by using a No. 4 round and Cerulean Blue for the orange feathers and yellow feathers, and to push the shadow on the chest between the two areas of lightning. Paint Burnt Sienna for the shadows of the blue feathers. Go back with Burnt Sienna mixed with Ultramarine Violet to push the shadows of the yellow feathers on the chest and wings.

9 Additions or Changes

If you want to change feathers, such as I did in the wing on the right, wet the area with water, lift with a paper towel, and then wait for the paper to dry completely before repainting your feathers. Here, I painted the new feathers in with a No. 4 round and Aureolin Yellow, then painted the shadows with a No. 2 round and a mixture of Burnt Sienna and Ultramarine Violet.

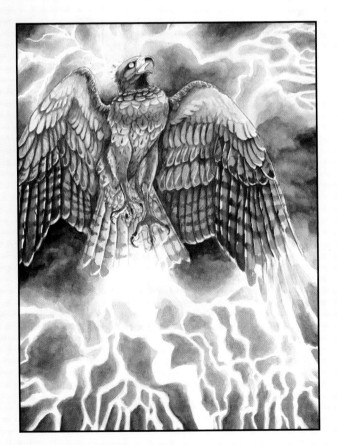

10 Finish Sky Details

Darken the sky around the lightning bolts by mixing Cobalt Blue and Raw Umber, and painting layers of washes with a No. 6 round. Use Payne's Gray for the darkest sections of the sky at the bottom and farthest from the central lightning bolt. Add some Cadmium Orange around the head and mix it with a little white gouache to create highlights in the clouds beneath the wings. Paint Van Dyke Brown in the dark areas of the sky around the bottom of the wings.

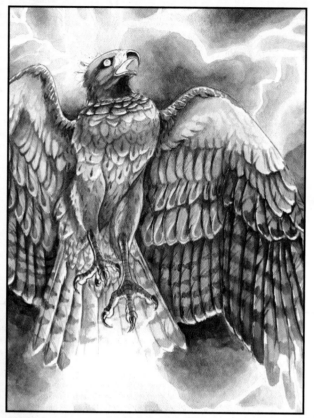

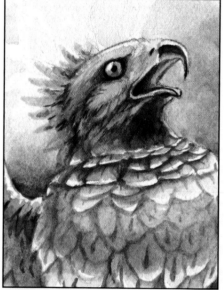

11 Paint Foot and Feather Details

At this step, go back and add texture and refine shadows to the feathers using a No. 2 round. For the orange feathers, use Ultramarine Violet to darken shadows and Burnt Sienna to add feather vane texture. For the yellow feathers, use Burnt Ochre for the feather vane texture. Use Indigo to deepen shadows and add feather texture to the blue feathers and blue markings. Add a wash of Cadmium Orange to the three innermost primary feathers.

Paint the scales on the legs with concentrated Ultramarine Violet and a No. 1 round. Because the bottoms of the feet are sharply illuminated by the lightning, it's fine to keep them white. Outline the talons with Indigo, but keep the highlights white.

12 Paint Face and Crest

Paint the inside of the mouth with a No. 2 round and a mixture of Quinacridone Rose and Burnt Umber. While wet, use Van Dyke Brown to darken the mouth farther back. Paint the cere (the area around the nostril) and the front of the face with Aureolin Yellow, and also the crest. Add some Cadmium Orange to the crest while it's still wet, and as shadow to the cere.

Paint the crest spots and eye with Phthalo Blue and when dry, use Payne's Gray mixed with Van Dyke Brown and a No. 1 round to paint in the nostril and the pupil and to add detail to the beak. Add some final feather texture to the head and crest using Van Dyke Brown and a No. 1 round.

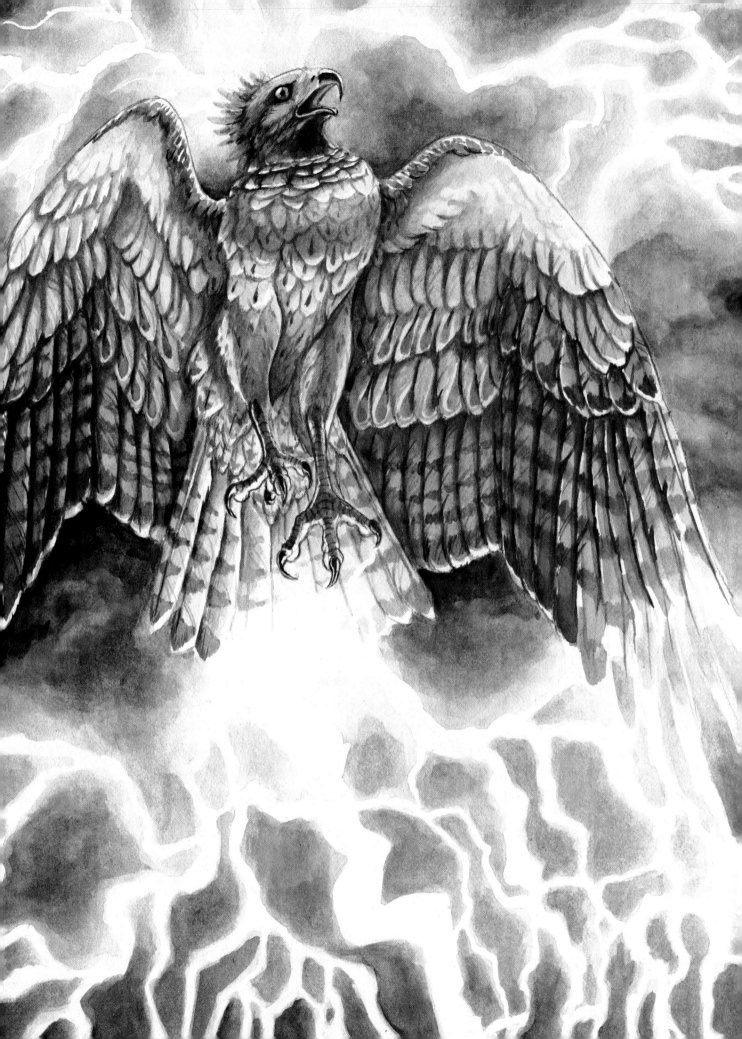

From the Ashes: The Phoenix

The Phoenix, or Firebird, is found in stories from around the world and is widely seen as a symbol of rebirth and the cycle of life. In most stories the Phoenix builds a nest of sticks when it is nearing the end of its life and, at long last, bursts into flames. Both nest and Phoenix burn, and from the ashes it is reborn. Some stories describe the Phoenix as a bird whose body is actually flame, and others show it as a bird with brilliant, fire-colored feathers. Other tales describe this bird as simply unbelievably beautiful in plumage, whose wings of fire are seen only at the moment of its death.

This Phoenix is just emerging from the ashes, the fire from its previous life still charring the tree where its nest once stood and curling around its new body. This long-necked Phoenix is inspired by the elegant form of a heron, but with the long, decorative plumes and brilliant feathers befitting a bird of fire.

MATERIALS LIST

Paper: hot-pressed watercolor paper

Brushes: Nos. 1, 2, 4, 6 and 8 rounds, old brush

Paint: Aureolin Yellow, Burnt Sienna, Cadmium Red, Cadmium Orange, Cobalt Blue, Dioxazine Violet, Indigo, Payne's Gray, Phthalo Blue, Quinacridone Rose, Raw Umber, Sap Green, Thio Violet, Ultramarine Violet, Van Dyke Brown

Other materials: white gouache

1 Draw the Phoenix
Part of the fun of drawing fantasy birds is being creative with feathers. Think of how feathers would work structurally as you add layered crests and long, decorative plumes. Draw this Phoenix with a variety of different types of feathers on its head—long feathers with a single plume at the end, slender, frilly feathers, and straight, stiff feathers. You can also exaggerate the bend of the wings or elongate the primary feathers. Use the form of the heron as an inspirational base for this elegant Phoenix.

2 Add Background Washes
With a No. 8 round, wet the background with clean water, except for the areas with fire. Start in the upper left with Sap Green, and add washes of Raw Umber while it's still wet. Work to the right with more Raw Umber, then in the bottom left, add washes of Sap Green, Raw Umber and Ultramarine Violet. Use a No. 2 round to paint the background between the open beak.

3 Paint the Fire

Erase the fire pencil lines a bit so they don't show through the paint. Wet the entire fire with a No. 6 round and clean water, going beyond the flames a bit into the background, then paint a wash of Aureolin Yellow, leaving some sections in the middle white. While the wash is still wet, go back with Cadmium Orange to paint the edges and the bottom, then use Cadmium Red to darken the coolest areas of the fire, such as at the very base and the flames at the very top. Go back with Aureolin Yellow over the orange to deepen the color.

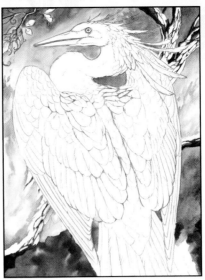

4 Add Tree Shadows and Begin Painting the Embers

Remember that you have two light sources—the sun and the fire. The side of the branch in the upper right is being illuminated by the fire, so there will only be a thin strip of shadow. Use a No. 4 round and Van Dyke Brown mixed with Indigo to paint the shadows on the trees. The bark crevices illuminated by fire will be sharp shadows.

Paint the embers beneath the Phoenix by wetting the paper with a No. 8 round and clean water, then paint a wash of Aureolin Yellow. While still wet, paint rough washes of Cadmium Orange and Cadmium Red to get a blotchy texture.

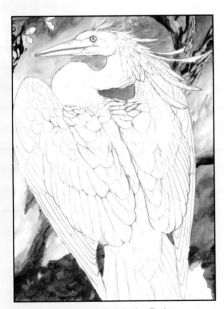

5 Paint Trees and Finish the Embers

Paint the trees with a No. 6 round and a mixture of Raw Umber and Cobalt Blue, using more Raw Umber closer to the fire. Where the branches are illuminated by fire, use only a light wash of Raw Umber. Paint the charred leaves with Payne's Gray mixed with Van Dyke Brown and a No. 2 round. Extend this dark mixture up the branches to suggest charred bark.

For the gray parts of the embers, mix Payne's Gray with white gouache and paint mounded shapes with a No. 4 round, adding some white gouache with an old brush for highlighted texture. Use this same gray mixture on the branches that have been charred by the fire.

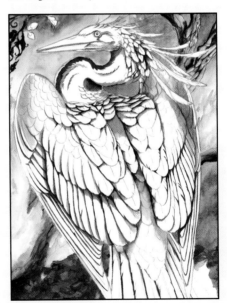

6 Paint the Feather Shadows

With a No. 2 round and a mixture of Van Dyke Brown and Dioxazine Violet, paint the shadows for the feathers on the upper wings, primary feathers, back, lower crest and neck. Use Burnt Sienna for the shadows on the face and upper crest, and paint the shadows on the secondary feathers and tail with a mixture of Indigo and Dioxazine Violet. It's not necessary to add a shadow to every single feather; add shadows only to the feathers that are not sitting completely flat, such as on the upper back. When painting these dark shadows, use a damp brush to blend them.

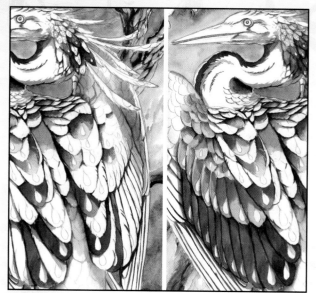

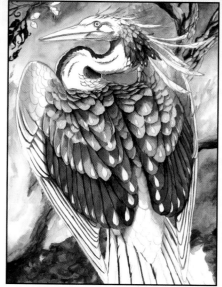

7 Begin Painting the Feathers

Draw spots on the feathers of the crest, back and lower feathers with a pencil, then begin painting around the spots with gradients of color. For the topmost feathers, paint with a No. 4 round and Aureolin Yellow. Then paint wet-on-wet at the base of the feather with Quinacridone Rose, blending as you go down. For the feathers below those, use Cadmium Orange. Then paint the base with Quinacridone Rose.

For the lowest feathers, use Quinacridone Rose for the base with Phthalo Blue at the tip of the feather. Avoid painting feathers directly next to each other; if the adjoining feather is still wet, the colors will bleed into the next feather. Use this same color scheme for the crest.

8 Continue Painting the Feathers

Using the same colors as before, paint the rest of the feathers with a No. 4 round, wet-on-wet, being sure the surrounding feathers are dry before painting. Each feather is a single wet-on-wet layer of the following: for the top feathers, use Aureolin Yellow with Quinacridone Rose; for the middle feathers, use Cadmium Orange with Quinacridone Rose; and for the secondary feathers, use Quinacridone Rose with Phthalo Blue.

Painting Fire

Painting fire in watercolor can be tricky because you can't paint light on top of dark. It's important to keep your paper white where you want your fire and then carefully add light washes to build the color of your fire.

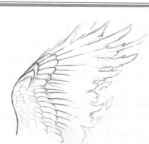

1. When painting fire on a dark background, you don't want a sharp line around the fire. To create that fire glow, paint clean water around the edges of the flames. Then paint a mix of Van Dyke Brown and Payne's Gray farthest from the flames. Carefully push the paint closer to the fire. Let the wet paint bleed and naturally create a gradual glow.

2. Let the background dry. Wet the area of the fire with clean water and a No. 4 round. Paint the entire fire except for the center with Aureolin Yellow. While still wet, add Cadmium Orange at the edges and a few spots of Cadmium Red. You can push the vibrancy with more color, but don't layer too much or the color will get too dark.

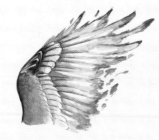

To paint fiery wings, start with the basic wing structure, but turn the primaries and secondaries to flame. Keep the basic structure, then fade into a flame.

9 Paint the Neck and Outer Wings

To paint the face and neck, wet the whole area, except for the small feathers, with clean water and a No. 8 round. Then use a No. 6 round to paint Aureolin Yellow on the face, Cadmium Orange on the entire neck and Quinacridone Rose over the base of the neck. Leave areas white for highlight.

Paint the rest of the wings with a No. 6 round and Aureolin Yellow, and paint the primary covert feathers with Cadmium Orange and the tip with Quinacridone Rose. Begin painting the primary feathers. Paint Quinacridone Rose almost all the way to the tip, then while still wet, paint the tip with Phthalo Blue and blend upward into the pink. This way you will get a pink-purple-blue gradient. It's okay if it's not perfect. This technique takes a bit of practice.

10 Finish Painting the Primary Feathers and Paint the Tail

Continue painting the primary feathers as explained in step 9, then begin painting the small feathers covering the tail with a No. 4 round and Quinacridone Rose. While wet, paint the base of each feather with Phthalo Blue

For the tail feathers, paint each alternating feather with Aureolin Yellow and a No. 4 round, then paint Cadmium Orange on the center of the feather while still wet. Wait until the feathers are dry, then paint the rest of the feathers the same way. For the feathers turning into flame on the right side, paint them the same way as the fire in step 3.

11 Add the Feather Markings

Paint the markings on the secondary feathers with a No. 2 round and Phthalo Blue mixed with Aureolin Yellow, leaving white spots for highlights. Do the same for the rest of the feathers, except only use Phthalo Blue. Go back with a damp brush and blend some of the color into one of the highlights, leaving the other completely white to give the markings a jewel-like appearance.

Do the same for the spots on the crest, but use a No. 1 round. Paint the neck feathers with the same Phthalo Blue and Aureolin Yellow mixture.

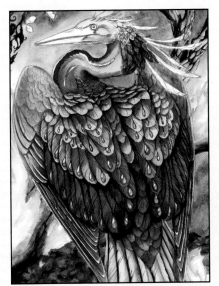

12 Add Final Feather and Background Details

For the orange and red feathers, paint in texture and push shadows with a No. 2 round and Burnt Sienna. Use Thio Violet on the pink and purple feathers and Cadmium Orange on the yellow feathers. Use a No. 4 round to add a shadow on the tail from the wings and on the far wing from the crest feathers with Burnt Sienna mixed with Ultramarine Violet.

Add detail to the bark texture with a No. 2 round and a mixture of Payne's Gray and Van Dyke Brown. Use this mixture to add darker texture to the embers.

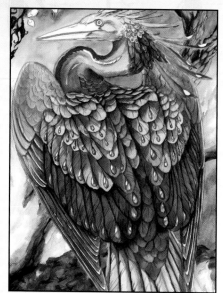

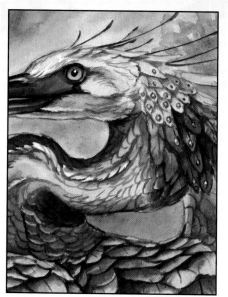

13 Paint the Crest and Fire Glow

Begin painting the crest with a No. 4 round starting at the top with Aureolin Yellow. Then for the lower feathers, add a bit of Phthalo Blue at the end, and gradually add more Phthalo Blue for the lowest feathers, leaving the spot at the end white. Paint the long, thin feathers on the head with Payne's Gray for the shafts and paint the tip with Quinacridone Rose.

Add a fire glow to the branches and neck with a No. 8 round and Aureolin Yellow, with Cadmium Orange for the fainter glow farther from the flames.

14 Paint the Neck, Face, Flowers and Leaves

Finish painting the face and neck by adding feather detail with a No. 2 round and Burnt Sienna. For the darkest area of the neck, use Van Dyke Brown. Paint the beak with a No. 4 round and washes of Indigo, then use Van Dyke Brown at the tip and lay a wash of Cadmium Orange at the base of the beak. Paint the crest spots with a No. 2 round and Aureolin Yellow, leaving a spot for the highlight. Then go over it with Quinacridone Rose.

Paint the eye with Aureolin Yellow, then while still wet, go over with a wash of Sap Green. Wait until the eye is dry, then paint the pupil with Payne's Gray and Van Dyke Brown. Give color to the flower buds with Quinacridone Rose and shade with Thio Violet. Paint the green leaves with Aureolin Yellow and a little Phthalo Blue, then shade with a bit of Ultramarine Violet.

Tips on Fire Glow

- Fire gives off a yellow and orange glow. The closer an object is to a fire, the stronger the color and brighter the light will be on that object. On this tree, the part directly next to the fire is extremely light and has a yellow glow. The farther from the fire, the more orange the glow will be.

- Using a cool shadow, such as blue, on the opposite edge will make the glow from your fire look even brighter and warmer.

- Any object with a bright light source like fire or direct sunlight will have shadows, such as on the bark, that will be extremely dark and sharp. Shadows not hit by direct light, such as the top of the tree, will be softer.

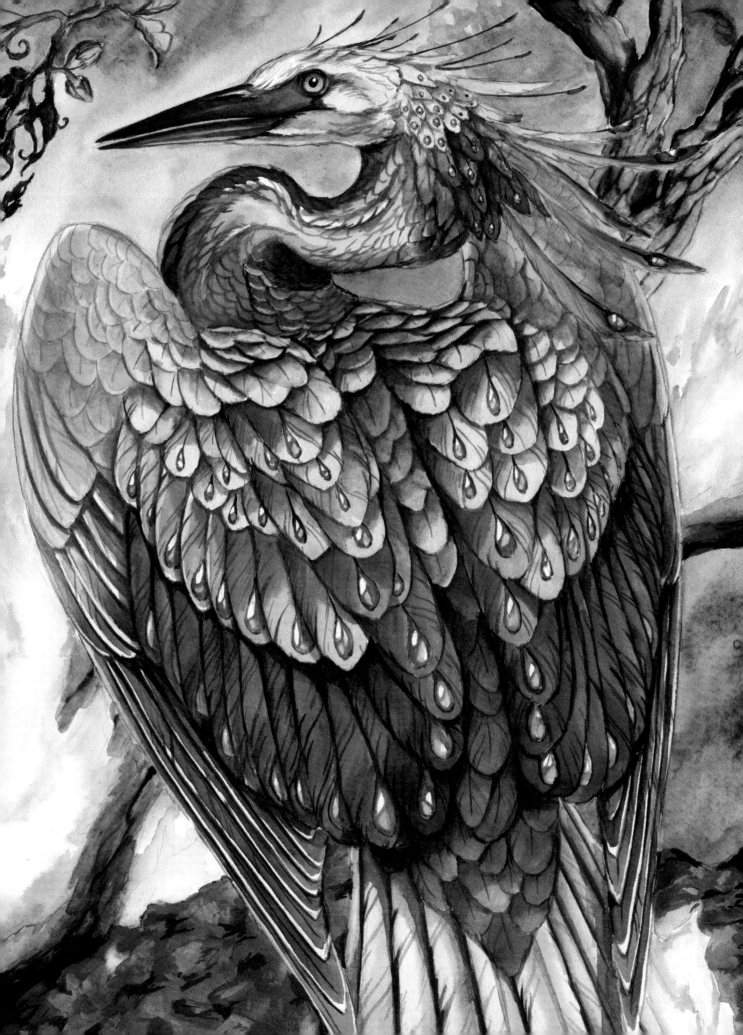

Flag Bearer: The Hippogryph

Half-eagle, half-horse, the hippogryph is more than simply an equine version of a gryphon. They are just as swift on the ground as in the air, and as a result, their taloned forelegs are thicker and sturdier, with a short rear toe and stubbier talons. Hippogryphs prefer the fields and forests rather than the rocky cliffs where gryphons dwell, but like gryphons, they are quite intelligent and have a complex culture. This hippogryph is a flag bearer for its herd and takes great pride in carrying the symbol of its family every morning as dawn breaks.

MATERIALS LIST

Paper: hot-pressed watercolor paper

Brushes: Nos. 1, 2, 4, 6 and 8 rounds, ¾-inch (19mm) mop

Paint: Aureolin Yellow, Burnt Ochre, Burnt Sienna, Cadmium Orange, Cadmium Yellow, Dioxazine Violet, Indigo, Payne's Gray, Phthalo Blue, Phthalo Green, Quinacridone Rose, Quinacridone Violet, Raw Umber, Sap Green, Sepia, Ultramarine Blue, Ultramarine Violet, Van Dyke Brown

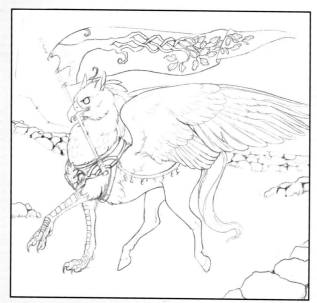

1 Draw the Hippogryph and the Scene
The biggest challenge with hippogryphs and gryphons is drawing both halves in proportion with one another. Make sure the eagle forelimbs are long and thick enough to match the equine rear legs. Stone walls on this rolling fieldscape will add a bit of dimension to an otherwise flat background. The knotwork tree in the banner may look tricky, but it's actually quite simple if you remember this rule: Every time a line goes under, the next time it will go over. When you finish, no limb should ever go over twice or under twice; it should always be under-over-under for each line.

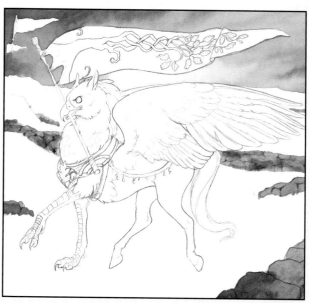

2 Paint the Sky and Add Washes to Stone Walls
Wet the entire sky with a No. 8 round and clean water, using a No. 4 round to wet the narrow corners. Starting at the top right, paint the sky with Aureolin Yellow except for the top left corner. Working wet-on-wet, take your No. 8 round and paint Quinacridone Rose along the top, leaving stripes of color. Paint Phthalo Blue on the top left, and then use Cadmium Orange to paint lines of color on the rightmost sky. Yellow, pink and blue blended together create a good sunrise or sunset. Be sure to leave the area closest to the horizon lightest.

While the sky is drying, paint a wash of color in the stone walls using a No. 8 round and a mixture of Ultramarine Blue and Van Dyke Brown, going back while wet and adding pure Ultramarine Blue or pure Van Dyke Brown for variation.

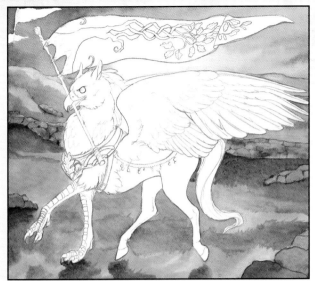

3 Paint a Grass Wash

Wet the foreground grass with a ¾-inch (19mm) mop and clean water, and use a No. 4 round to wet the smaller areas. Use a No. 8 round to paint a mixture of Sap Green and Burnt Ochre in the grass in the foreground and middle ground, and while still wet, paint in shadows with a mixture of Sap Green and Ultramarine Violet. Because the light source is on the right side of the hippogryph, the shadows on the grass should be on its left.

Take the tip of your No. 4 round to drag some of the wet wash up in the shadows for a grass-like texture. For the background hills, use a similar mixture, but with more Burnt Ochre and less Sap Green.

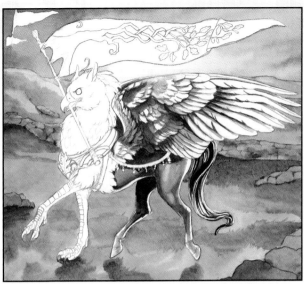

4 Paint Base Shadows on the Wings and Hindquarters

Use a No. 4 round and a mixture of Van Dyke Brown and Dioxazine Violet to paint the shadows on the horse half and the wings. Although the main light source is on the other side, there's still plenty of ambient light to illuminate and create shadows on this side of the hippogryph. However, be sure to leave the edges light, because they will be illuminated by the sky behind. Add shadow and texture to the tail with a No. 2 round and Indigo mixed with Van Dyke Brown.

Paint the white on the legs and hooves with a light mixture of Van Dyke Brown and Ultramarine Violet.

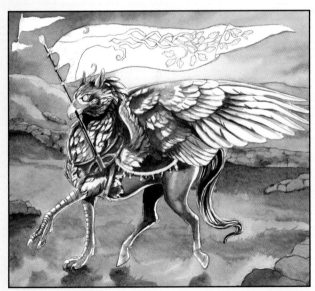

5 Paint Base Shadows on the Rest of the Body and Adornments

Paint the shadows and feather details on the head and chest with a No. 2 round and a mixture of Van Dyke Brown and Payne's Gray. Deepen the shadows with a little Dioxazine Violet. Use a mixture of Burnt Ochre and Van Dyke Brown to shade the cere and legs, and for the bronze oak leaf, acorns and metal bars on the chest plate. Shade the leather of the chest plate and straps with Van Dyke Brown mixed with Dioxazine Violet. Paint the flagpole with Sepia.

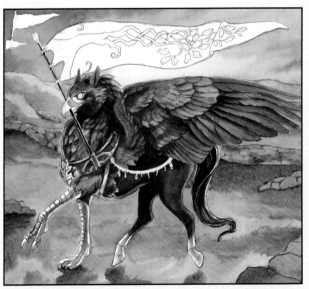

6 Paint Washes on the Hippogryph

With a No. 6 round, paint a wash of Cadmium Yellow mixed with Burnt Sienna on the head and chest of the Hippogryph, keeping the tips of the feathers more yellow. Switch to Burnt Sienna and Burnt Ochre for the wings, and use a mixture of Burnt Sienna and Dioxazine Violet for the primary and secondary feathers.

Paint the horse half with a wash of Burnt Sienna and Burnt Ochre, and add a wash to the tail with Sepia. When dry, go back and lay a light wash of Burnt Sienna over the horse half to deepen the color.

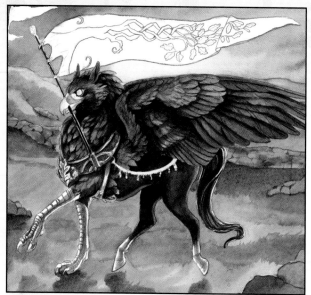

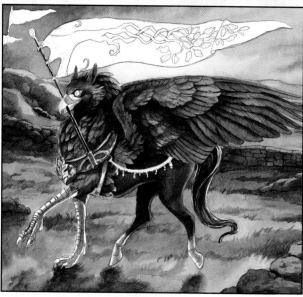

7 Add Final Shadows and Feather Details

Use a No. 2 round to paint in the darkest shadows for the feathers and body with Indigo, and deepen the shadows in the wings with Van Dyke Brown. Use Indigo to add subtle shadow to the horse half. At this stage, to really push your colors and values, you will want to work in layers, letting your first layer dry before adding more shadow. It may take you three or four layers to achieve color and shadow depth.

8 Add Final Background Details

Mix Sap Green with Ultramarine Violet for the grass shadows. Mix Sap Green with Burnt Ochre to add dimension and texture to the grass. Add a little bit of Burnt Sienna to the wet washes. Be sure to leave the peaks of the hills lighter, because that's where the light is touching. Add a few long shadows to the base of the flagpoles on the top of the hill. Add grass texture with a No. 2 round. For the big shadow from the hippogryph, switch to a No. 8 round.

Finish the stone walls with a wash of Payne's Gray and Sepia, painting everything except the tops of the stone. Go back with a No. 2 round and paint in the gaps in the walls.

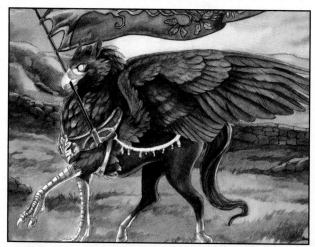

9 Paint the Flags

Paint the negative space on the large flag with a No. 4 round and Phthalo Green mixed with Aureolin Yellow, switching to a No. 2 round for the smallest areas. Draw a feather design on the second largest flag, and paint it with a light wash of Van Dyke Brown with a dark Burnt Sienna border. Paint the other flag with Cadmium Yellow. Use Raw Umber for the flagpoles. Once dry, paint the tree on the flag with Raw Umber and the leaves with Sap Green mixed with Burnt Ochre. Outline the feather and paint the dots on the other flag with Indigo.

10 Finish Flag Details and Add Final Washes

Use a No. 1 round and Van Dyke Brown to paint around the tree and branches on the flag and for the veins in the leaves. Then paint Indigo along the green border of the flag. Paint shadow on the green flag with a No. 4 round and Phthalo Blue mixed with Payne's Gray, and on the leaves and tree with Van Dyke Brown. Add shadows to the feather flag and the yellow flag.

Add a final wash of color to the hippogryph with a No. 8 round and Raw Umber, painting the tail, legs and all the feathers except for the primary and secondary feathers. Add a light wash of Burnt Ochre to the grass and tops of the stone walls.

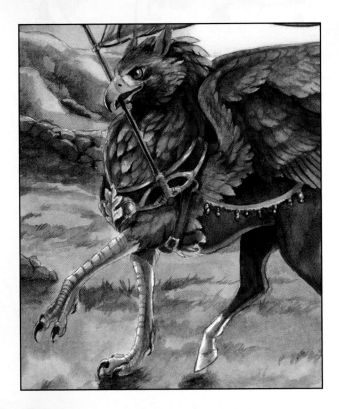

11 Paint the Face, Legs and Adornments

Use a No. 2 round to paint the eye with Van Dyke Brown, using thicker paint for the darker areas and leaving a white spot for the highlight. Use Quinacridone Rose and a No. 4 round to paint the leather of the chest plate and straps. Paint the metal oak leaf, acorns, legs and cere with Cadmium Yellow, using Burnt Ochre to shade. Add Ultramarine Violet for the darkest shadows on the legs, and use Indigo for the darkest shadows on the leather.

Paint the beak with Indigo mixed with Van Dyke Brown, blending with a No. 2 round with clean water. Paint the pupil and talons with this mixture. Add color to the strap along the side of the hippogryph with Sap Green mixed with Burnt Ochre and shade with a little Ultramarine Violet. Paint the baubles with Quinacridone Violet mixed with Burnt Ochre.

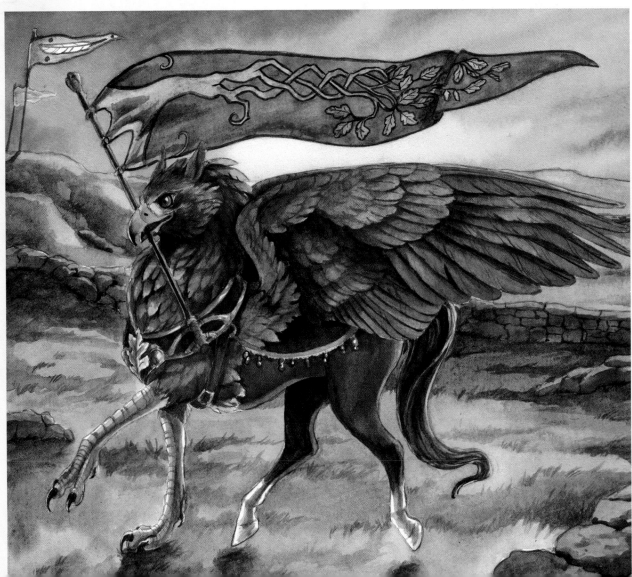

City Guard: The Gryphon

On tall columns around the capital sit gryphon guards, armed with sharp eyes and sturdy spears. They are ever vigilant and watching for trouble, be it a mischievous pickpocket or a dangerous enemy spy. From their tall perches they can spot the slightest hint of trouble, and thanks to their fearless and selfless duty to their city, the capital remains a safe and peaceful place.

MATERIALS LIST

Paper: illustration board

Brushes: Nos. 1, 2, 4, 6 and 8 rounds.

Paint: Alizarin Crimson, Burnt Ochre, Burnt Sienna, Burnt Umber, Caput Mortuum Violet, Cadmium Yellow, Cobalt Blue, Dioxazine Violet, Hooker's Green, Indigo, Naples Yellow, Payne's Gray, Permanent Green, Phthalo Blue, Prussian Blue, Quinacridone Rose, Raw Umber, Sap Green, Ultramarine Violet, Sepia, Van Dyke Brown

1 Draw the Gryphon and Cityscape
To create this cityscape, you will use basic one-point perspective. **For more on perspective, go to www.impact-books.com/wingedfantasy.** Draw your horizon line about one-third from the top of the page and draw a dot in the center for your vanishing point. Any horizontal lines going from front to back will be slanted toward the vanishing point.

The column is based on an Ionic column. Draw guidelines to make sure the volutes (spirals) are the same size, or draw the volute on one side, then trace it using tracing paper and flip it over on the opposite side to transfer it. Because this town is home to birds and gryphons, design a cityscape that would be friendly to flighted creatures—tall towers and wooded gardens on the roof, for example.

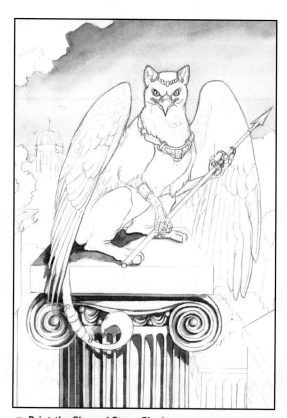

2 Paint the Sky and Stone Shadows
Erase your guidelines and lay a wash of clean water in the sky with a No. 8 round. Paint the top of the sky with Phthalo Blue, going lighter as you go down. At the bottom, paint a light wash of Naples Yellow while the wash is still wet.

Use a mixture of Caput Mortuum Violet, Naples Yellow and a little bit of Ultramarine Violet with a No. 2 round to carefully paint the darkest shadows in the flutes (the long, rounded grooves) based on the sun shining from the upper right. Think about what will cast a shadow. Use a damp brush to blend out the shadows on the volutes. Add lighter shadows to the left side of the pillar with a light wash of the same mixture.

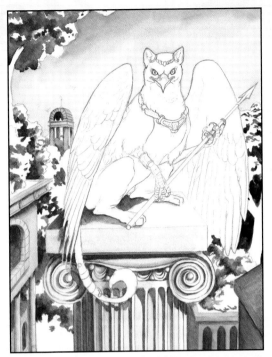

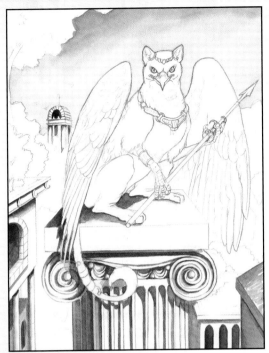

3 Paint Shadows on Buildings

Use a mixture of Van Dyke Brown and Indigo and a No. 4 round to paint shadows on the buildings, with the darkest shadows being under overhangs and protruding stone. Use browner or bluer mixtures to vary the color of the buildings. Go back to the pillar with a No. 4 round and Cobalt Blue mixed with Ultramarine Violet to push the shadows.

4 Paint the Stone and Add Tree Shadows

With a No. 6 round, add color to the stone building on the right and in the background with a mixture of Naples Yellow and Ultramarine Violet. Then use a wash of Cobalt Blue for the cool gray building, and a mixture of Indigo and Sepia for the far right building. Use Caput Mortuum Violet mixed with Burnt Ochre for the roof of the far right building and the roof of the building in the background. Add a light wash of Naples Yellow to the whole pillar, except the very top, and when dry, add Payne's Gray to the darkest shadows.

For the trees on the left, use a mixture of Hooker's Green and Ultramarine Violet and a No. 4 round to add shadows and rough texture. Use Sap Green mixed with Dioxazine Violet for the trees to the right, and then for the far right trees, mix Hooker's Green with Prussian Blue for the shadows.

5 Add Color to the Trees

When painting groups of trees, it's important to not paint them all the same color. There's always slight variations in color, even if they are all green. Use three different mixtures of green for different trees—Sap Green and Cadmium Yellow, Hooker's Green and Cadmium Yellow, and Permanent Green and Burnt Ochre. Paint these in with a No. 8 round, and use the tip to dab leaf texture in the sky on the edges of the trees.

Paint the grass on the rooftops with Permanent Green mixed with Cadmium Yellow and a No. 4 round. Add a base wash to the trunks of the trees with a mixture of Van Dyke Brown and Cobalt Blue.

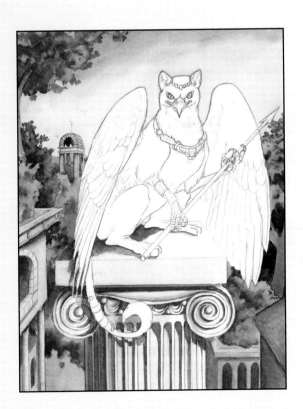

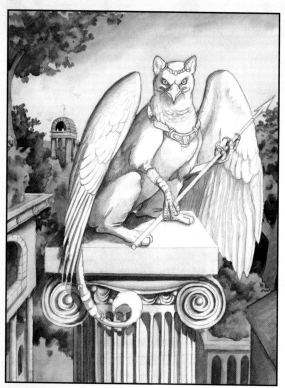

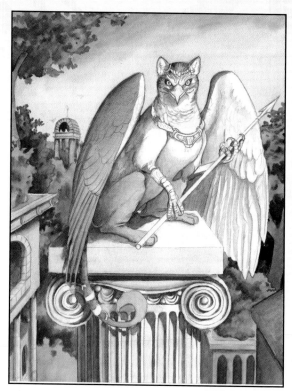

6 **Add Shadows to the Gryphon**
For the body and underwings, use a mixture of Naples Yellow and Ultramarine Violet and a No. 4 round to paint shadows, and blend out with a damp brush. The body is going to be an off-white buff color, so you don't need to go too dark with the shadows. Add a very light wash of Alizarin Crimson in a few areas to add a bit of warmth. Use Van Dyke Brown mixed with Dioxazine Violet to add shadow to the upper wing, and blend the shadow out with a damp brush. Shade the cere and legs with a No. 2 round and Van Dyke Brown.

7 **Paint a Wash over the Upper Wings and Legs**
Use Burnt Umber and a No. 4 round to paint a wash over the upper wing and leg of the gryphon. Use a lighter wash to add a bit of brown to the shadows on the belly and underwing. Switch to a No. 2 round to paint markings on the head and neck.

8 **Begin Painting Feather Details**
Begin painting the bars on the feathers with Sepia and a No. 2 round, and when dry, go over the bars with Burnt Umber. For the upper feathers, blend out the Sepia with a damp brush (as seen in the lower row), then go over with Burnt Umber once dry (as seen in the upper row).

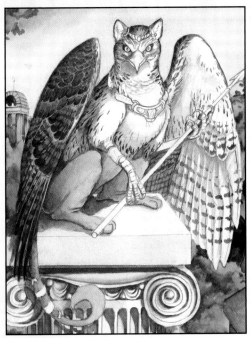

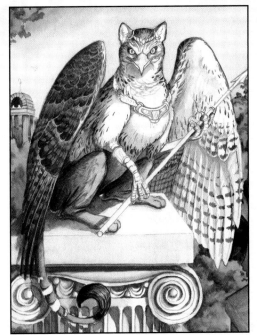

9 Finish Painting Feather Details
Continue painting the upper wing coverts with Sepia, then a wash of Burnt Umber and No. 2 round. Use Sepia mixed with Burnt Umber to paint markings on the chest, leg feathers and underwing, then use a lighter wash of this color to paint the underwing bars. Switch to Burnt Umber to add some more feather markings to the head and neck. For the primaries on the upper wing, use Sepia. Then when dry, use a No. 4 round to paint a wash of Cobalt Blue and Burnt Umber.

10 Add Detail to the Legs and Tail
Using a No. 4 round, paint Sepia on the legs and tail to add deeper shadow, including a shadow on the foot from the spear. Add fur texture with a No. 1 round and a mixture of Sepia and Burnt Umber, and paint fur texture on the lightest area of the legs with just Burnt Umber. Use Sepia and a No. 2 round to paint the dark tail tuft, using the tip to paint strands of fur. Then wet the brush and blend out on the bend of the tuft to create a gradual highlight.

Gryphon Weapons and Armor

When designing weapons and armor for a gryphon, think not only of gryphon equivalents of human weapons and armor, but specialized items that would work well specifically for their body type.

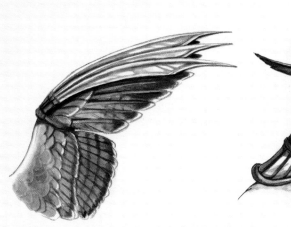

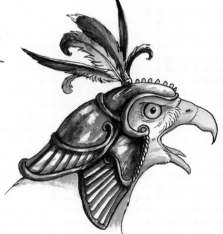

Gryphons have a powerful beak and sharp talons to fight with, but their wings also have a lot of potential as well. These wing blades attach at the wrist joint on the wing, so they don't interfere with the fold of the wing. They give the gryphon an extra weapon in flight.

A helmet doesn't have to be a plain piece of metal. Add engraving, jewels and decorative rivets and plumes to this essential piece of armor.

This leg blade attaches to the foreleg with a leather strap to keep a gryphon's talons free of held weapons.

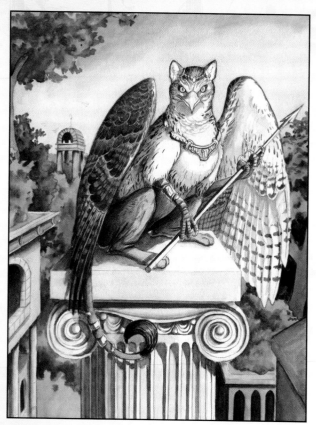

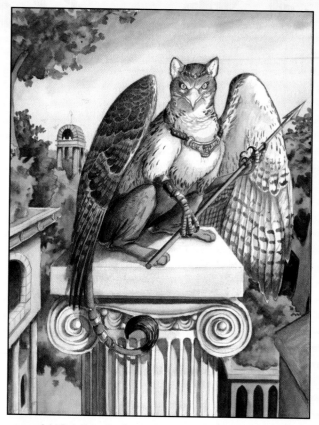

11 Add Shadow to the Accessories and Buildings and Color the Forelegs

Mix Burnt Ochre with Van Dyke Brown and paint shadows on the leather forearm cuff, gold tail cuff, neck jewelry and head adornment with a No. 2 round. Paint a shadow on the shaft of the spear with Van Dyke Brown mixed with Indigo, and use Indigo for the shadow of the metal spear tip. Paint the shadows of the neck jewelry leather with Sepia. Paint the forelegs with Cadmium Yellow mixed with Burnt Ochre, and deepen the shadows with Burnt Sienna mixed with Ultramarine Violet.

Use a No. 4 round to add depth to the shadow of the buildings with a mixture of Indigo and Van Dyke Brown.

12 Add Detail to the Spear, Adornments and Final Washes

Paint the leather of the arm cuff and necklace with Burnt Sienna mixed with Quinacridone Rose, then paint the metal with Burnt Ochre mixed with Cadmium Yellow. Use Phthalo Blue and a No. 1 round for the jewels, and add a little Permanent Green to the arm cuff jewel. Paint the talons with Indigo mixed with Sepia. Use a No. 2 round and Raw Umber to paint the spear, and Indigo for the final color on the spear tip.

Use a No. 4 round and a light wash of Raw Umber to add a warm tint to the gryphon, painting everything except the whitest feathers. Switch to a No. 8 round and paint a light wash of Naples Yellow on the pillar, everywhere except for the very top and on the brightest highlights. Finish the wing tips with a wash of Sepia and a No. 4 round.

Gryphon Adornments

Like humans, gryphons love to adorn themselves with jewels and precious metals. When designing jewelry pieces, be sure they fit in such a way that they won't interfere with movement or flight. Wing decorations, for example, may look lovely, but if they prevent a wing from closing or opening, then they aren't very functional.

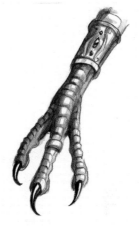

Earrings

A gryphon's large, feline ears give it plenty of space for earrings. Try giving your gryphon hoops or studs, or dangling a chain between two piercings.

Tail Jewelry

Because the tail is flexible, try not to sheath it in a long, unyielding cuff. Spiral cuffs that can move with the tail are an excellent way to have a functional piece of tail jewelry.

Rings and Foreleg Cuffs

Long bird toes are perfect for rings, and a metal or leather cuff can make a gryphon's long, slender forelegs even more elegant. A gryphon lord or lady might embellish jewelry with special stones to show rank or wealth.

Painting Stones

Cabochon

A cabochon is a stone with a smooth, polished, rounded surface. Start by drawing the shape of your stone, then use a No. 2 round to paint a dark color around the edge and across the middle. Use a damp brush to blend out, and be sure to keep a bright highlight on the top and in a narrow curve along the bottom. When dry, add a line of darker color along the center and blend out with a damp brush. Add a wash of a bright yellow, in this case Aureolin Yellow, to push the color.

Faceted Stones

Many precious gems, such as diamonds, rubies and emeralds, are faceted, which shows their brilliant color and translucence even better than a rounded face. Start with a hexagon, then draw lines radiating out to an overall circular shape. Because each face catches a different amount of light, leave some completely white and others very dark. The center tends to have a mixture of highlight and shadow.

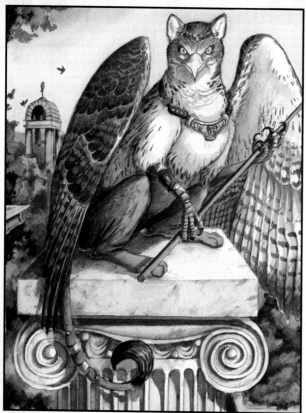

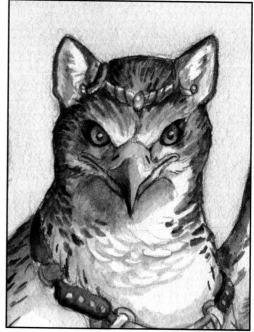

13 Final Background Details

Deepen the tree shadows with a mixture of Sap Green and Indigo, and use a No. 4 round to create irregular texture. Switch to Hooker's Green mixed with Prussian Blue for the trees on the far right. For the trunks, shade with Indigo and Van Dyke Brown, and use the tip of your brush for bark texture.

Add very light texture to the stone of the pillar with a No. 4 round and a very watered-down wash of Indigo and Van Dyke Brown. Immediately go over the marks with a damp brush for just a suggestion of texture. Use this same mixture for the building to the left. For the background building, paint the metal rod on the top with a No. 1 round and Van Dyke Brown for the shadow and Burnt Ochre for the metal. Paint the birds with Van Dyke Brown and Indigo.

14 Paint the Face Details

Use a No. 1 round to paint the eyes with Cadmium Yellow with Burnt Sienna along the top. Paint Van Dyke Brown along the head to deepen the shadow and markings, then use Van Dyke Brown mixed with Indigo to shade the inside of the ears. Use Indigo to paint the beak, blending with a damp brush for a gradient, then darken with Payne's Gray. Use Payne's Gray for the pupils once the first wash is dry, and use this to paint the nostrils.

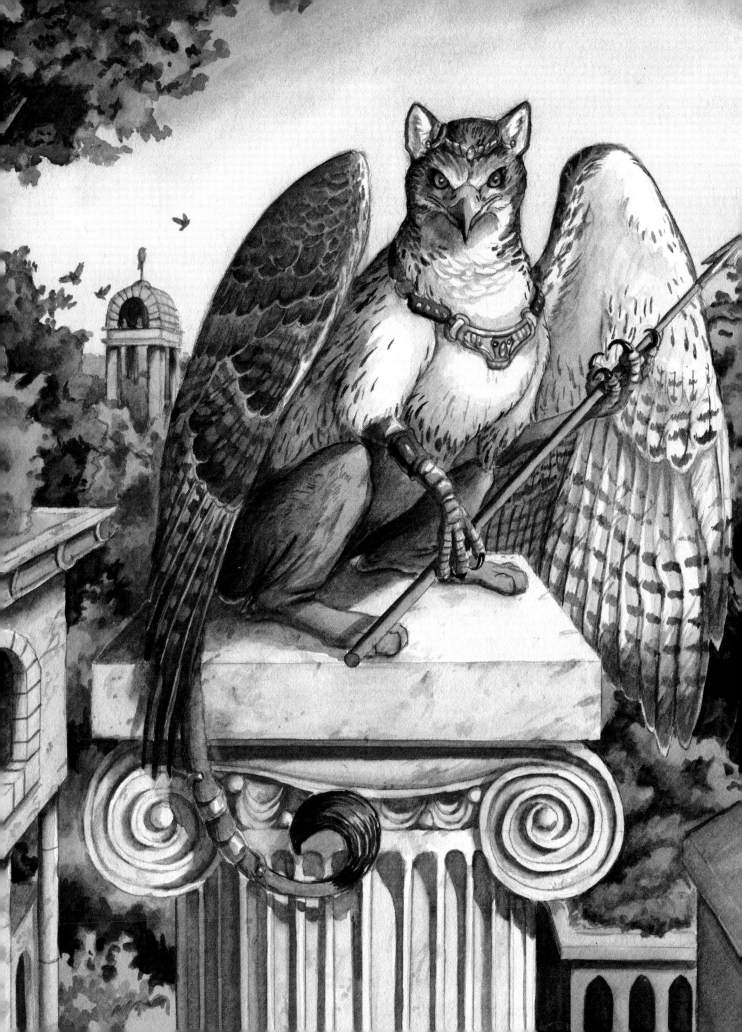

Conclusion

Although this book teaches how to create beings from myth and legend, the most successful and interesting creations will be those inspired by elements of the real world. Even an animal that is entirely born from your imagination can be designed with inspiration from the world around you. When your audience recognizes elements of existing creatures in your painting, it gives your fantastical beings a touch of realism. Studying the pattern of scales on an alligator and styling your dragon's spine from their shape and texture, for instance, or familiarizing yourself with the order and layering of a vulture's wing for a pegasus will help push your creatures from simply made-up, to believably fantastical.

There's no limit on the possibilities that exist to create your own winged beings. Even the most common mythological beasts that fill our storybooks and legends can be inspiration for the ideas behind your own unique creature, so never be afraid to experiment and explore! Draw and doodle, sketch animals from life and use your imagination to discover what otherworldly roots those animals may have in a world of flight and magic.

Everything you learned in this book can and should be adjusted to your own style and taste. There's no rule in the world of art that says a Pegasus must have white bird wings or a gryphon must be half-eagle and half-lion. Give your Pegasi bat wings, or create a pigeon-rat gryphon. Fashion a dragon out of autumn leaves, or give it spiral shells for horns. If you have an idea you want to try, there's no reason you shouldn't. There's no barrier between your imagination and a finished painting, as long as you aren't afraid to pick up the brush and begin!

Index

Photo by Colleen Backman

About the Author

Brenda Lyons has been drawn to winged creatures, particularly birds, since she was a young child. She remembers the first time she found a heavy book full of John James Audubon's paintings in the library and how she was drawn in by the dynamic poses and personalities his birds seemed to have. The ink drawings of Peter Parnall's raptors fueled her inspiration as well. Her art gradually shifted to the world of fantasy and myth, creating naturalistic wildlife illustrations, but with a touch of the otherworldly.

She graduated in 2007 from Rocky Mountain College with a degree in studio art, and from the Savannah College of Art and Design in 2009 with a master's of fine art in illustration, and studied for a semester in Galway, Ireland. Though she currently resides in her home state of Connecticut, she loves to travel around the country for conventions and art shows. When not painting, she volunteers at Horizon Wings in Connecticut, where she helps with educational programs and rehabilitation of sick and injured raptors. She also competes in archery at a local level.

Aside from watercolor, Brenda also uses acrylic, ink and graphite, and creates fantasy and nature-based masks and jewelry from leather.

 Other fine IMPACT Books are available from your favorite bookstore, art supply store or online supplier. Visit our website at fwmedia.com.

18 17 16 15 14 5 4 3 2 1

DISTRIBUTED IN CANADA BY FRASER DIRECT
100 Armstrong Avenue
Georgetown, ON, Canada L7G 5S4
Tel: (905) 877-4411

DISTRIBUTED IN THE U.K. AND EUROPE
BY F&W MEDIA INTERNATIONAL, LTD
Brunel House, Forde Close, Newton Abbot,
TQ12 4PU, UK
Tel: (+44) 1626 323200; Fax: (+44) 1626 323319
Email: enquiries@fwmedia.com

DISTRIBUTED IN AUSTRALIA BY CAPRICORN LINK
P.O. Box 704, S. Windsor NSW, 2756 Australia
Tel: (02) 4560-1600; Fax: (02) 4577 5288
Email: books@capricornlink.com.au

ISBN 13: 978-1-4403-3530-3

Edited by Beth Erikson
Designed by Geoffrey Raker
Production coordinated by Mark Griffin

Metric Conversion Chart

To convert	to	multiply by
Inches	Centimeters	2.54
Centimeters	Inches	0.4
Feet	Centimeters	30.5
Centimeters	Feet	0.03
Yards	Meters	0.9
Meters	Yards	1.1

Acknowledgments and Dedication

Special thanks to Dad, who always encouraged me and stood by me through all the decisions I've made. To my brother, Steve, who is an amazing artist and inspired me to keep drawing. To Angela, who has been one of the best friends through all these years. To Mona Clough, who saw potential in my ideas; and to Beth Erikson for all her help in creating this book.

Also in memory of my mom, who was one of the first supporters of my art and always gave her honest opinion, support and help with even my earliest drawings.

Ideas. Instruction. Inspiration.

Download FREE bonus materials with demos and tips about fur texture, perspective, how to draw a parrotgryph and more at impact-books.com/WingedFantasy.

Learn how to draw and paint even more fantasy creatures with some of our other **IMPACT** titles!

These and other fine **IMPACT** products are available at your local art & craft retailer, bookstore or online supplier. Visit our website at impact-books.com.

Follow **IMPACT** for the latest news, free wallpapers, free demos and chances to win FREE BOOKS!

Follow us!

IMPACT-BOOKS.COM

- ▶ Connect with your favorite artists
- ▶ Get the latest in comic, fantasy and sci-fi art instruction, tips and techniques
- ▶ Be the first to get special deals on the products you need to improve your art